CREATIVE
ACRYLIC
PAINTING
TECHNIQUES

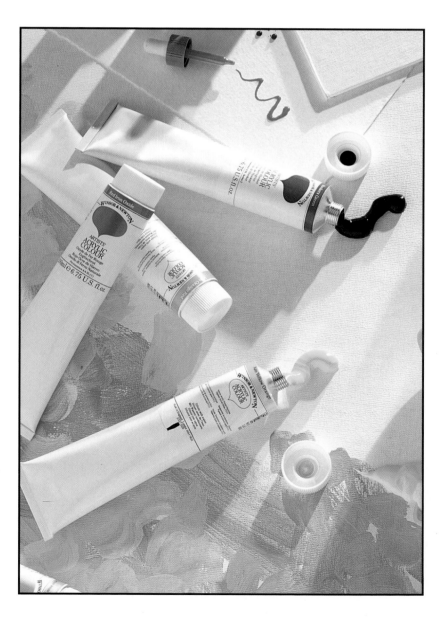

CREATIVE
ACRYLIC
PAINTING
TECHNIQUES

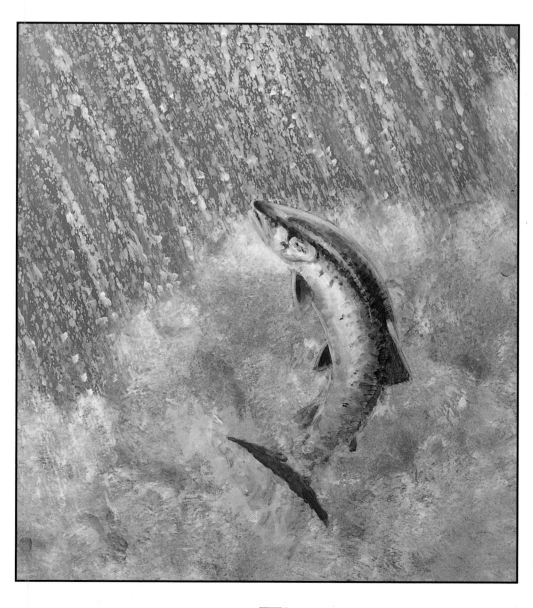

NORTH LIGHT BOOKS

Cover painting by Susan Pontefract.
Painting on page 3 by Richard Smith.

Based on *The Art of Drawing and Painting*, published
in the UK by
© Eaglemoss Publications Ltd 1995
All rights reserved

First published in the USA in 1995
by North Light Books,
an imprint of F&W Publications Inc.,
1507 Dana Avenue,
Cincinnati, Ohio 45207.

ISBN 0-89134-710-0

Manufactured in Hong Kong

10 9 8 7 6 5 4 3 2 1

Contents

PART 1

Basics of Acrylic Painting

Exploring acrylic

With many of the advantages of oil and watercolour paints – and quite a few plus points all its own – acrylic is wonderfully versatile and a joy to handle.

Whatever your taste in painting, acrylic is well worth trying. Based on a synthetic, plastic resin, this flexible paint lends itself well to a whole range of techniques and is capable of producing everything from the most delicate washes and glazes to bold, thick, juicy layers.

It has increased in popularity steadily ever since it arrived on the art scene about 50 years ago. This is mainly because of its great advantages, particularly for beginners, over traditional forms of paint.

Acrylic is quick drying, has good covering power and great brilliance of colour – it doesn't fade in the sun as watercolours do, nor does it darken with time like oil colours. And, once dry, the paint takes the form of a flexible plastic coating which is almost indestructible.

You can use acrylic on a wide variety of surfaces. Paper, cardboard, card, canvas and wood are all suitable. It can also be applied on glass, metal or fabric, provided they are non-greasy and have enough 'tooth' to hold the paint.

Thinning the paint

In acrylic paint the pigments used are held together in a milky liquid plastic which turns

▼ **With many of the qualities of oil paints – but drying in a fraction of the time oil takes – acrylic gives you a golden opportunity to work quickly, laying on rich, thick, textured layers to convey intense drama, movement and atmosphere.**
'A port in the storm' by Gordana Bjelic-Rados, 16 x 26in

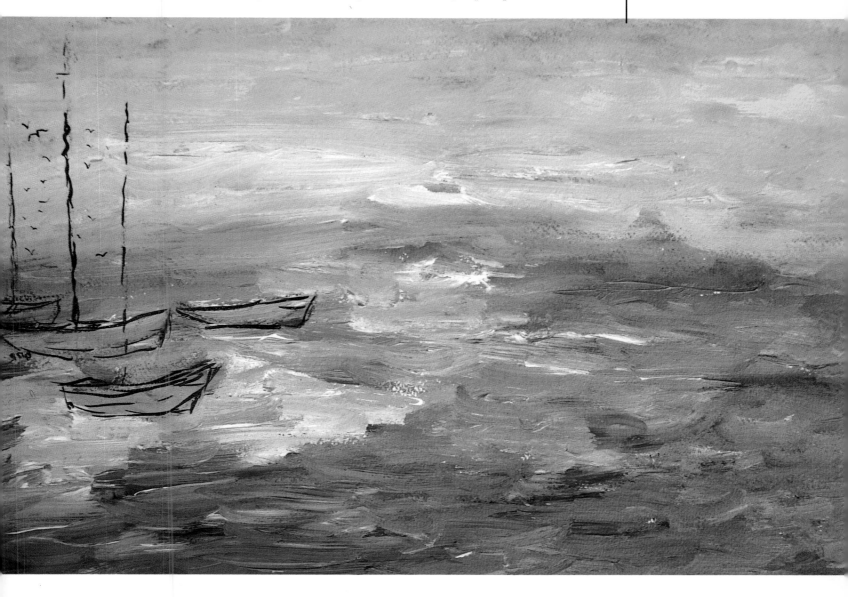

▼**Generous sweeps of the brush combined with a sensitive composition make the most of the limited but effective palette of colours chosen by the artist.**
'Knitting' by Sarah Cawkwell, 30 x 22in

clear when dry. Like watercolour, acrylic dissolves in water – you can use water to thin or extend the paint and to clean your brushes and palettes. But unlike other water-based paints it sets and becomes insoluble once dry.

On the plus side, this means a painting can't be damaged by water once it has dried. It also allows you to overpaint and correct mistakes. The disadvantage is that acrylic can damage your brushes and palettes. If the paint is left to dry on brushes they become almost impossible to clean. You need to rinse them regularly and never let paint dry on them.

Water isn't the only medium used to thin or extend acrylic. Most acrylic paint manufacturers produce their own painting mediums which change the way acrylic behaves. The two most important are gloss and matt. Gloss medium thins acrylic paint so that it flows easily and dries to a shiny finish like an oil painting. Matt medium has exactly the same consistency but dries to a non-shiny finish.

Cutting down on drying time

The outstanding quality of acrylic paint is the speed at which it dries. It becomes touch-dry as soon as the water content evaporates and can usually be overpainted within 30 minutes. This is marvellous if you need to work quickly – to capture the fleeting effects of light on a landscape, for example.

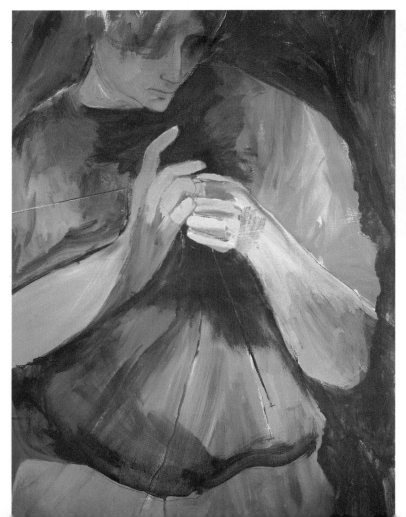

You can also lay in an underpainting and overpaint with layers almost at once without the long drying times required for oil. And at the end of a day painting outdoors you have a dry paper or canvas to take home rather than an oily surface which is difficult to carry and always seems to fall butter-side-down. Even thick layers of paint have a touch-dry surface at the end of the day.

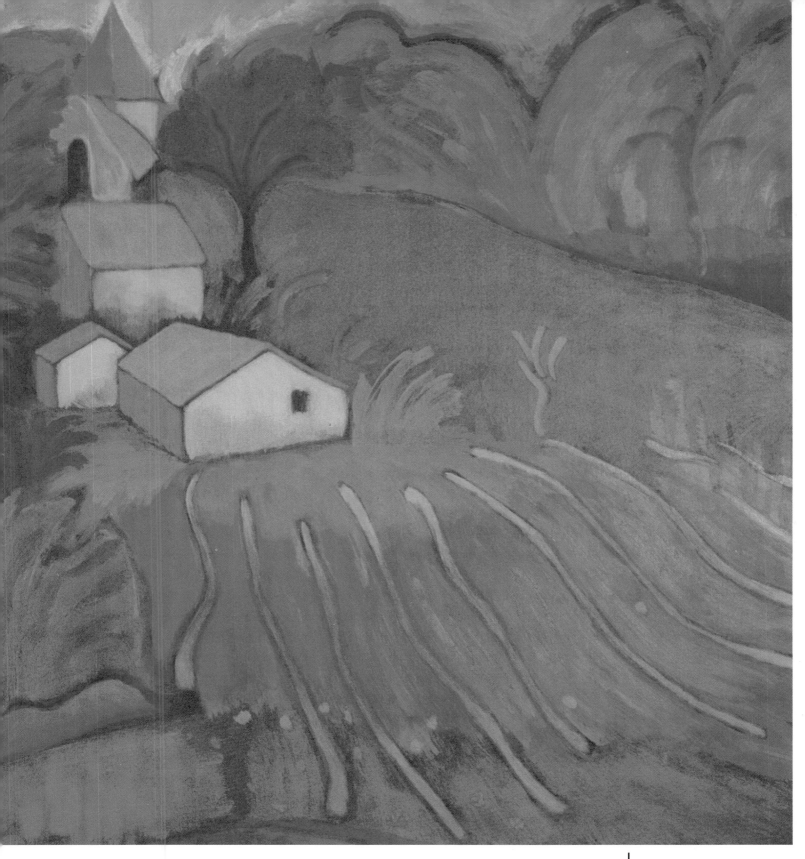

Acrylic underpainting

Once acrylic is dry it can be used as a base for other media. You can combine acrylic and oil very effectively, laying in the underpainting in fast-drying acrylic then completing the painting in oil using traditional oil techniques. This approach allows you to block in the broad structures of the composition and cover the white of the canvas very quickly, but then develop the painting in a more considered way in oil. (Remember that you can use oil paints over acrylic – but never try to put acrylic paints over oil.)

A combination of acrylic and oil is a useful way of working outdoors – using acrylic paint in the field but completing the painting in oil in the studio. This approach is similar to that used by the Flemish Old Masters who laid in

▲ **Simple brushstrokes in the vibrant colours that are the hallmark of acrylic paints combine in this pleasing scene.**
'Vailhourles 1' by Terry Burke, coloured paper, 52 x 38cm

► **Versatile brushwork, with many bold strokes and lines, gives masses of interesting texture in this painting.** 'Busk' by Bill Taylor, acrylic on card/cardboard, 13 x10in

▼ **Though lending itself well to covering large areas of canvas or paper, acrylic is also capable of great delicacy and precision. Here the artist has achieved a wide variety of different textures and also a high degree of realism.** 'Waiting for mum' by Richard J Smith, acrylic on board, 32 x 24in

the underpainting in egg tempera, overlaying this with translucent glazes of oil paint. The resulting pictures have a depth of colour and a glowing quality rarely matched today.

You can also combine acrylic paints with many other media – oil pastel, pastel, crayon and pencil are just some of the possibilities.

As well as being fast drying and unaffected by water once dry, acrylic is highly adhesive. This makes it excellent for outdoor murals – it is weather resistant and adheres well to most surfaces. It is also good for collage techniques since the undiluted paint and the various mediums can be used to glue paper or fabrics to the support.

Acrylic texture pastes (gels) and modelling mediums are especially strong adhesives and can also be used to create relief surfaces.

A range of approaches

Thinned with water and used on paper, acrylic can be used to create transparent washes which closely resemble watercolour or gouache. Using it directly from the tube or very slightly thinned, you can build up rich impastos – as with oil. It is equally good for small-scale works on paper and for large easel paintings on canvas.

Not all acrylic paints are the same – some are more fluid than others. Some makers give only one formula while others offer the paint in a buttery consistency, rather like oil paint, and in a more fluid form as well. The thicker paints are better for impasto techniques where the mark of the brush is important, while flow formula is excellent for large-scale staining techniques.

Choosing acrylic paints

Today the range of acrylic paints is simply vast. With information about the most recent developments, you can use the right paint for the right job, saving yourself time, money and a lot of hard work.

Paint manufacturers are constantly developing and changing their acrylic paints. This is tremendously exciting – but keeping informed about current products is not easy. Even experienced professionals may miss out on new possibilities because they are unfamiliar with recent developments.

Liquid acrylics are a typical example. Fairly new products, they slightly resemble brilliant liquid watercolours or inks (which tend to be fugitive – fading when exposed to light). Because they all look similar they may often be grouped together – wrongly, since most liquid acrylics are permanent, not fugitive. If artists don't know about them, they're limiting their creative possibilities.

What is acrylic?

Acrylic paint is simply pigment dispersed in a film of transparent liquid plastic (technically speaking, an emulsion consisting of plastic acrylic resin and water). You can dilute acrylic paint with water, but remember that it is completely insoluble once dry.

In its liquid form the emulsion has a milky appearance, but after the water evaporates it is transparent. You can test this with one of the acrylic mediums – just brush some undiluted gloss or matt medium (an emulsion without any pigment) on to a tinted support. You'll see that it's rich and creamy straight out of the bottle, but completely transparent when dry.

Types of paint

Most paint manufacturers have at least one range of acrylic paint in their catalogue – and some have several. The main differences between one range and another are the consistency and the number of colours.

You can apply acrylics thickly for impasto and thinly for washes and staining techniques. Thick, textured impasto requires a stiff paint which can retain the strong mark of the brush or painting knife. Thinner, more fluid paint is best for washes. Adding proprietary mediums to thicken or thin the paint is one way to increase the paint's versatility.

Some manufacturers, however, produce several ranges of paint with different consistencies to save you the time and trouble of mixing. Here we look at three of the largest acrylic paint manufacturers. Their products are widely available in most art shops.

DID YOU KNOW?

What are alkyds?
Often confused with acrylics, alkyds are fast-drying oil paints (but not as fast as acrylic paints) that do not mix with water. Use them on their own, or combine them with oil paints. To modify the way alkyds behave and to quicken their drying time, use alkyd mediums such as Winsor & Newton's Wingel or Liquin.

▼ **Here the artist's use of opaque acrylic is bold and loose. The scumbled water and the sky give a dramatic sense of depth, helping your eye to travel from the opaque water to the bright red building and into the city-scape and beyond.**
'St Paul's from the South Bank' by Terry McKivragan, acrylic on hardboard, 36 ¼ x 44in

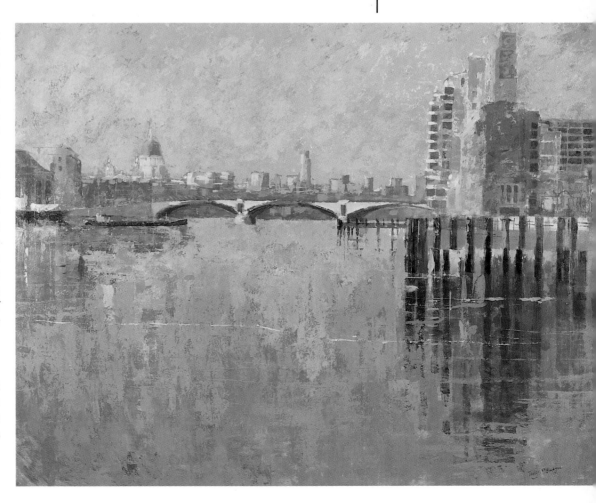

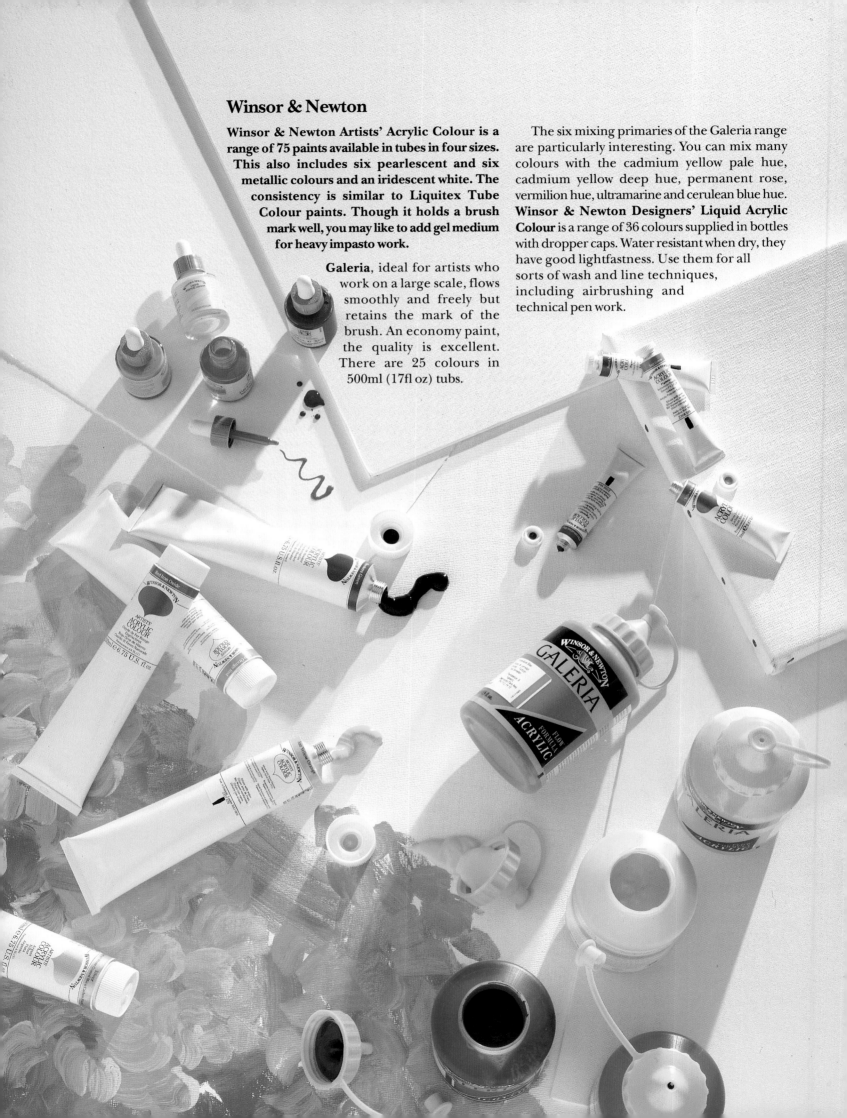

Winsor & Newton

Winsor & Newton Artists' Acrylic Colour is a range of 75 paints available in tubes in four sizes. This also includes six pearlescent and six metallic colours and an iridescent white. The consistency is similar to Liquitex Tube Colour paints. Though it holds a brush mark well, you may like to add gel medium for heavy impasto work.

Galeria, ideal for artists who work on a large scale, flows smoothly and freely but retains the mark of the brush. An economy paint, the quality is excellent. There are 25 colours in 500ml (17fl oz) tubs.

The six mixing primaries of the Galeria range are particularly interesting. You can mix many colours with the cadmium yellow pale hue, cadmium yellow deep hue, permanent rose, vermilion hue, ultramarine and cerulean blue hue. **Winsor & Newton Designers' Liquid Acrylic Colour** is a range of 36 colours supplied in bottles with dropper caps. Water resistant when dry, they have good lightfastness. Use them for all sorts of wash and line techniques, including airbrushing and technical pen work.

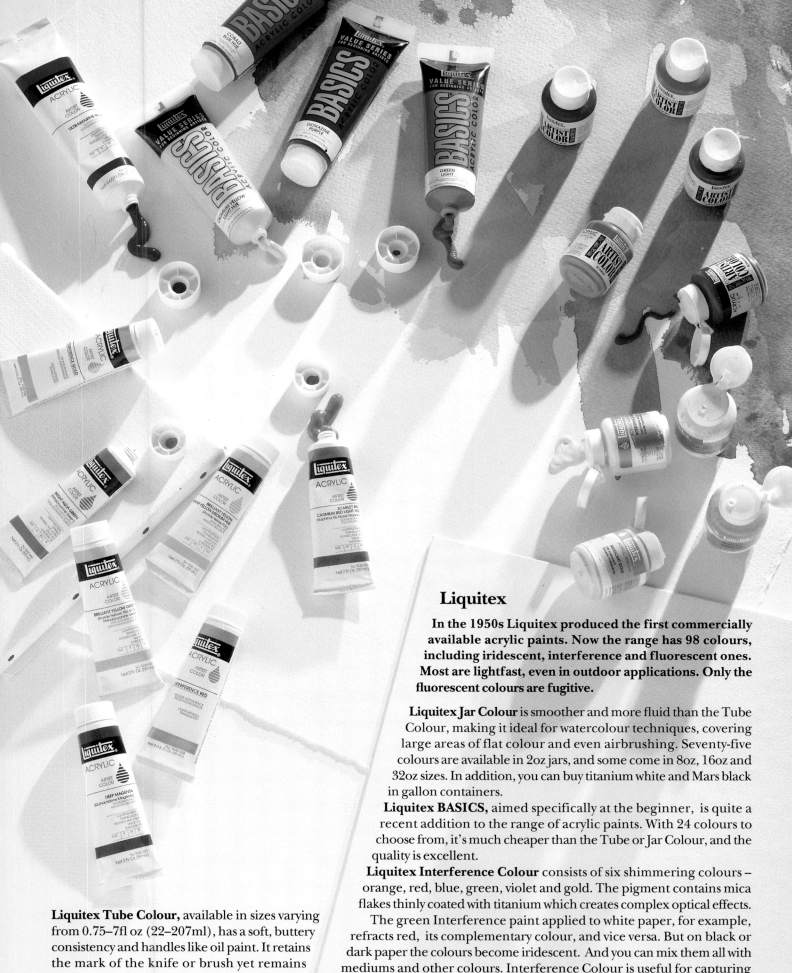

Liquitex

In the 1950s Liquitex produced the first commercially available acrylic paints. Now the range has 98 colours, including iridescent, interference and fluorescent ones. Most are lightfast, even in outdoor applications. Only the fluorescent colours are fugitive.

Liquitex Jar Colour is smoother and more fluid than the Tube Colour, making it ideal for watercolour techniques, covering large areas of flat colour and even airbrushing. Seventy-five colours are available in 2oz jars, and some come in 8oz, 16oz and 32oz sizes. In addition, you can buy titanium white and Mars black in gallon containers.

Liquitex BASICS, aimed specifically at the beginner, is quite a recent addition to the range of acrylic paints. With 24 colours to choose from, it's much cheaper than the Tube or Jar Colour, and the quality is excellent.

Liquitex Interference Colour consists of six shimmering colours – orange, red, blue, green, violet and gold. The pigment contains mica flakes thinly coated with titanium which creates complex optical effects. The green Interference paint applied to white paper, for example, refracts red, its complementary colour, and vice versa. But on black or dark paper the colours become iridescent. And you can mix them all with mediums and other colours. Interference Colour is useful for capturing the iridescent qualities on some bird plumages, for instance.

Liquitex Fluorescent Colour appears to glow even when mixed with other acrylic paints. Don't use it for paintings you want to keep because it's fugitive.

Liquitex Tube Colour, available in sizes varying from 0.75–7fl oz (22–207ml), has a soft, buttery consistency and handles like oil paint. It retains the mark of the knife or brush yet remains flexible when dry. The complete range isn't available in all tube sizes. Mars and ivory black come in large 8fl oz (237ml) tubes.

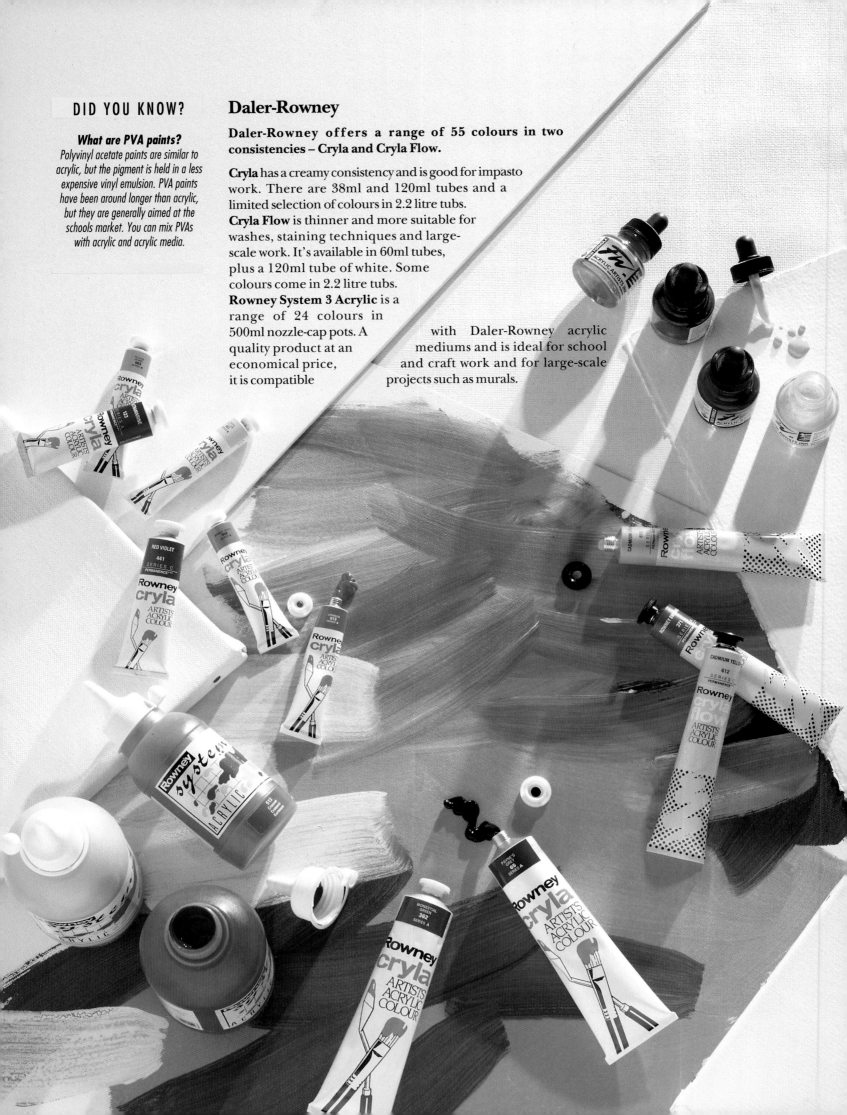

Daler-Rowney

Daler-Rowney offers a range of 55 colours in two consistencies – Cryla and Cryla Flow.

Cryla has a creamy consistency and is good for impasto work. There are 38ml and 120ml tubes and a limited selection of colours in 2.2 litre tubs.

Cryla Flow is thinner and more suitable for washes, staining techniques and large-scale work. It's available in 60ml tubes, plus a 120ml tube of white. Some colours come in 2.2 litre tubs.

Rowney System 3 Acrylic is a range of 24 colours in 500ml nozzle-cap pots. A quality product at an economical price, it is compatible with Daler-Rowney acrylic mediums and is ideal for school and craft work and for large-scale projects such as murals.

Liquid acrylics

Liquid acrylics – the most fluid form of acrylic paint – come in many dazzling transparent and opaque colours.

Acrylic paints exist in many forms – from buttery, paste-like consistencies through to liquids. Because they're fairly new (40 or so years old compared with 500 years for oils), manufacturers haven't standardized the range of products, and this causes a lot of confusion for artists – beginners and experienced alike. Liquid acrylics are a typical example – they're so fluid that they closely resemble traditional coloured inks and brilliant liquid watercolours.

Traditional coloured inks are bound with shellac (an alcohol-soluble resin made from insect secretions). They are waterproof when dry and tend to be made from dyes. Generally, they are not lightfast, but some colours, such as black and white, are more lightfast than others.

Brilliant liquid watercolours are bound with gum arabic. Like the inks, they are not generally lightfast but are water soluble when dry.

Liquid acrylics are bound with a film of transparent liquid plastic (acrylic). They are water resistant when dry and tend to be more transparent and flexible than shellac-based inks. Their advantage is that they are made from pigments, which are generally more lightfast than dyes.

Lightfastness

Why would anyone want to use a fugitive dye or a pigment, no matter how beautiful the effect? The reason is that coloured inks and brilliant watercolours were originally designed for graphic illustrations which are turned into printed matter such as greeting cards,

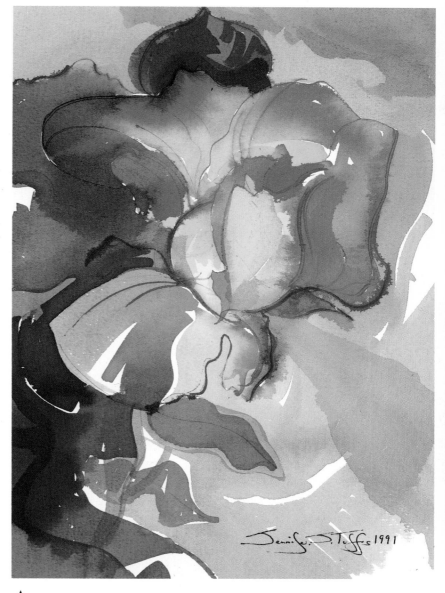

▲ Liquid acrylics can be used in the same way as watercolour or ink. They have similar depth of colour to inks, but they are generally more lightfast.

'Caught between day and night' by Jennifer Tuffs, Magic Colour Liquid Acrylics on watercolour paper, 9 x 12in

Royal Sovereign's Magic Colour Liquid Acrylics

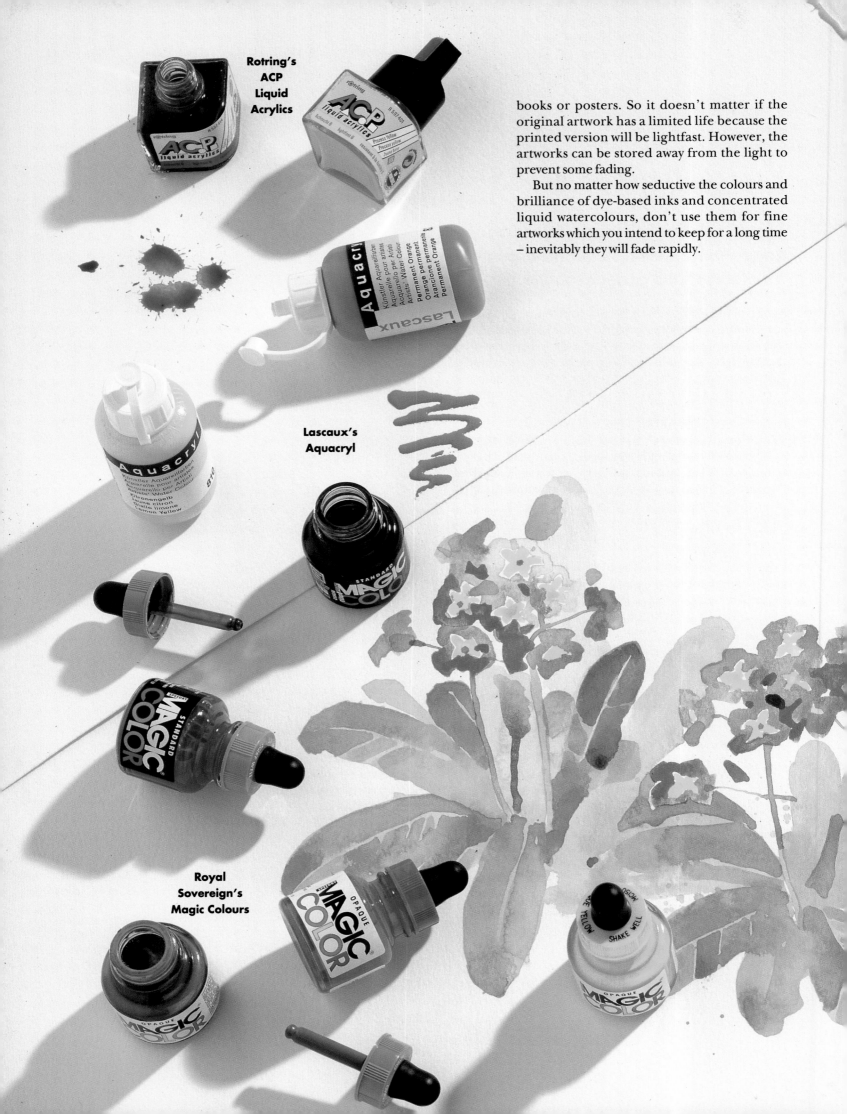

**Rotring's
ACP
Liquid
Acrylics**

**Lascaux's
Aquacryl**

**Royal
Sovereign's
Magic Colours**

books or posters. So it doesn't matter if the original artwork has a limited life because the printed version will be lightfast. However, the artworks can be stored away from the light to prevent some fading.

But no matter how seductive the colours and brilliance of dye-based inks and concentrated liquid watercolours, don't use them for fine artworks which you intend to keep for a long time – inevitably they will fade rapidly.

Using liquid acrylics

These paints are densely pigmented – in other words, a little goes a long way. You can mix all the colours to create an endless range of transparent colours, or add a little white to create opaque paint.

Supports Your choice of support with liquid acrylics is vast – cardboard, watercolour paper, millboard, canvas board and even sheets of acetate. And you can create vibrant stained effects on raw canvas, either to produce a finished image or to use as an underpainting.

Drawing Liquid acrylics even work well in technical pens for precise, detailed drawing such as in architectural studies. They are also a boon for calligraphy, allowing you to create beautiful flowing lines with dip and reservoir pens. Because liquid acrylics are water resistant when dry, you must *always* wash the dip pens in water after use, and replace the cap firmly on reservoir and technical pens. Flush reservoir pens thoroughly with water after use to prevent paint from drying up inside. If the paint does dry inside, clean it out with airbrush cleaning fluid.

Watercolours You can use liquid acrylics with a soft brush for traditional watercolour techniques such as wet-in-wet and wet-on-dry. Also try mixing the colours together by pouring, dripping and tipping to create wonderful rainbow effects. Try

▶ Use the dropper caps on some bottles of liquid acrylics to transfer paint to a watercolour palette or to drop paint straight on to your painting. If you use a dropper cap, there is no fear of contaminating the colour in the bottle with another paint colour.

using a straw to blow rivers of colour across the support, or use a hair dryer to create even more dramatic results.

Crafts Liquid acrylics have many craft applications – they are excellent for decorating resin, wood and leather. You can create stained-glass effects by applying them to glass. (In some cases manufacturers recommend a medium to improve adhesion to smooth surfaces.)

Mixed media It's also possible to combine other media successfully with liquid acrylics – for example, watercolours, gouache, other acrylics, pastel and pencil. You can achieve stunning effects by applying transparent colours over pearlescent acrylics, such as Daler-Rowney's Pearlescent Liquid Acrylics, or Liquitex's concentrated Opalescent Acrylic Colour.

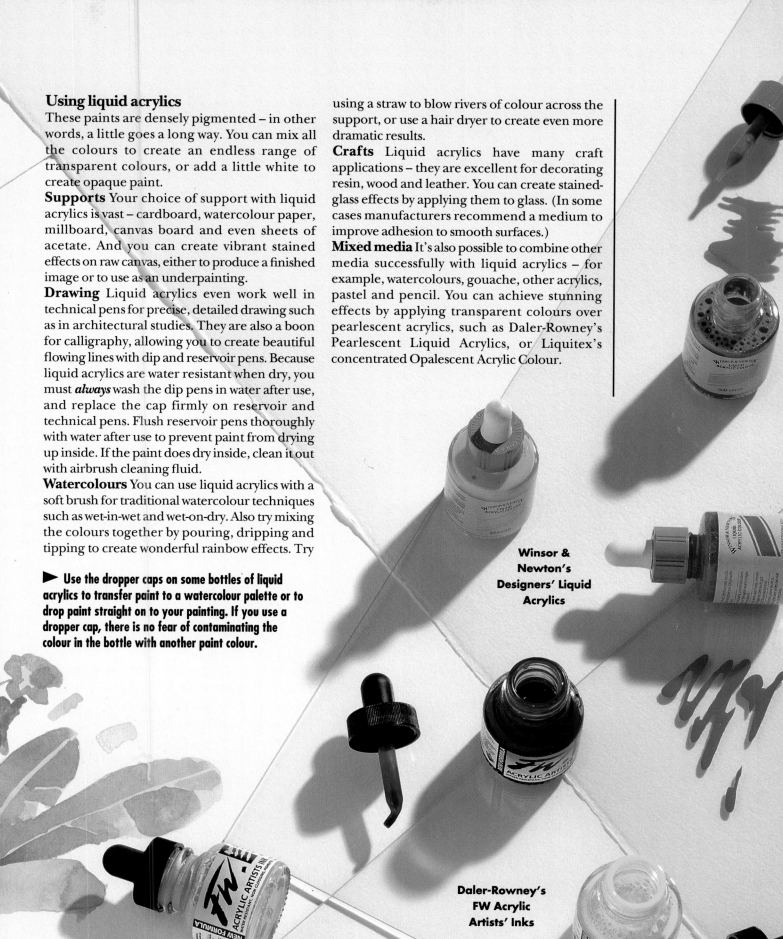

Winsor & Newton's Designers' Liquid Acrylics

Daler-Rowney's FW Acrylic Artists' Inks

Products on the market

Most liquid acrylics are supplied in bottles with dropper caps, enabling you to draw colour directly from the bottle and put it on the palette. (Dipping your brush into the bottle contaminates the colour quickly.) There's a wide range of liquid acrylics on the market today. Here's a handful of manufacturers; your local art shop should stock one or more of the following.

Rotring's ACP Liquid Acrylics come in 36 colours, including five greys and three process colours: cyan, magenta and process yellow. They come in 30ml glass bottles, with dropper caps.

Winsor & Newton's Designers' Liquid Acrylic Colours have 36 colours, including three greys and the three process colours. They are supplied in 30ml bottles with dropper caps.

Royal Sovereign's Magic Color consists of 40 colours, including 10 opaques. They come in bottles with dropper caps.

Daler-Rowney's FW Acrylic Artists' Ink comprises 30 colours in 29.5ml bottles with dropper caps and 14ml bottles with screw caps.

Lascaux's Aquacryl is a new product. Thin layers of paint become almost water resistant, but thick layers can be dissolved in water. This means you can re-mix colours which have dried on your palette. The range comprises 46 colours in 85, 250 and 500ml bottles.

Other related products

Liquitex's Concentrated Artists' Colour is really a craft product, ideal for stencilling, fabric painting and other craft applications.

Daler-Rowney produces a range of 21 Pearlescent Liquid Acrylics which have many fine art, graphic and craft applications. But they shouldn't be used in a technical pen (or airbrush) because they may clog it.

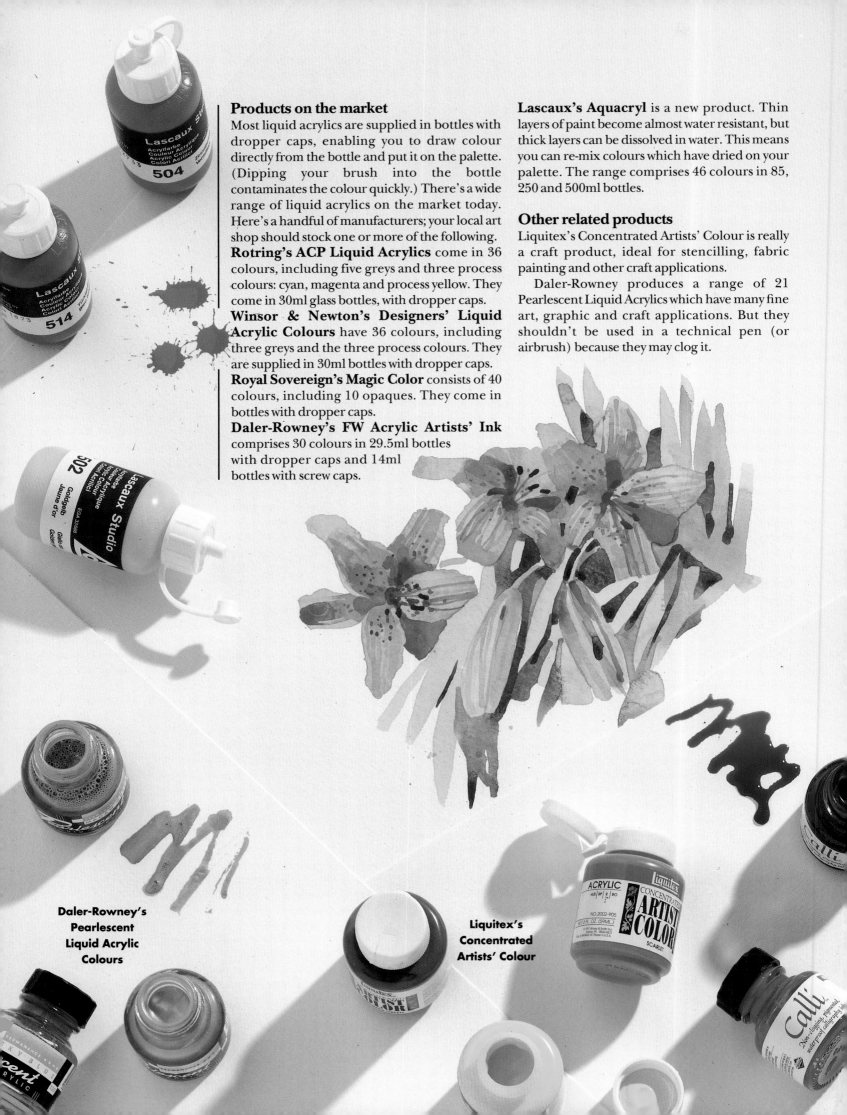

Daler-Rowney's Pearlescent Liquid Acrylic Colours

Liquitex's Concentrated Artists' Colour

Palettes for acrylic paints

Choosing a palette for your acrylics isn't simply a matter of picking up the first one that comes to hand. You also have to consider which materials work best with the paints themselves.

Throwing away a perfectly good palette because you can't clean the paint off it is not only irritating, it's a complete waste of money.

Unfortunately, this happens all too often with acrylics. These paints dry very quickly, and the highly adhesive properties of the medium make it impossible to remove dried paint easily or successfully from certain materials. Once dry, acrylic paint is completely insoluble – you can't wipe it off with water, turps or any other solvent.

It's therefore best to avoid surfaces that are porous, or those that provide a key for the paint to stick to. Wood, for example, with its small pits and grain marks, is a bad choice, even if it has been given a coat of varnish.

The best materials to mix acrylics on are those that are washable, with a smooth, non-porous and scratch-resistant surface. Plastic, melamine and glass are practical choices. They're excellent for mixing on, and quick and easy to clean.

▼ There's a good range of palettes for acrylics available in art shops, some of which will help keep your paints usable for longer. However, you don't have to choose an expensive option; a ceramic plate or tear-off paper palette may well be all you need.

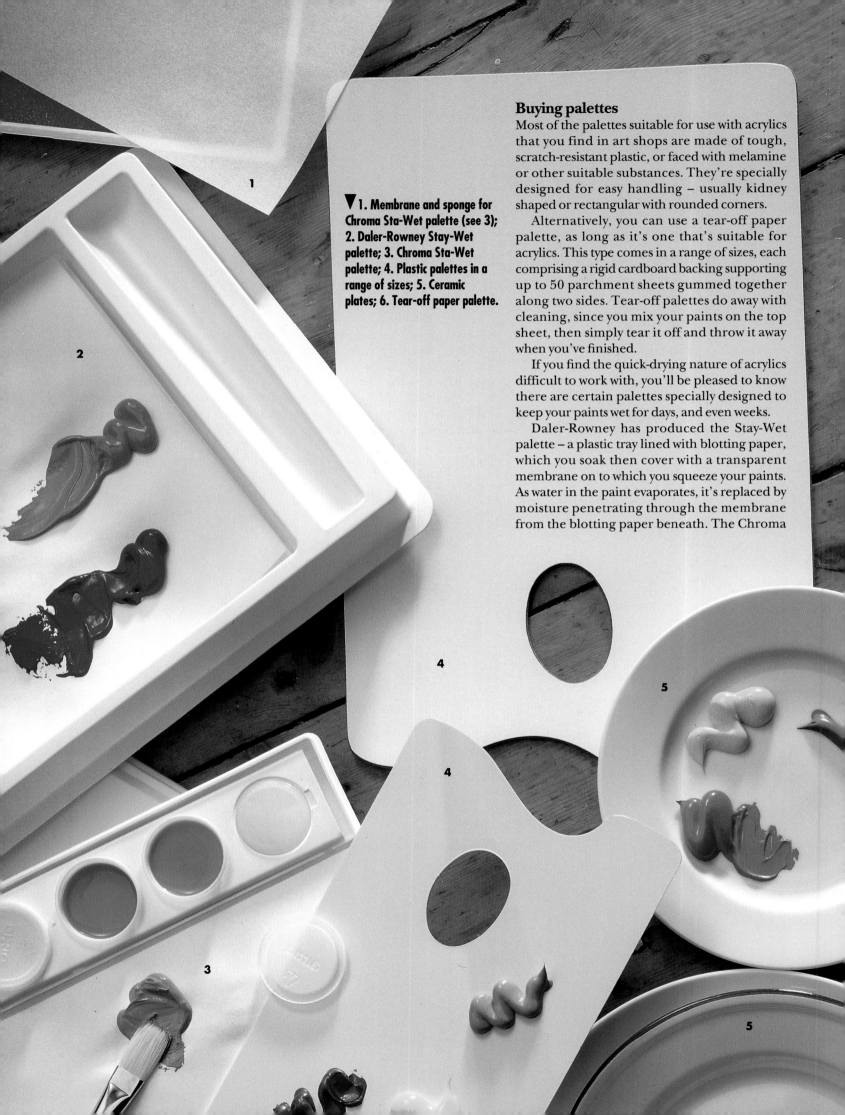

▼1. Membrane and sponge for Chroma Sta-Wet palette (see 3); 2. Daler-Rowney Stay-Wet palette; 3. Chroma Sta-Wet palette; 4. Plastic palettes in a range of sizes; 5. Ceramic plates; 6. Tear-off paper palette.

Buying palettes

Most of the palettes suitable for use with acrylics that you find in art shops are made of tough, scratch-resistant plastic, or faced with melamine or other suitable substances. They're specially designed for easy handling – usually kidney shaped or rectangular with rounded corners.

Alternatively, you can use a tear-off paper palette, as long as it's one that's suitable for acrylics. This type comes in a range of sizes, each comprising a rigid cardboard backing supporting up to 50 parchment sheets gummed together along two sides. Tear-off palettes do away with cleaning, since you mix your paints on the top sheet, then simply tear it off and throw it away when you've finished.

If you find the quick-drying nature of acrylics difficult to work with, you'll be pleased to know there are certain palettes specially designed to keep your paints wet for days, and even weeks.

Daler-Rowney has produced the Stay-Wet palette – a plastic tray lined with blotting paper, which you soak then cover with a transparent membrane on to which you squeeze your paints. As water in the paint evaporates, it's replaced by moisture penetrating through the membrane from the blotting paper beneath. The Chroma

Sta-Wet palette works in the same way. It consists of a tough, polyvinyl box containing a sponge and membrane. Both products are available in a range of sizes.

Making your own

Many artists who use acrylics prefer to make customized palettes to suit their own individual approach to painting. It's a good idea, since the materials you need are cheap and easily obtainable, and it means you can make your palette any shape or size you wish. It needn't be complex – just a flat, oblong surface cut to the size you want will do. (Try to round off the corners for safety's sake.) If you prefer working on a large scale, it can be big enough to hold lots of different mixes. Or if you like sitting down at your easel, you can shape it to fit a particular table or work surface.

There are a number of suitable materials you can use to make a palette. Formica, melamine and other similar laminates are available from timber yards and DIY shops, and many small firms sell cheap off-cuts.

Glass makes an excellent surface for mixing acrylics, and it's readily available from glaziers or picture framers. Bear in mind, though, that glass makes a much heavier palette than plastic. Make it safer to use by sticking plastic tape around the edges. Better still, attach it permanently to a flat surface, such as a piece of board, with some glue.

Plastic is a good choice. You can buy off-cuts from shopfitters or signwriters. Glaziers and picture framers sometimes stock transparent plastic.

Metal is another suitable surface, as long as it's enamelled or industrially painted. If not, it'll stain and go rusty. Don't use stainless metal – it's generally too reflective for good colour mixing.

Getting your tones right

If you're used to mixing oils on a dark wooden surface, you may find it difficult to judge tones on a sparkling white plastic or Formica palette. Colours which look bright or dark on the palette often appear pale and chalky next to deeper tones on the painting. Beginners may find themselves somewhat hampered by this obstacle.

The solution is simple – change to a toned palette. Go for neutral colours which won't

Tip

Wet paint

To keep your paints wet, spray them regularly with a spray atomizer. Or make your own 'stay-wet' palette using a Tupperware box containing a sheet of wet blotting paper under a sheet of greaseproof paper. As long as the box is watertight, and you keep wetting and replacing the blotting paper, your paints will remain wet for some time.

distort colours and that represent the mid-tones of your painting. A few purpose-made acrylic palettes are brown, while some are brown on one side, white on the other, giving you a choice. Alternatively, make your own toned palette by slipping a sheet of mid-brown or mid-grey paper beneath some glass or clear perspex before securing it on to a board.

Cleaning your palette

To remove dried paint from any palettes made of the materials mentioned above, simply soak the entire item in hot water for a while. The water seeps between the paint and the smooth surface, loosening the hardened colour which then peels off easily – often in one piece. Use a palette knife and damp cloth to scrape off persistent paint gently, taking care not to scratch the surface with the knife. Don't use a scourer or wire wool on non-scratchproof materials. They score the surface, leaving a key for the paint to adhere to – which makes future cleaning much more difficult.

For large, immobile palettes, dribble hot water on and around the dried paint. Leave this to soak, then peel the paint away or remove it with a palette knife. Afterwards, wipe away all the residual stains with a clean rag dipped in water. (The importance of good housekeeping to the artist cannot be understated. Half an hour spent cleaning brushes and palettes, replacing lids and so on is always well spent, given the price of most artists' materials.)

▼1. White Formica; 2. Grey Formica;
3. Clear plastic; 4. White plastic;
5. Glass.

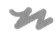
Brushes for acrylic paints

Choosing good brushes to paint with is as vital as selecting the best ingredients for a recipe. After all, they're not just a tool for applying paint, but an important means of artistic expression.

Acrylic has established itself as an extremely versatile and popular medium and is used more and more by professional artists and beginners alike. Recently, manufacturers, recognizing its increasing popularity, have filled a gap in the market for good brushes to use with acrylic paints. Naturally, brushes traditionally used with oil and watercolour are also suitable. This means you're spoiled by a huge, perhaps even confusing, array when it comes to selecting the right ones for your style of painting.

The type of brush you go for depends on the techniques you want to use. It also depends on the kind of support you choose and on the size of the painting. The softer fibres used to make watercolour brushes are best if you are going to use thin wash techniques on paper. But for large-scale easel paintings, where you want to use various oil techniques, choose bristle-type brushes which will be stiff enough to carry and apply quite a large quantity of thick acrylic paint.

▼ Once artists using acrylic made do with brushes for oil or watercolour. But today there are several excellent ranges made especially for acrylic. The most expensive are sable, but the sable/synthetic blends and the all-synthetic types are perfectly adequate for most purposes.

Brushes shown here: 1 Dalon (Daler-Rowney) – synthetic, soft; 2 Kolinsky Plus (Liquitex) – sable/synthetic blend, soft; 3 Series 6000 (Liquitex) – synthetic, soft; 4 Prolene (Pro Arte) – synthetic, soft; 5 Bristlewhite hog (Daler-Rowney) – pure hog, stiff ; 6 Cryla (Daler-Rowney) – synthetic, stiff; 7 Acrylix (Pro Arte) – synthetic, stiff.

◀ **Different brush techniques create specific effects. In this pastoral painting, many strokes are laid side by side with a fine brush to describe the straggly wool of the sheep. The artist has used a large flat brush to block in the clumps of heather (see detail), and a smooth brush to blend the distant hills and sky.**
'In Passing' by Peter Unsworth, acrylic on canvas, 130 x 130cm

Soft brushes

Soft-fibre brushes are ideal for holding dilute paint. They're used with watercolour, gouache, acrylic and even thinned oils. Perfect for watercolour-type washes, glazes and thin scumbles, they are also indispensable for fine line and detailed work.

There's a variety of soft brushes in natural materials, including sable, squirrel, ox and goat hair or mixtures of these. Sable, the most expensive, is considered the best. Its springiness and ability to hold paint and retain a fine point are unmatched by any other hairs. However, since acrylic is so rough on brushes it's probably better to avoid using sable – it's too expensive to risk. Sable/synthetic blends, such as the Liquitex 'Kolinsky Plus' range, are perfectly good for acrylics, but for beginners synthetic substitutes are the best bet.

There is an ever-increasing range of synthetic brushes on the market, with quality and versatility improving all the time. They perform well, but cost much less than their natural fibre equivalents, so if the brush does get clogged with paint, replacing it won't break the bank. Daler-Rowney make a range called 'Dalon'. The golden fibres are springy and silky textured. The round brushes come to a good point for detailed work, while the bigger sizes are good for laying down large areas of glazes, washes and flat colour. Other ranges have similar good qualities. Liquitex have their Series 6000, Pro Arte make 'Prolene' and Winsor & Newton produce 'Cotman'. All of them are excellent, inexpensive alternatives to sable.

▶ **This is a beautiful example of brushwork – descriptive and expressive. The solid shapes of the pots and pears are confidently explored by the marks of the brush, while looser, but no less expressive, marks describe the background.**
Fine brushwork on petals and stems (detail) gives the flowers a touch of delicacy that contrasts well with the overall boldness of the painting.
'Still life with blue pot and flowers' by Anne-Marie Butlin, acrylic on paper, 18 x 22in

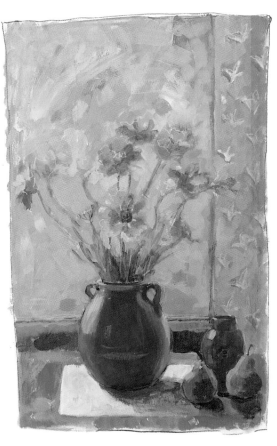

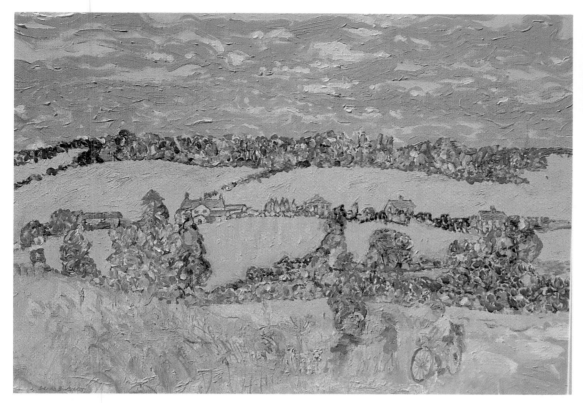

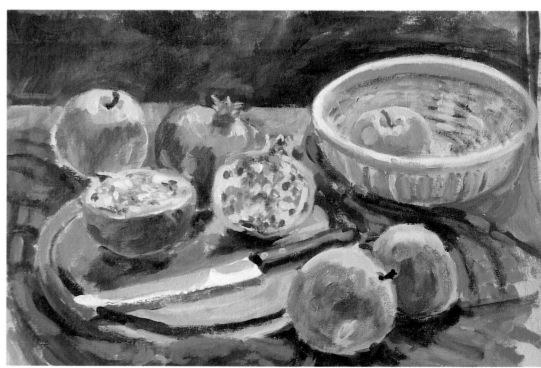

◀ In this landscape, the abstract use of colour makes the paint itself as important as the subject – so its application is vital. Plenty of fine brushwork brings the figures, houses and most notably the foliage, to vibrant life. Skilled use of brushes both large and small, round and flat gives vigour and excitement to the sky and clouds (see detail).

'Children in a field' by Brenda Brin Booker, acrylic on canvas, 24 x 18in, reproduced by courtesy of Five Women Artists Plus

Stiff brushes

You can use acrylic paint thickly in much the same way as oils, and even create a richly textured impasto surface. The mark of the brush is an important part of the paint surface – it becomes expressive as well as descriptive. For this you need a stiff-fibre brush which can hold the thicker paint. Its shape and size, responsiveness to the support and the way it balances in your hand are all vital factors that you need to consider.

Traditionally oil painting brushes were made from hog's hair/bristle, but again manufacturers have devised some good synthetic alternatives which cost less.

Pro Arte produce a range called 'Acrylix'. These are firm enough to hold stiff paint, but are still flexible and have a silky texture – ideal for a range of acrylic techniques. 'Cryla' brushes from Daler-Rowney are designed especially for acrylic. They have a good 'snap' and enough firmness for impasto techniques, but are flexible enough for washes and glazes. The range is extensive, with long-handled and short-handled brushes in various shapes and sizes, including a big 25mm wash brush.

▼ You can see individual brushstrokes everywhere you look in this painting. Broad marks examine the forms of the fruit and the background, and contrast with the dabs made by a small brush for the pomegranate pips. The exterior of the bowl is painted in single strokes made by a flat brush to contrast with the finer brushmarks on the inside (see detail).

'Pomegranates' by Alastair Adams, acrylic on board, 11¾ x 18¾in

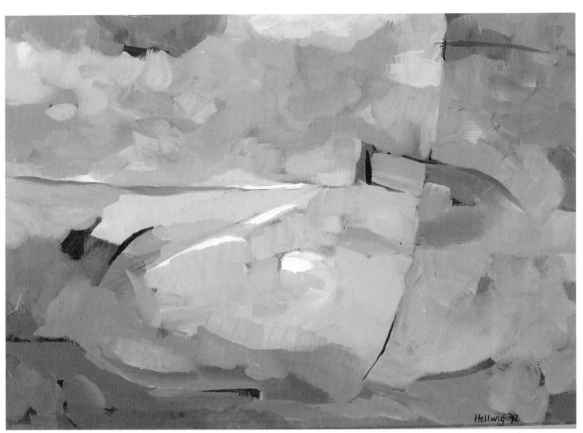

▶ **The brushwork in this painting has a distinct 'spatula' feel to it, where the artist has used the edge of a flat brush to break the wider bands of paint (see detail). In an abstract, the brushstrokes take on even more significance as the artist abandons realism for the sake of expression.**

'Blue Landscape' by Marianne Hellwig John, acrylic on board, 18 x 24in

Sizes and series

Stiff brushes, whether bristle or synthetic, are available in sizes from 1 (the smallest) to 16 (the largest). Soft brushes start at 000 and go up to 14 or 16. Soft flats, often called one-stroke brushes, are generally sized according to the width of the brush. Sizes can vary from series to series. For example, a No.6 in one series will not be exactly the same as a No.6 in another.

You should also note that with soft brushes, it's best to go for short handles, since you'll be working on a relatively small scale and close to the support. With stiff brushes, long handles allow you to stand back from your work.

Beginner's selection

Don't get too many brushes at first – buy the minimum and add to your collection gradually. Go for slightly bigger brushes than you think you'll need. Small ones tend to encourage fiddling, but a big brush forces you to simplify and find the broad forms.

Start with a couple of soft rounds – Nos.6 and 12 or 14. You'll also need some stiff brushes. Choose a good quality synthetic – a No.10 round and a No.12 filbert should get you going. Finally, you'll find a 1in (2.5cm) decorator's brush useful for filling in large expanses.

When choosing brushes, look for quality. A well made brush retains its shape, has a pleasing spring in its fibres, and holds plenty of paint. Above all, a good brush 'feels right'. It's well balanced, has a neatly finished ferrule with no sharp edges, and the hairs sit neatly, dry or wet.

Getting acquainted

Brushes of different shapes make varying marks, so it's a good idea to spend time getting to know each one. Use some paint and scrap paper to explore the effects you can achieve with both thinned and thick paint. Try washes, glazes and scumbles. Also look at the textured effects you get, using first the tip of the brush, then the side, then the flat. Learn to enjoy the brush and become familiar with its balance and how it handles. Explore long flowing lines, brisk gestural strokes and short stabbing marks. You'll have lots of fun and expand your skills all at once!

Cleaning your brushes

Acrylic paint dries quickly, and once dry is not soluble in water. So be very diligent about rinsing each of your brushes as you go. **Never** let paint dry on the brush, or you'll find it difficult to remove. If your inspiration carries you away, leaving you no time to rinse the brushes, leave them in a jar of water. Although this isn't recommended practice, anything is better than letting the brush clog with dry paint.

After each painting session clean all your brushes thoroughly, using the following routine. First remove any surplus paint by wiping the brush on a rag or paper towel. Then swirl the brush vigorously in a pot of water to remove as much paint as possible, tapping it on the base of the jar to dislodge stubborn paint from the ferrule. Now wipe the brush on a rag. Hold a cake of soap in one hand, wet the brush and work it round on the soap. Make sure the soap reaches right up into the fibres and around the ferrule. Rinse the brush under clean running water. If there's still some colour coming off the brush, work it over the surface of the soap again and rinse.

The next job is to wipe the brush on a rag or a paper towel. Finally, re-shape it with your fingers and leave it to dry brush-end up in a jar.

Supports for acrylic paints

You can use acrylic paints on a greater variety of supports than any other medium. A little information and a handful of techniques can open up a wealth of creative possibilities.

There's a substantial list of suitable supports for acrylic paints – paper, cardboard, hardboard, wood, sketching papers, canvas boards, canvas and a variety of fabrics. Each has its own qualities and is suited to different approaches. Knowing what they are gives you freedom to explore different styles of painting.

Preparing the ground

With oils, you can't paint straight on to unsealed supports, but acrylic paint doesn't damage or rot them, so sealing is not necessary. This is useful in some cases, but at times you'll still want to change the colour or surface texture of your support with a primer. Matt and gloss acrylic mediums, for instance, seal the surface with an impermeable transparent layer, so you retain the original colour of the support. This allows you to use the warm colour of, say, linen or cardboard as a tinted ground. There are several transparent primers available.

Many artists prefer to start with a crisp white surface. For this, you can use a proprietary acrylic primer, loosely applying a single layer to soften the colour of the support, or building up several layers to make a brilliant white surface. Acrylic gesso is used in the same way, but has a softer, chalkier, more absorbent texture. It's suitable for firm supports such as card or board – on flexible canvas it might crack. Some artists simply use white household emulsion (latex) paint, mixing in a little acrylic paint for a tinted surface.

▼1. Saunders Waterford rag paper, 300lb, rough. 2. Grey mount board. 3. Inexpensive, recycled paper. 4. Mount board – perfect for acrylic washes like those in this picture.

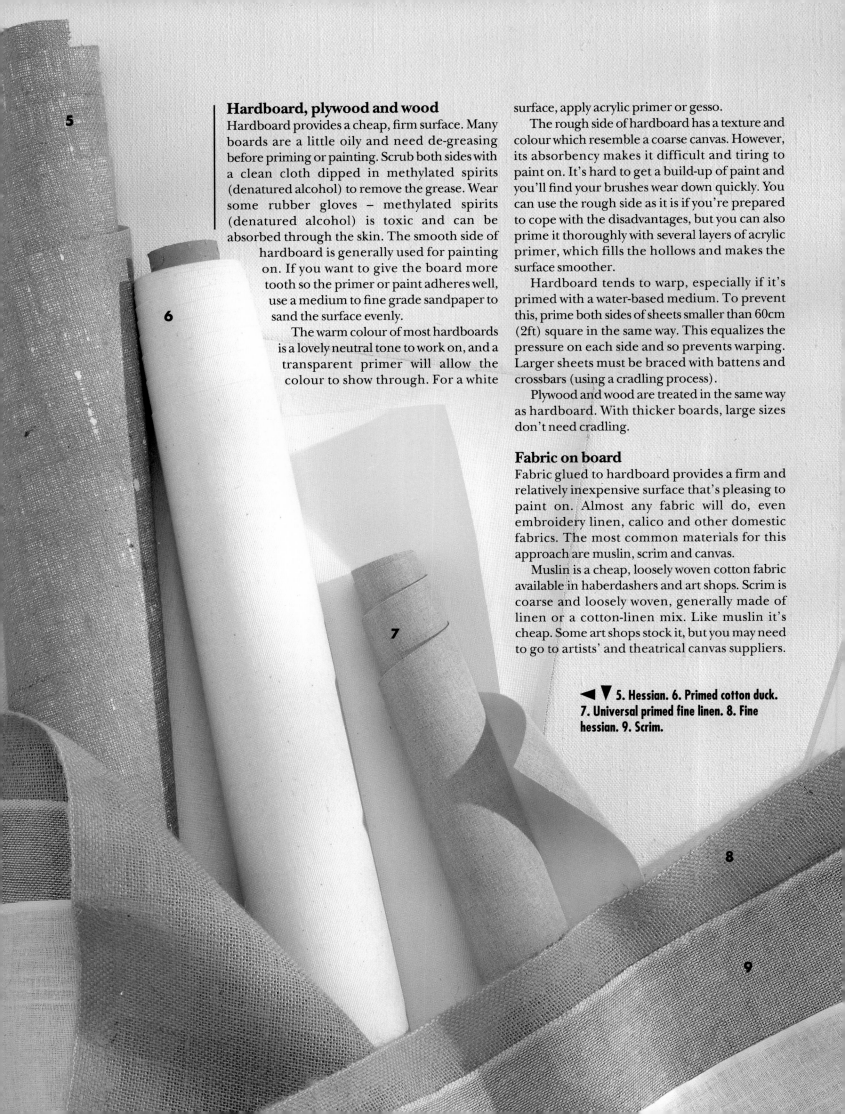

Hardboard, plywood and wood

Hardboard provides a cheap, firm surface. Many boards are a little oily and need de-greasing before priming or painting. Scrub both sides with a clean cloth dipped in methylated spirits (denatured alcohol) to remove the grease. Wear some rubber gloves – methylated spirits (denatured alcohol) is toxic and can be absorbed through the skin. The smooth side of hardboard is generally used for painting on. If you want to give the board more tooth so the primer or paint adheres well, use a medium to fine grade sandpaper to sand the surface evenly.

The warm colour of most hardboards is a lovely neutral tone to work on, and a transparent primer will allow the colour to show through. For a white surface, apply acrylic primer or gesso.

The rough side of hardboard has a texture and colour which resemble a coarse canvas. However, its absorbency makes it difficult and tiring to paint on. It's hard to get a build-up of paint and you'll find your brushes wear down quickly. You can use the rough side as it is if you're prepared to cope with the disadvantages, but you can also prime it thoroughly with several layers of acrylic primer, which fills the hollows and makes the surface smoother.

Hardboard tends to warp, especially if it's primed with a water-based medium. To prevent this, prime both sides of sheets smaller than 60cm (2ft) square in the same way. This equalizes the pressure on each side and so prevents warping. Larger sheets must be braced with battens and crossbars (using a cradling process).

Plywood and wood are treated in the same way as hardboard. With thicker boards, large sizes don't need cradling.

Fabric on board

Fabric glued to hardboard provides a firm and relatively inexpensive surface that's pleasing to paint on. Almost any fabric will do, even embroidery linen, calico and other domestic fabrics. The most common materials for this approach are muslin, scrim and canvas.

Muslin is a cheap, loosely woven cotton fabric available in haberdashers and art shops. Scrim is coarse and loosely woven, generally made of linen or a cotton-linen mix. Like muslin it's cheap. Some art shops stock it, but you may need to go to artists' and theatrical canvas suppliers.

◀▼ 5. Hessian. 6. Primed cotton duck. 7. Universal primed fine linen. 8. Fine hessian. 9. Scrim.

Scrim or muslin can be glued to board for a support with some of the qualities of canvas.

Gluing fabric on to hardboard

Start by cutting the hardboard to the size you want. Lay it over the fabric, then cut the fabric to size, allowing a 5cm (2in) overlap all round; ensure the fabric is cut parallel to the weave. Place the board, smooth side up, on your work surface and lay the fabric over it. Apply either acrylic medium or an adhesive over the top of the fabric. The adhesive or medium sinks through the fabric, pasting it to the board and sealing the surface at the same time. (Of course with thicker, more densely woven fabrics, you should apply glue to the back of the fabric and then paste it on to the board.)

Work from the centre out to the edges, smoothing the fabric as you go, and keeping the weave parallel to the edge of the board. Turn the board over, laying it across wooden battens to keep the wet surface clear of your work surface. Fold the fabric over the back of the board as neatly as you can and carefully paste it in place. Then cover the back of the entire board with your adhesive or acrylic medium. This stops the board from warping. Leave the board leaning against a wall until it is thoroughly dry.

Stretched canvas

There are many different types of canvas available, including linen, cotton, flax, hessian, hemp and mixtures. They vary in weight, weave, quality and price. Linen has a fine, closely woven, irregular texture that's interesting and easy to work on. It's mid grey-brown in colour. Cotton is cheaper, softer and bulkier, with a regular, man-made texture and a creamy oatmeal colour. Look out for cotton duck – a tough, densely woven fabric with an even weave. Flax and hessian are cheaper and have a coarse open weave, and a distinctive warm grey colour.

Many artists enjoy working on stretched canvas because of the way the taut cloth responds to pressure from the brush. The weave and colour of canvas contribute in an important way to the appearance of the final image, and influence the way the artist works. Good art shops stock ready-stretched canvases in a variety of materials, including cotton duck of varying weights, linen and cotton/linen mixes.

You don't need to seal canvas for acrylic paintings. This offers you the chance to stain it with colour washes. The paint sinks into the fabric instead of sitting on the surface, creating an entirely different type of painting.

You can buy canvas primed or unprimed. As it's easy to prime, you can buy it raw and prepare it yourself. Then you can decide exactly what type of surface you want. You can prime stretched canvas with acrylic primer, acrylic emulsion or emulsion paint. A ready-primed stretched canvas, prepared with an oil-based primer is unsuitable for acrylics. 'Universal primed' supports can be used, though.

▼ **10. Muslin. 11 & 12. Tinted cards. 13. Hardboard. 14. Coarse linen, stretched and universal primed. 15. Canvas board. 16. Reverse side of stretched linen.**

Paper and cardboard

Paper is the cheapest readily available support. If you want to use traditional watercolour or gouache techniques – laying down a series of transparent or semi-transparent washes – watercolour paper, either white or tinted, gives an excellent surface. Prepare it as for watercolours, stretching papers lighter than 140lb, especially if you use a lot of wet washes.

Some art shops and stationers sell pads of inexpensive recycled papers which have an interesting texture and colour. Untreated, they absorb paint like blotting paper, but you can seal them with a dilute solution of either gloss or matt medium. Add about 20% water and apply with a soft brush, then tape the paper to a board with gum strip.

Sketching papers, textured to resemble canvas, are primed for acrylic. They can be bought in pads from art shops in all the standard sizes, and are an ideal, cheap surface for the beginner.

Acrylic can also be used on tinted card and board. If you use watercolour board or mount board you do away with the need to stretch paper.

Cardboard and strawboard have a lovely texture and colour. Use them untreated for washes, impasto, mixed media work and collage. You'll find them absorbent, and your brush may drag on the surface. To make them better for painting on, but maintaining their colour and texture, seal them with a layer of dilute acrylic medium, adding about 20% water. A coat of acrylic primer or 2-3 coats of gesso provide a white surface with a good tooth.

Canvas boards

There are two types of canvas board. One has an imitation canvas surface, the other is board on to which canvas has been laminated. Available in a range of sizes and textures, they are light, portable and cheaper than stretched canvas. Ensure you buy boards for acrylic.

◀▼ 17. Inexpensive, recycled papers. 18. Recycled grey strawboard. 19. Cryla sketching block. And a selection of watercolour papers.

Improvised supports

If you paint regularly, buying ready-made supports can become quite costly. So cast an improvising eye around your house – you're likely to find some interesting recyclable alternatives.

If you have a junk room or attic, that's the best place to look for materials to turn into supports for acrylic paintings. Many surfaces can be painted on, though some may need a little preparation. You can use different types of packaging (such as cardboard boxes from supermarkets, brown manila paper or the card from used, stiff-backed envelopes), wrapping paper, backing boards from old frames, left-over mount card (mat board) and even newspaper.

The advantages of recycling materials aren't just a matter of economics. You can make a support any shape or size you like, so you needn't be restricted by the standard portrait/landscape format of most ready-made canvases and canvas boards. Also, these makeshift supports provide interesting surface textures and colours, which

may trigger off an inventive approach to your painting and bring a stimulating breath of fresh air to your work.

If it's unusual surfaces you're after, a length of scrim or muslin, or a sheet of decorative oriental paper, or hand-made, highly-textured paper can also be transformed into an excellent support. All you need is a little know-how.

▼ **Acrylic, the most universal of media, can be used on almost any surface, especially if those surfaces are prepared as described here. Many of these make good surfaces for other media – oils, gouache, pastels.**

Mounting and sizing

Lightweight papers need to be mounted to prevent them tearing, buckling or curling over at the sides. You also need to mount fabrics to make them rigid. In the demonstration here, our artist mounts papers and fabric on thin cardboard found lying around her studio – the backs of old sketchbooks, mainly.

If you're using a rigid material, – stiff cardboard, say – you can paint straight on to it without much fear of it buckling. However, cardboard tends to be rather absorbent. It soaks up the paint's moisture, so you need to apply more paint than usual. Some artists like the feel of working like this. If you don't, simply seal the surface with a layer of size.

The good news is that you can use the same solutions for mounting and sizing. Acrylic mediums (such as matt or gel mediums) diluted with water make excellent adhesives for mounting as well as sealants for sizing. Wallpaper paste is a good adhesive too, but it's inadvisable to use it as a size since it contains fungicides that may react chemically with the paint.

To tone your ground, mix your acrylic colour with your solution. Mix in white paint for a white ground or, for an alternative, hard-wearing white ground, mix transparent primer, water and white household emulsion (latex) paint.

To make or to buy?

The problem with home-made supports is that you don't know what's in them. You may be using a card or cardboard with a high acid content. These supports cannot guarantee a long-lasting picture (still, this didn't stop Toulouse Lautrec painting on cardboard). If you size with emulsion (latex) you should render the surface of the support inert – in effect, you are separating the paint layer from the actual support.

Take risks and have fun, but aim for total soundness if you can. If you want your work to last, prepare your surfaces with care or consider sticking to rigorously tested ready-made ones.

Envelope cardboard

◀1 This cardboard was part of a used stiff-backed office envelope. Its warm brown colour offsets the autumn leaf painted on it. Since it's quite sturdy, all you need do is size it – this type of card is very absorbent. Our artist used diluted Liquitex matte gel medium, brushing the solution on to the surface briskly with a decorator's brush.

▶2 The colour of the support modifies the colours painted on it. It enhances the leaf colours and unifies them at the same time. For other subjects, the colour provides a good mid-tone to start painting from.

Decorative paper on cardboard

▶**1** Our artist wanted to use this paper's pattern as the background for her next leaf painting. Although the paper is quite strong and unlikely to tear, she thought it was better to mount it on cardboard or thin card to stop it from curling over when wet.

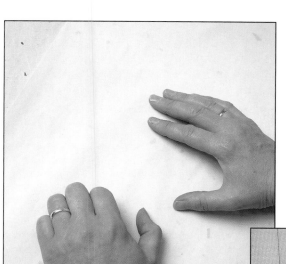

▲**2** Brush diluted Liquitex matte gel medium on to the back of the paper with the decorator's brush. Brush it out well to leave a thin, even layer. Place the paper on the card carefully and smooth away any air bubbles, working from the middle of the sheet to the edges. Do this through a sheet of spare paper to avoid getting grease or dirt marks on the surface. For more pressure, smooth the paper with the back of a spoon or a rubber roller.

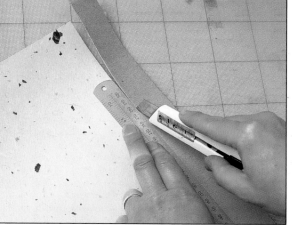

◀**3** The sheet of paper was smaller than the supporting card, so our artist cut off the overlap with a sharp craft knife. Use a straight edge – such as a metal ruler – to guide you.

◀**4** Our artist decided against sizing this paper and painted straight on to it. It makes a lovely background for these autumn leaves, the dark flecks of the paper adding to the feeling of the leaves floating down from the tree.

▼ **You'll need the right equipment to transform your found materials into supports. Gather together a simple kit consisting of suitable adhesive or size, a decorator's brush, a craft knife, a pair of scissors and a ruler.**

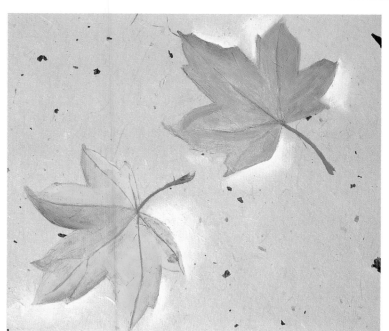

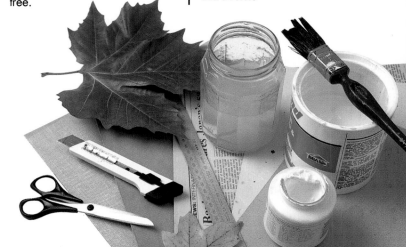

Newspaper on cardboard

▶**1** Newsprint can be incorporated into your designs with interesting results. Newspaper is very fragile when wet, so it's important to give it the stability of a card or cardboard backing.

Wallpaper paste was the adhesive this time. Mix it up following the manufacturer's instructions, stirring it well to dissolve all the powder. The consistency should be thin enough to brush out well, yet not so thin that it drips from the brush too much.

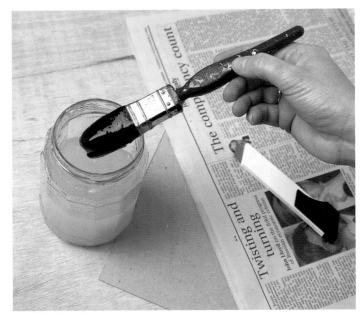

◀**2** Apply the wallpaper paste to the back of the paper (you'll have to decide which side you want to paint on). Start from the middle, working out towards the edges, and brushing vigorously to get rid of any lumps. Once it's wet, be careful not to tear the paper.

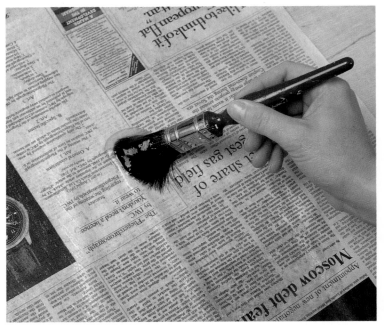

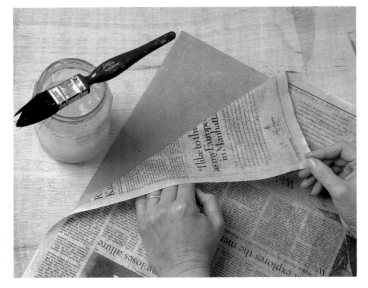

▲**3** Position the newspaper on the card/cardboard and smooth it down from the middle outwards to dispel any air bubbles. When the surface has dried a little, put it face down on some spare paper (ensuring the surface is glue-free), and place a drawing board over it. Weight this down (with books, for example) to encourage your support to dry flat. Once it has dried completely, cut off the overlap around the edges as before.

◀**4** Although she liked the colour of the paper, our artist wanted to modify it to complement her subject. She sized this absorbent paper with dilute Liquitex matte gel medium, and mixed in some yellow acrylic paint to tone the ground.

Brown manila paper on cardboard

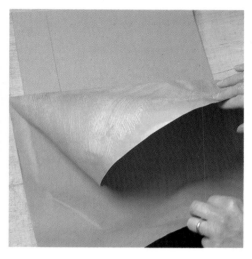

▲**1** Brown paper has a lovely colour and texture that makes a wonderful mid-toned ground for many subjects, and it's ideal for these autumn leaves. This sketchbook backing makes a sturdy support for the paper too.

▲**2** Before you get slap-happy with your brush and glue, decide which side of the paper you want to work on. Our artist chose to paint on the dull side, so she pasted the other side down on to the card/cardboard. Again, she used dilute Liquitex matte gel medium as an adhesive, brushing it out thoroughly in several different directions.

▲**3** When you stick the paper and card/cardboard together, try bending the paper in half (ensuring it doesn't crease), then place the middle of it across the middle of the card/cardboard. Roll out one side at a time smoothing out the bumps as you go. This stops air bubbles getting trapped between paper and card/cardboard.

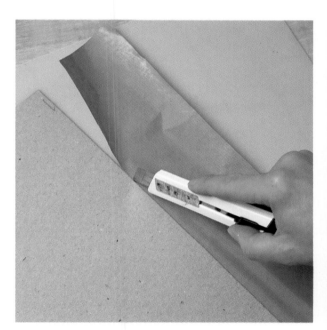

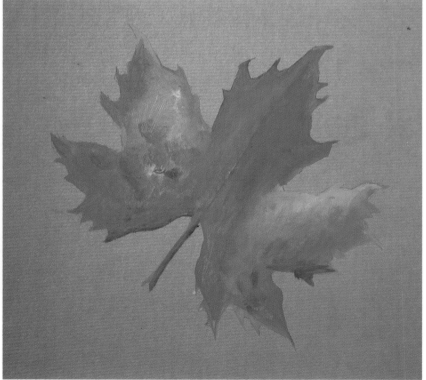

▲**4** Once dry, turn over and cut off the overlap with a sharp craft knife. The card/cardboard was quite thick, so our artist cut the paper freehand, using the edge of the card/cardboard as a guide. If you're cutting the overlap off on the back, angle the craft knife so the tip points into the card/cardboard. This avoids an unsightly overlap on the picture side, leaving the edges clean and tidy.

▲**5** Brown paper has an organic, natural look that enhances this subject. Our artist liked it so much, she let it stand as the entire background for her picture.

Muslin on card

▶ **1** Muslin is fairly cheap and makes an excellent support. Cut a sheet of card/cardboard to size. Lay the fabric down on a flat surface and place the card/cardboard over it. Cut the muslin around the card, leaving a 1in overlap. Make sure you place the fabric so its grain runs either horizontally or vertically across the card/cardboard, rather than at an angle.

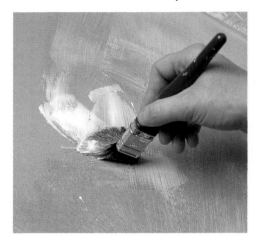

▲ **2** Our artist wanted a good strong adhesive to make sure the fabric stuck fast to the board, so she used PVA, diluting it with a little water. Apply this to the board with the decorator's brush. Brush it out well so it's even, and quite thin – if it's too thick, it will seep through the open weave of the fabric.

▲ **3** Lay the muslin on the board with the grain running horizontally or vertically across it. Smooth it from the centre outwards, working quickly to finish before the glue dries. If the fabric remains unstuck in areas, lift it up and apply more glue to the board before sticking it down again.

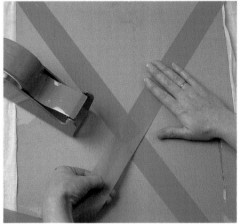

▲ **4** This particular card was quite thin, so our artist used brown tape to stick a cross-shape on the back to stop the edges from curling over. Stick the tape down from corner to corner and repeat on the other corners to complete the cross. Carefully cut off any overlapping tape.

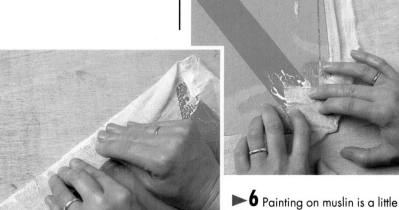

◀ **5** Apply some PVA solution to the back of the card on the corners, then pull the fabric corners over the card at 45° angles and stick them down. Pull the sides over the edge of the card and stick them down in the same way (inset). Make sure you pull the fabric over tightly to leave a good, clean edge on the right side. Leave to dry.

▶ **6** Painting on muslin is a little like working on a canvas, so it can be a cheap alternative. It has a lovely fabric texture so, if you're working on a large scale, you'll find it much cheaper than a huge, ready-made canvas.

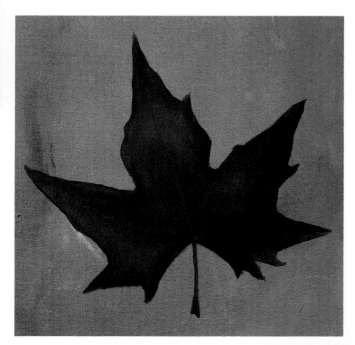

Mediums for acrylic paints

There are mediums to make acrylic colours thicker or thinner, more transparent or more opaque, glossy or matt. You can even buy mediums to control the paint's drying rate.

You can greatly increase the versatility of acrylic paints by mixing them with one or more widely available acrylic mediums.

There are six main types of medium. Because acrylics are fairly new, some manufacturers may give their products different names. Read the label and ask for help in your local art shop.

Gloss medium Acrylic paints used straight from the tube dry to an eggshell finish. For a shiny finish, add gloss medium directly to the paint to thin it to a fluid consistency – but remember that mixing in water dilutes the medium, making it less glossy. If you add enough medium, the paint becomes transparent and the underlying colours shine through.

Gloss medium is ideal for applying thin layers of colour. The paint acquires depth and luminosity – qualities associated with watercolour – without loss of its adhesive properties. Gloss medium looks milky in the bottle, but dries to a transparent, shiny finish.

Experiment with different amounts of medium to find out how much to mix with the paint. Adding too much gives a more transparent layer of colour but reduces the paint's intensity.

Matt medium Like gloss, this makes the paint thinner and more fluid, but it dries to a very non-shiny finish. For a semi-gloss surface, use equal parts of matt and gloss mediums.

Because both matt and gloss mediums dry very rapidly, always keep your brushes in a jar of water when not in use. Otherwise, within a few minutes they become hard and unusable.

Flow improver Sold in bottles, this dilutes acrylic paint for maximum flow and transparency. Unlike water, it doesn't dilute the colour or reduce the paint's adhesive qualities. This makes it ideal for painting large washes of smooth

Tip

Applying mediums
Squeeze out a blob of paint on to your palette, and make a well in the middle of it. Add one or more of the mediums a little at a time, and mix thoroughly with a palette knife. If required, dilute the paint further with water, and use immediately. If you are using more than one colour plus a medium, mix the colours first, and then add the medium.

▼ **Manufacturers' names for their mediums seldom leave you guessing. Be prepared, though, to do some trying and testing to achieve the effect you're after**

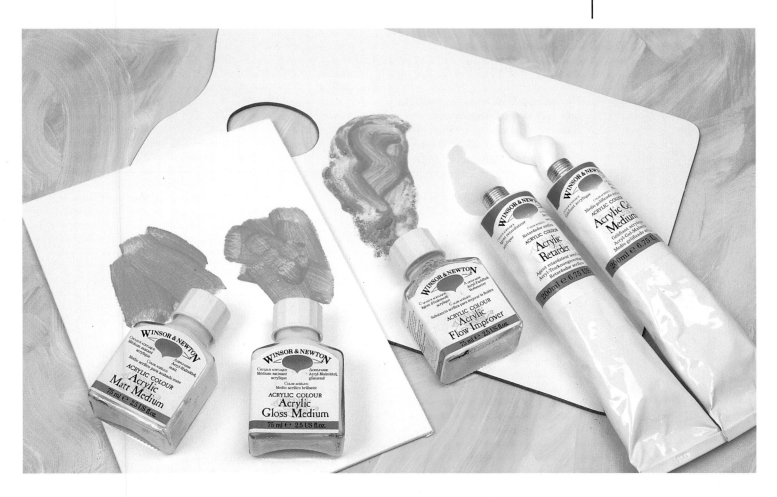

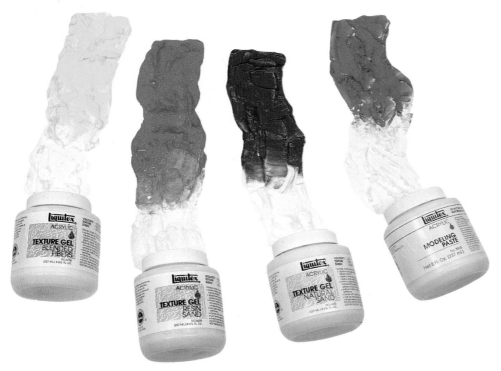

◀ When it's a textured finish you want for your picture, you need look no further than texture gel and modelling paste. With practice the right texture and sheen are at your fingertips.

Experiment by adding different proportions of retarder, but don't exceed one part retarder to three parts colour because this affects the paint's consistency.

Texture gel Sometimes called gel medium, this paste-like substance thickens paint without altering its colour. It dries clear and is ideal for rich, thick brushstrokes and for impasto effects. It also increases the adhesive quality of paint, making it useful for collages.

Liquitex's acrylic texture gels offer you four formulas for easy impasto work: Ceramic Stucco, Blended Fibers, Natural Sand and Resin Sand. They have different textures and sheens. You can mix in the paint before application or paint over the dried area later.

Modelling pastes Sold in tubs and jars, modelling paste is initially thick and white. It lightens any paint it's mixed with, though, so allow for that. It has the consistency of putty and thickens the paint more than a gel medium.

Applying it to rigid surfaces such as wood or board makes a highly textured underpainting. It's best to apply a mixture of modelling paste and acrylic paint in several thinnish layers to create a thickly textured surface. Build up the surface gradually, allowing each layer to dry before adding the next. If you use only one thick layer, the paste cracks when it dries.

To make it smoother and more fluid, thin it with gloss or matt medium. Mixed 50:50 with gel medium it can be applied to flexible surfaces such as linen and cotton canvas.

colour. While matt and gloss mediums change the finish of the paint when dry, flow improver does not. (However, if you add too much flow improver, the paint may begin to foam, causing small bubbles to appear in the paint.)

An alternative to shop-bought flow improver is washing-up liquid/dishwasher detergent. As a general rule add one or two parts flow improver or dish washing liquid to twenty parts paint.

Retarder Acrylic paint is renowned for its incredibly fast drying rate. Retarder is a translucent gel which delays the fast-setting property of acrylic paints without most of the time affecting the consistency or colour. Depending on how much retarder you add, you can extend the paint's drying time from half an hour to as long as an entire day. Retarder is invaluable when you need to work slowly to blend colours smoothly – for example, when you want subtle gradations of skin tone in a portrait.

Autumn woodland scene

The set-up The artist used various art books and photographs for inspiration. Instead of copying one source directly, he created a work stamped and moulded with his own ideas, drawing on the sources only as reference.

▶ **1** Sketch in the tree trunks and the horizon with the 4B graphite pencil. Mix a light grey from titanium white, yellow ochre and Payne's gray, using a little acrylic matt medium and a touch of water to thin the paint to the consistency you want. Then quickly block in the tree trunks with your mix, using a No.5 brush.

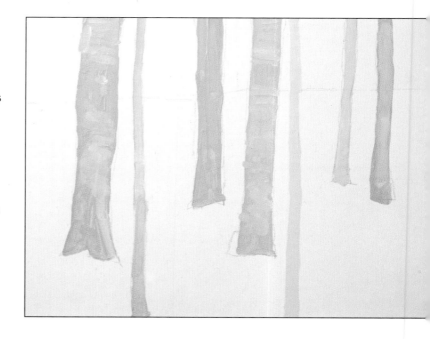

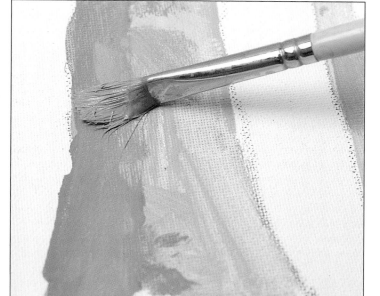

▲ **2** Darken the mix with a little more Payne's gray and paint the dark grey vertical and horizontal tones seen on some of the trunks. Add more titanium white to create light tones for the horizontal bands on a few of the trunks. Make sure the trees in the foreground are lighter than those in the background so that you gain the impression of distance.

Next, mix some raw umber, Payne's gray and yellow ochre with a tiny amount of white and matt medium and paint in the dark background. A uniform tone creates flat-looking, one-dimensional objects, so vary the degree of darkness and light to give a sense of depth. Add titanium white to the mixture to lighten it, and raw umber to darken it.

▲ **3** Mix azo yellow medium, Indo orange red and alizarin crimson with matt medium and block in the leaf-laden foreground and middleground. Scrub in this watery mixture, then leave to dry.

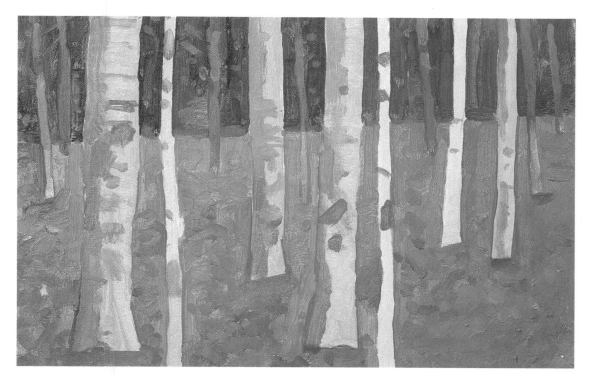

◀ **4** Then add small, thickish dabs of a mixture of azo yellow medium, Indo orange red, alizarin crimson and matt medium. This creates light and dark tones. Allow a few dabs of pure crimson to show through in some areas.

Work freely and loosely – don't worry about exact detail. Allow the whole thing to dry.

▶ **5** While the foreground and middleground are drying, paint in the dark tones of the background to provide greater depth. Mix some Payne's gray, sap green, yellow ochre, alizarin crimson, raw umber and titanium white (adding a touch of matt medium again), and apply with the No.2 brush. Allow the green and crimson to show through in places – you can do this by not mixing the paint too thoroughly.

Work across the horizon, adding dark and light areas to create depth.

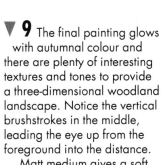

6 Mix a little Liquitex Natural Sand texture gel (or acrylic gel medium) with yellow ochre, and use the No.18 painting knife to dab on thick, generous blobs of paint in the foreground and the middleground to represent fallen leaves.

7 Add a few dabs of the same mix among the trees for the hanging and falling leaves. Allow to

8 Mix alizarin crimson, azo yellow medium and more Natural Sand texture gel. Dab on this orange mix as you did with the yellow. Don't forget to paint in the hanging leaves.

You can build up several layers of texture in this way until you're satisfied with the result.

9 The final painting glows with autumnal colour and there are plenty of interesting textures and tones to provide a three-dimensional woodland landscape. Notice the vertical brushstrokes in the middle, leading the eye up from the foreground into the distance.

Matt medium gives a soft look to the surface – it goes well with the autumn theme.

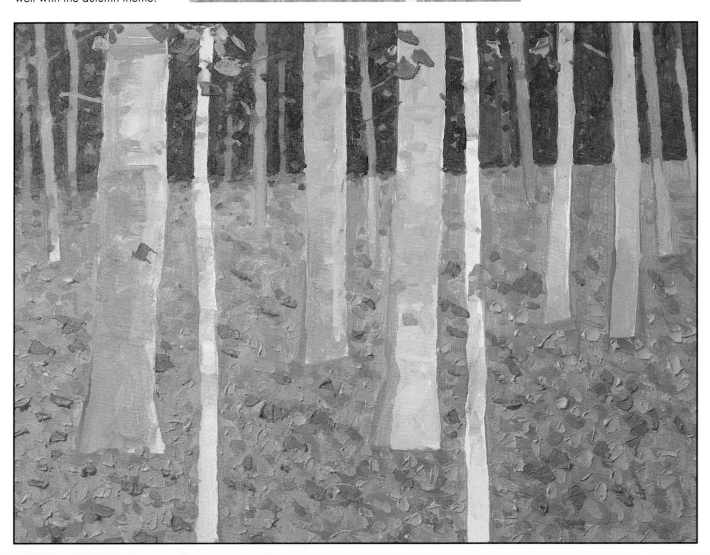

PART 2

Creative Techniques

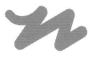

The versatility of acrylics

With fast-drying acrylic paints, you have the opportunity to work loosely and expressively as well as going for pin-point details – all in one sitting.

Because acrylic paints dry so fast, they are one of the most versatile media to work with, allowing you to block in large areas and make fine details easily at the same time. (With oils you have to work in stages, allowing time for the paint surface to dry slightly, otherwise you will find that you are simply moving the paint around.)

Even thick acrylic impasto forms a skin quickly, allowing you to overpaint in minutes. Adding one or more of the mediums available – gloss and matt mediums, texture gels and pastes, and flow improvers – increases the paint's versatility even further.

Creating the right combination of detail and loose, gestural brushwork is important – you don't want the foreground and background competing for attention with the main subject. In our artist's demonstration painting of two Spitfires, for example, he applied the paint loosely and expressively for the sky and the foliage, scumbling and blending colours with his fingers, then used a fine brush to paint the details of the planes with precision. Even the insignia have been carefully rendered.

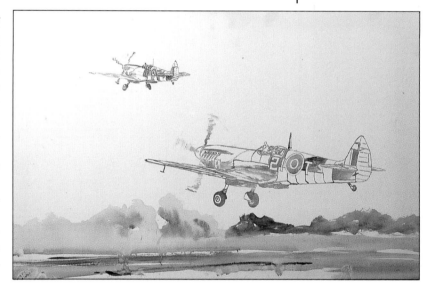

The set-up Our artist based his painting on photos which he took at an air show. Use our finished painting to help you, or find suitable pictures in books or magazines to use as references. Better still, try to visit an air show for yourself!

▲**1** Draw the composition on the canvas with your 2B pencil. Then mix a large quantity of gloss medium and water (roughly half and half). Mix this with your paints to intensify the colours and give the finished painting a slight shine.

Block in the planes with a mix of dilute gloss medium, Mars black and light violet. Combine the dilute gloss medium with Mars black and varying amounts of Hooker's green to block in the land. Allow to dry.

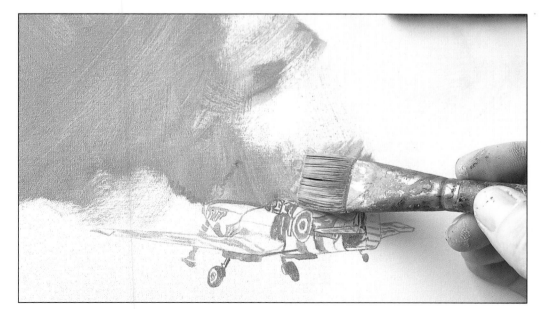

◄**2** Paint in the sky with a dilute mix of cobalt blue and titanium white, using your 1in flat brush. Blot occasionally with a cotton rag to create texture in the sky.

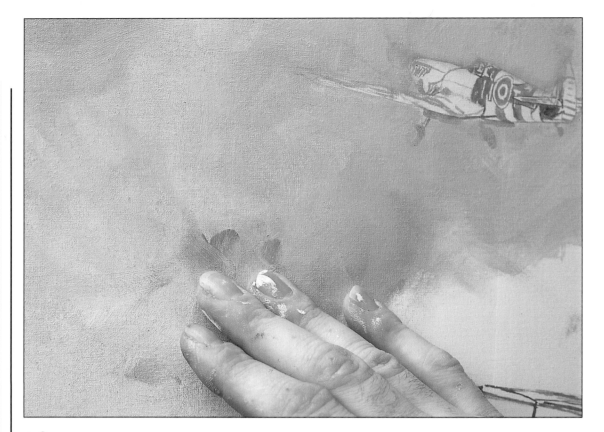

YOU WILL NEED

- [] A 16 x 24in piece of acrylic-primed 9oz cotton duck canvas
- [] A Stay-wet palette
- [] Two jars of water
- [] An easel
- [] A 2B pencil
- [] A cotton rag
- [] Acrylic gloss medium
- [] Three brushes: a 1in flat and a No.3 and No.5 round synthetic/sable
- [] Twelve acrylic colours: Mars black, light violet, Hooker's green, cobalt blue, titanium white, alizarin crimson, cadmium yellow, dioxazine purple, burnt sienna, yellow oxide, yellow ochre and Liquitex' Acra gold (this colour is being discontinued, so if you can't get it, use burnt sienna which is very similar)

▲ **3** Add white and light violet to vary the tones across the sky. Make broad, free strokes, and use your fingers to blend the paint, adding a touch of Mars black to create rain clouds. Don't worry at this point if you lose the edges of the plane – you can redefine them later on.

► **4** Fill in the dark areas on the upper plane with a mix of Mars black and cobalt blue. The point of your No.3 round brush is perfect for capturing fine details, such as the cockpit and the tail. Mix titanium white with just a touch of Mars black to create a light grey for the blur of the moving propeller.

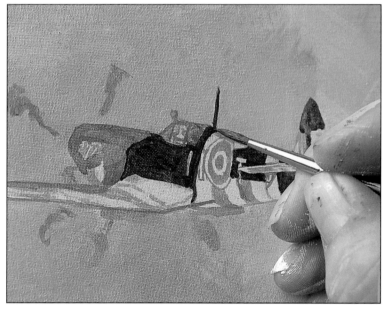

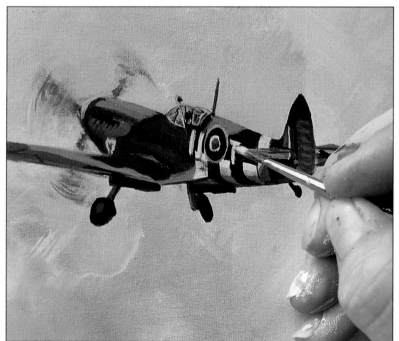

◄ **5** Add a little Mars black and cobalt blue to the top plane's propeller and blend it with your finger to suggest movement. Paint the edge of the wings and the undercarriage with Mars black mixed with dilute gloss medium, and fill in the lighter tones of the plane with light violet and the grey you mixed in step 1. Notice how the plane takes on a metallic look. Allow to dry.

Continue to add details to the top plane. Use your No.3 brush loaded with alizarin crimson toned down with a tiny amount of Mars black to fill in the reddish target insignia on the fuselage and fin. Paint the yellow circle around the insignia with cadmium yellow, and use titanium white for the lettering.

Mix dioxazine purple, Mars black and a little dilute gloss medium to rework all the darkest areas, such as the wheels and undercarriage.

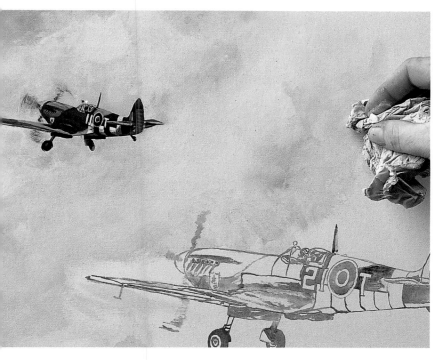

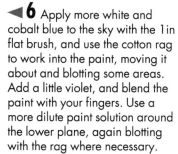

◄6 Apply more white and cobalt blue to the sky with the 1in flat brush, and use the cotton rag to work into the paint, moving it about and blotting some areas. Add a little violet, and blend the paint with your fingers. Use a more dilute paint solution around the lower plane, again blotting with the rag where necessary.

Let yourself go to create a loose, expressive sky with lots of character.

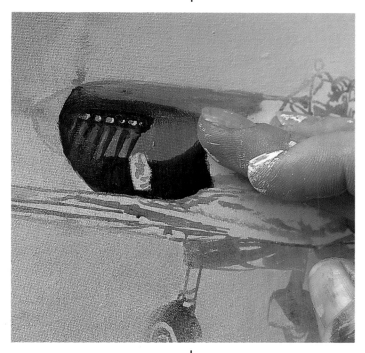

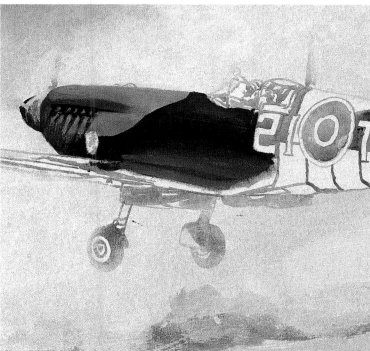

▲7 Mix cobalt blue and white for the top of the lower plane. Use the No.3 brush. Add the exhausts with black, and blend the two colours slightly. Add some dilute gloss medium, cobalt blue and black, and work back across the body and side panels.

▲8 Apply blackish grey details to the lower plane's nose cone. Add some dioxazine purple and a little Hooker's green to enrich the black areas. Paint the red insignia with alizarin crimson toned down with Mars black, then use titanium white for the number and letter on the fuselage.

►9 Fill in the wing with light blue (cobalt blue and white). Add black to this mix to make a dark grey, and work over the darkest areas of the wing.

Continue working on the sky with blues and whites made from cobalt blue and white.

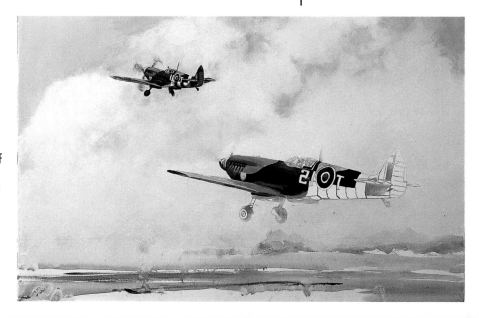

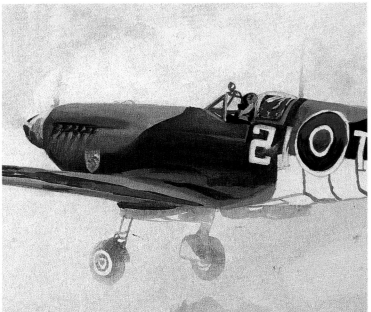

◄10 Work on the cockpit and pilot. Use cadmium yellow and white for details and Mars black for the undercarriage and wheels. Lighten the wheel centres with a grey mix. Detail the stripes under the plane's tail, darkening the black with purple as they curve under. Follow the form of the plane with your brushstrokes. Shade the white stripes too, as they turn under the plane.

►11 Mix Mars black with dioxazine purple, and paint in the dark areas of the tail. Add the fin with a mid-tone grey (mixed from Mars black and titanium white with a little cobalt blue). Put in black stripes over the fin, and blend the colours with your finger. Use a lighter grey on the tailplane.

Tip

Means to an end
Remember, brushes are simply tools – a means to an end. If you can achieve the results you want more effectively without them, don't use them! Our artist favoured rags and fingers in this painting for subtle blending effects.

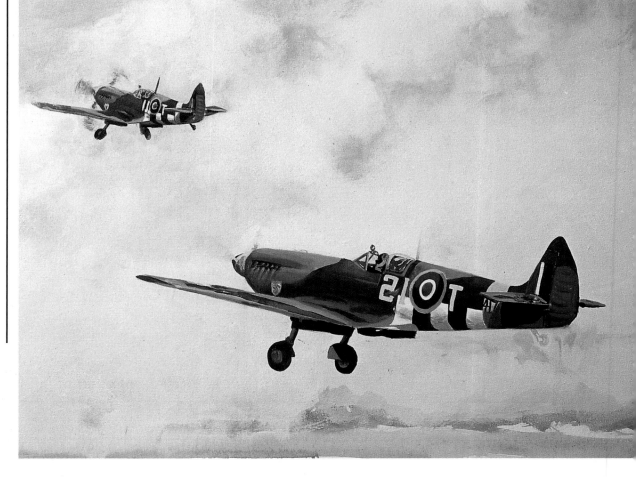

►12 Add the colour details on the tail's insignia with the same colours you used on the fuselage. The Spitfires are now starting to look extremely realistic – notice how three-dimensional they appear.

◄13 Now begin work on the trees and land with Hooker's green darkened slightly with a touch of dioxazine purple. Scrub on the colour loosely, twisting and turning your 1in brush; then blot areas with the rag. Scratch into the foliage with your brush handle for texture if you wish.

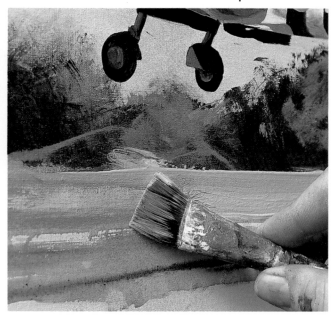

►14 Mix a dark green with Hooker's green and burnt sienna and use it to darken some areas of the bushes to provide tonal contrasts. Block in the grassy area along the runway with yellow oxide, titanium white and Hooker's green. Again, vary your mixes (some light, others dark) to provide depth. Also vary your brushstrokes to add interest and a fresh look. Don't try to render details but aim to make the foliage loose and expressive.

◄15 For the runway's dark greys, mix cobalt blue, titanium white, Mars black, dioxazine purple and dilute gloss medium in various proportions and make long, smooth horizontal strokes with your 1in flat brush.

With the same brush, apply Hooker's green randomly in front of the bushes to suggest growth. Touch in a little grey and yellow ochre under the bushes, blotting areas with a damp rag. Mix some Acra gold and yellow ochre, and flick it in sharp strokes to add more colour to this area.

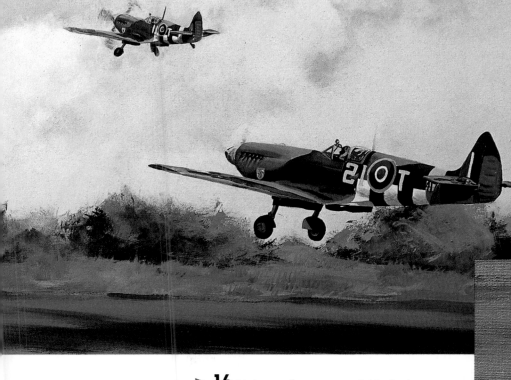

►16 Make a yellow-green with Hooker's green, yellow ochre and white, and use flicking strokes with your No.5 brush in many directions to suggest grass in front of the runway. Again, alter the proportions of the colours to vary the tones.

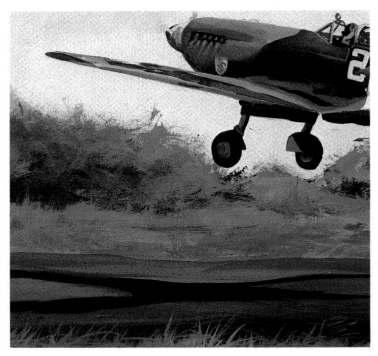

◄ **17** Paint the lower plane's indistinct shadow on the runway with a mix of cobalt blue and Mars black. Blend this smoothly with your 1in flat brush.

▼ **18** Add any last-minute details, such as the lower plane's aerial, with Mars black. Tone down the blur of the upper plane's propeller with a little titanium white, applied with your finger, and add the propeller blur on the lower plane in the same way you did for the upper plane.

Sky, land and runway have been painted loosely and expressively to give the impression of a bright, breezy day. Yet the details on the planes – veterans of World War II – are spot-on. The artist captured the scene in one sitting with great energy and spirit.

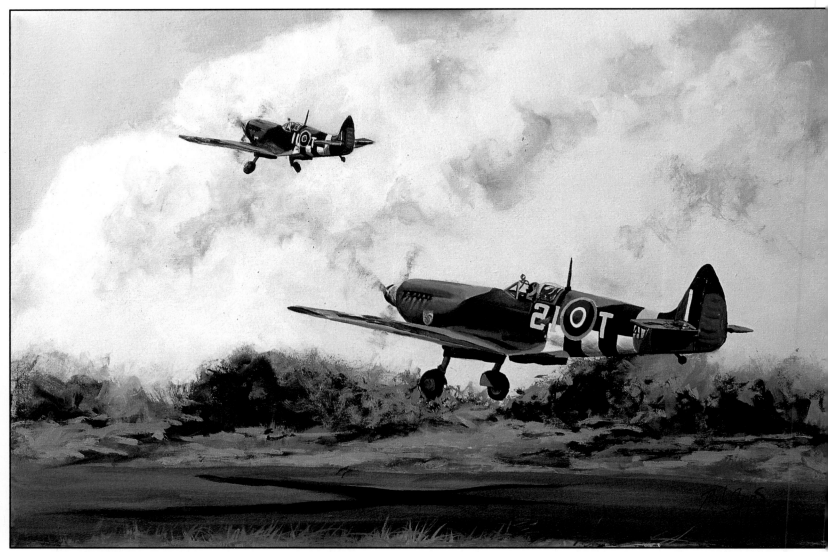

Washes, spatters & puddles

Traditional watercolour techniques can add a new dimension to acrylic painting. The medium's ability to dry fast means that subsequent layers will not muddy its colours or disturb its lines.

Acrylics can be used in much the same way as traditional watercolours. However, unlike watercolours, which remain soluble and tend to mix with subsequent layers, acrylics dry permanently – they are not re-soluble in water. This allows the artist to build up layers of transparent colour to achieve extremely subtle effects. The transparent quality of acrylic (when used as watercolour), means that it's advisable for beginners to stick to the tried and tested watercolour maxim of working light to dark.

Acrylics tend to be brighter than their watercolour equivalents, so you may find it helps to test your washes on a piece of paper first. Most watercolour techniques are possible with acrylics.

In the painting demonstrated here, the most important of these was to allow paint to puddle in some areas to suggest the contours of the car. Remember to allow each layer to dry before applying the next. Gently playing a hair dryer over the surface is a useful way of speeding up this process. But be careful not to blow wet paint into places you don't want it to go.

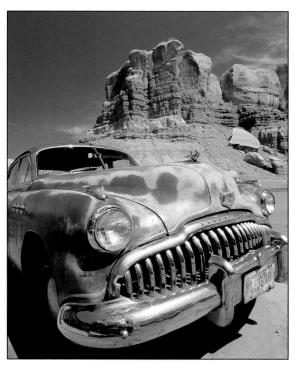

◀ **The set-up** Our artist decided that acrylics were the ideal medium to depict a classic car in a desert setting.

He decided to use the paint thin, and, as with watercolour, to leave the white of the paper support to describe the highlights on the bumpers and headlamps. Other watercolour techniques he called into play include wet-on-dry washes, puddling and spattering.

◀ **1** Lightly sketch all the main elements of the subject with the HB pencil. Use the No.10 round brush to paint the sky with a wash of cobalt blue and a touch of ultramarine. Turn the board upside down so that the washes travel in the right direction. Roll the brush around the white clouds to break up the clean edges of the wash.

Use this blue mix with the No.6 brush to work in all the areas of blue which are reflected in the car window and the chrome. Tilt the board so the paint puddles at the bottom of the washes, suggesting darker reflections. Add a little alizarin crimson to your mix. Use this around the bumper and blend it in to the wet area.

YOU WILL NEED

- [] A 15 X 22in sheet of 200lb NOT Bockingford/cold pressed watercolour paper, stretched and taped to a board
- [] A table easel
- [] HB pencil
- [] A palette for acrylics
- [] Two jars of water
- [] Kitchen roll
- [] A hair dryer
- [] Two round brushes: a No.10 and a No.6
- [] Nine Liquitex acrylics: yellow oxide, alizarin crimson hue, cadmium red light, naphthol crimson, cobalt blue, ultramarine blue, sap green, burnt sienna and Payne's gray

◀ **2** Use a very watery mix of yellow oxide and the No.10 brush to wash over the rocks and car. After the last wash has dried, add a little cadmium red light to the mix. Use this to paint over the car to give it a slight pinkness. Add a little more cadmium red light to the wash to redden the foreground and also to paint in the darker area of the far headlamp (see step 4).

Add more yellow oxide and cadmium red light to your mix to create an orange. Use this to paint over the rocks, leaving out the lighter areas.

▶ **3** Add a little more cadmium red light to the mix and work over the roof of the car. Wet the car's rusty areas with clean water and add a little burnt sienna to the red-orange mix. Flood this into the wet areas. When dry, the resulting watermarks describe perfectly the worn paintwork on the car.

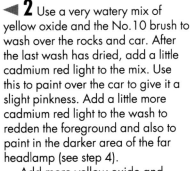

▼ **4** By varying the ratio of paint to water, you can mix different tones of orange. Work across the rocks, alternating lighter and darker colours to suggest contours. Add the car's red badge, the shadows between the radiator bars and the shadows and writing on the number plate. Take the No.6 brush and spatter a little of this mix over the left of the car's bodywork and over the bonnet/hood to suggest rust.

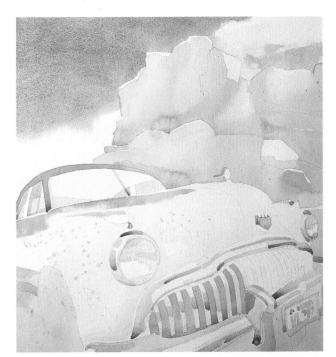

▶ **5** Using the same varied orange mixes as before, work over the rocks once more, building up form as you overlay washes. Allow the rocks to dry, and darken the intensity of one of the orange mixes with cadmium red light. Use the No.6 brush once more to spatter over the rocks. Protect the sky with your free hand or a torn piece of paper.

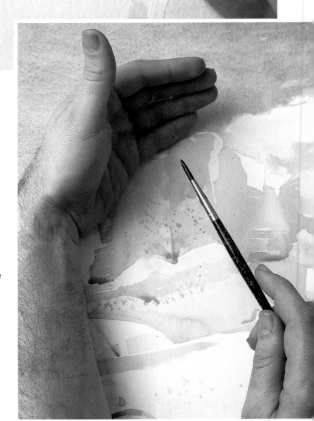

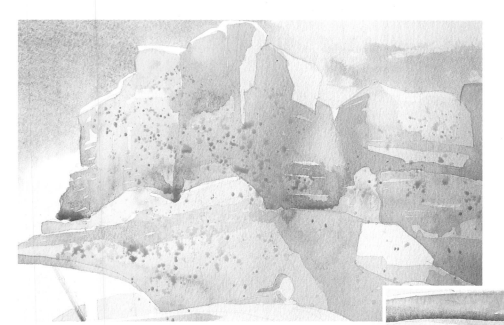

◀ **6** See how the spattering adds interest and texture to the rocks. Continue to spatter over the lower foreground – this helps to liven up the picture. Don't worry if some spatters bleed into the wet paper. They may look obvious at this stage, but as these areas are developed they become much less noticeable.

▶ **7** Make a mix using sap green, ultramarine and Payne's gray. Use this to work over the bonnet/hood, wetting areas with clean water and dropping in colour. The colour bleeds through and gives the appearance of peeling and distressed paintwork. Use the mix to work around the headlights and 'draw' in the contours of the bonnet/hood.

◀ **8** Use the mid orange mix and the No.6 brush to paint in the lines on the nearest headlamp and fill in the hub cap. Add Payne's gray to the mix and detail the dark reflections in the lamp. Leave the picture to dry thoroughly.

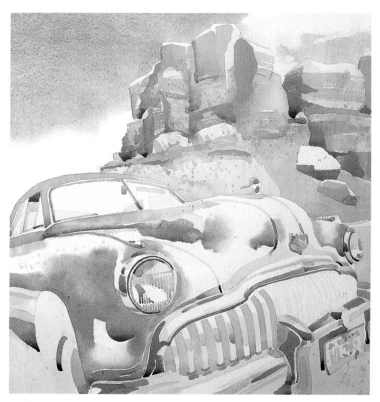

▲**9** Add some naphthol crimson and a little ultramarine to the darker orange mix. Work over the rocks, really pulling out their shadowed, craggy areas. Do a little more spattering with this dark colour to suggest a pock-marked surface.

Mix some Payne's gray and ultramarine and carefully outline the windscreen and headlamps. Work over the chrome, stroking in the dark reflections with this deep colour. Also use some for the shadow of the number plate.

▲**10** All the light and mid tones are now in place so you can begin working on the darkest colours and tones. The picture now begins to develop depth and sparkle as these darker areas are painted in.

Use a dark mixture of Payne's gray and a little naphthol crimson to paint the dark areas inside the car (see step 12), and paint the shadows under the car, not forgetting the ones around the wheels.

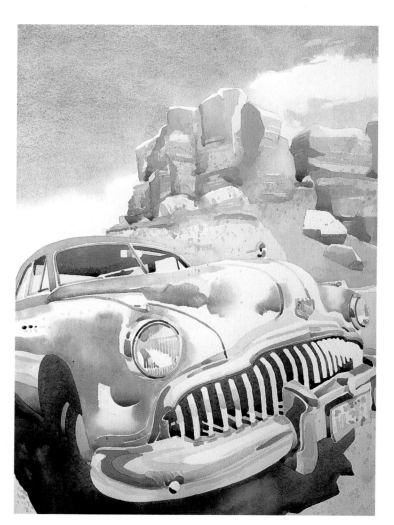

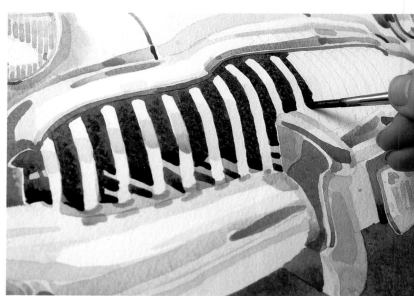

▲**11** Carefully paint through the radiator grille with the same mix, leaving slanting orange highlights inside. These help suggest the light passing through the grille and create an excellent three-dimensional effect.

◄**12** Allow the painting to dry. Then stand back to assess the work so far. Mix some Payne's gray and a little naphthol crimson to darken some tones on the chrome.

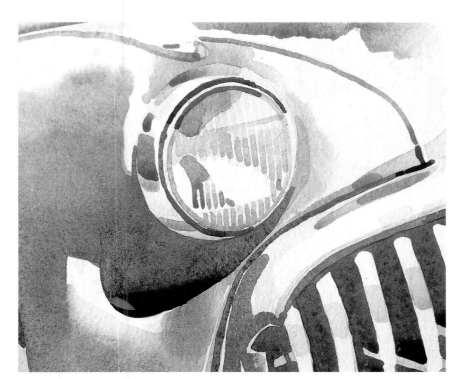

◀ **13** Mix some sap green, a little ultramarine and some Payne's gray. Use this to intensify the colour on the bonnet. While the area is still wet, mix some naphthol crimson and Payne's gray and paint in the shadow under the headlamp. See how our artist let the colour pool here to create a really deep tone which conveys the shape of the car. Try placing the board at a slight angle, so the wet paint settles at the bottom of the shadow's curve where the colour is deepest.

Using the No.6 brush, carefully run a dark line over the top of the radiator.

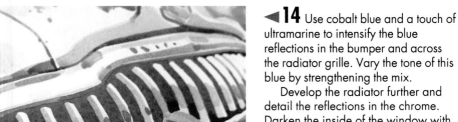

◀ **14** Use cobalt blue and a touch of ultramarine to intensify the blue reflections in the bumper and across the radiator grille. Vary the tone of this blue by strengthening the mix.

Develop the radiator further and detail the reflections in the chrome. Darken the inside of the window with Payne's gray and a little naphthol crimson. Then use the same mix to work around the edges of the bonnet and on the headlamp. Also work on the tyre, and darken the shadow under the front bumper.

Tip

Quick fix
Remember that acrylics are not water-soluble when dry, so if you make a mistake it must be corrected while the paint is still wet. Don't panic! Carefully blot off the paint with plenty of clean kitchen roll, then continue painting.

▶ **15** Mix cadmium red light and yellow ochre and a little alizarin crimson in varying proportions and use these to highlight ridges on the rocks.

To lift the painting, some more colour is needed in the sky. Use an intense mix of cobalt blue and ultramarine to work across this area. Turn your board upside down if it makes it easier to paint.

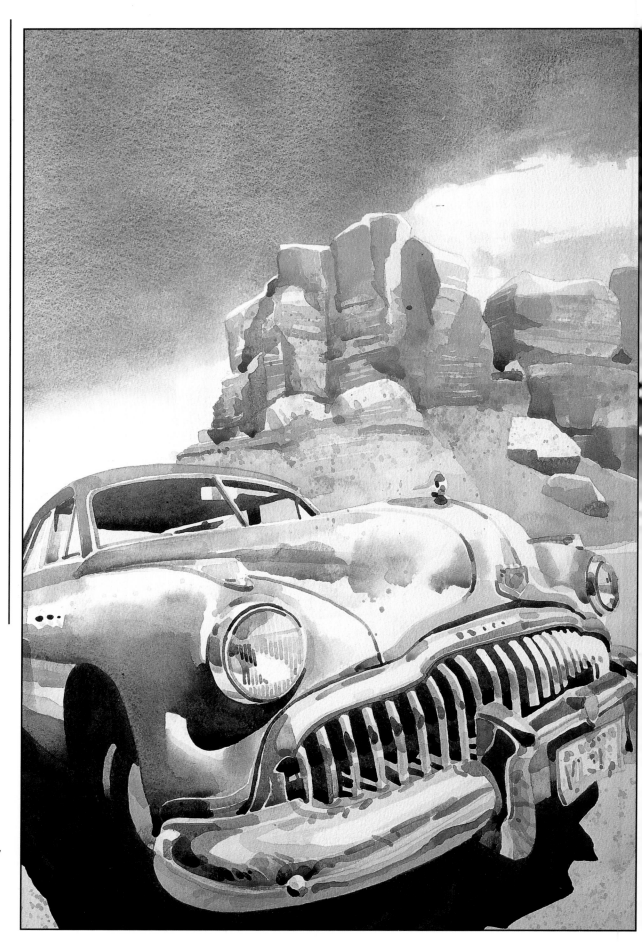

Tip

White out

Our artist didn't include any white on his palette because it's a very opaque paint and would make his mixes opaque — he wanted his washes to be transparent, like watercolour. However, if you want to lighten a tone which is too dark or to cover a mistake, you can take advantage of white's opacity by adding it to a mix to cover the paint layer underneath.

▶ **16** As a final touch, use a deep orange mix to paint a line across the bumper to warm the colour there. Make any other adjustments you think necessary. Our artist put a little more orange 'rust' on top of the bonnet/hood, for example.

The finished painting demonstrates the colourful and bold effect that acrylic paints can have when used like watercolours. The composition is further enlivened by the drastically foreshortened perspective of the car. The artist's use of spattering and watermarks has also added texture to the picture.

Using a limited palette

You don't need many acrylic colours to begin painting. Using a limited palette helps you become familiar with your colours and their mixes, and it also holds the composition together.

There are dozens of acrylic colours on the market today – not just the more traditional ones like Payne's gray and ultramarine, but also wild pearlescent and metallic silvers, burning-bright yellows and oranges and many others. Even the spectrum of landscape colours is vast.

Most beginners make the mistake of buying far too many acrylic colours. You simply don't need them. In fact, if you have a wide range of colours at your disposal, you'll probably spend a lot of time deliberating about colour selection instead of dealing with their application or improving your compositional skills. The colours you choose for your limited palette depend on your subject – for example, a palette for landscapes is likely to be completely different from one for portraits, and even for portraits it depends on the sitter's skin colour.

Restricting your palette to four or five colours helps to unify the whole composition. You can find hints of the five colours our artist used in his demonstration all over the painting – and they contribute an important sense of harmony to the whole picture. You can also mix a number of other colours from the basic palette to create different tones, helping you to become familiar with your colours and their mixes.

In our artist's painting, the medium density fibreboard (MDF) is left unpainted in places, where it provides an excellent mid-tone for the dried leaves of the reedmace. And the colour and texture of the board shine through the thin wash of colour laid down for the still water in the middleground, creating the effect of a shimmering, reflective surface.

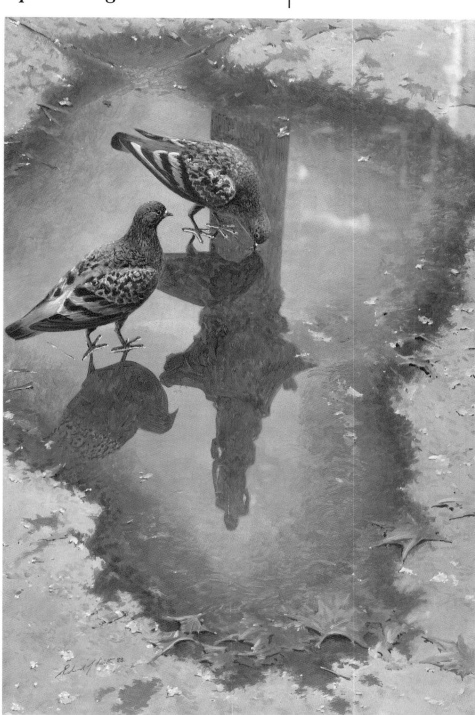

► **Using only a limited palette of six colours – yellow ochre, French ultramarine, burnt umber, burnt sienna, titanium white and philo green – the artist has achieved great depth and variety.**
'Trafalgar Square' by Richard Smith, 1988, acrylic on hardboard, 30½ x 20½in

Reedmace in the lake margins

▼ ▶ The set-up Our artist combined elements from two photographs of reedmace in a lake in Bedfordshire. A close-up of some reedmace served as the main reference, but he introduced the simple background from his second photo to balance his composition and reflect foreground colour.

YOU WILL NEED

- [] *One sheet of 30 x 20in (6mm thick) medium density fibreboard (MDF)*
- [] *Four brushes – a No.9 long flat, a No. 9 short flat, a No.6 round and a 2in decorators' brush*
- [] *One 50mm (2in) long painting knife*
- [] *Palette knife*
- [] *Two jars of water*
- [] *Disposable palette*
- [] *Sponge*
- [] *Water sprayer*
- [] *Acrylic matt medium*
- [] *Five acrylic colours – burnt umber, yellow ochre, ultramarine, titanium white and burnt sienna*

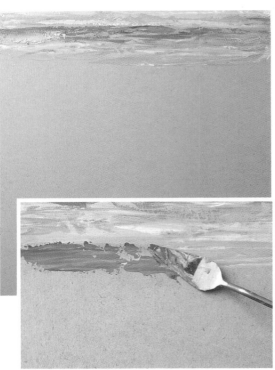

◀ 1 Mix ultramarine and white on your palette with the painting knife, and spread a narrow band of colour along the top edge of the board for the sky. Then paint the distant bank of the lake with a rough mix of yellow ochre, white and slight touches of burnt umber; suggest the outline of trees and bushes with the tip of the knife.

Now paint the lake using loose mixes of ultramarine, white and touches of burnt umber, leaving the pigment virtually pure in places and letting the board show through in others. Make sweeping horizontal strokes. The edge of the knife is useful for suggesting different wave patterns (inset).

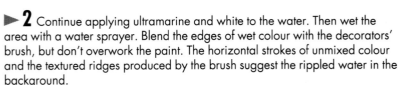

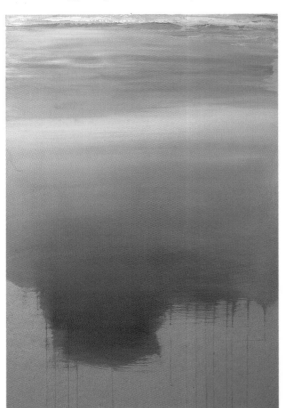

▶ 2 Continue applying ultramarine and white to the water. Then wet the area with a water sprayer. Blend the edges of wet colour with the decorators' brush, but don't overwork the paint. The horizontal strokes of unmixed colour and the textured ridges produced by the brush suggest the rippled water in the background.

Continue painting the water with pale mixes of ultramarine and white. Make horizontal strokes back and forth across the board with the same brush, spraying on a little more water if needed. Apply the paint thinly like a glaze, letting the warm tone of the board show here and there. Add more blue, then burnt umber as you move down to the foreground. Leave it to dry.

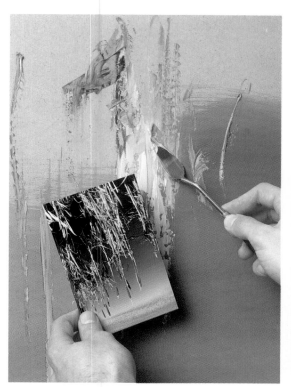

◀ **3** Here our artist turned both painting and photo upside down to help him paint what his eye was really seeing, rather than what he expected to see. It also forced him to concentrate on a detail, without distraction from the overall composition.

Use loose mixes of yellow ochre, white and touches of burnt umber to establish the lighter tones of the reedmace. Make long, vertical strokes with the painting knife in some areas, short dabs in others.

Tip

Spreading paint

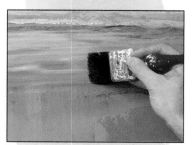

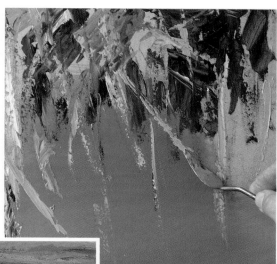

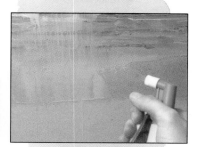

Adjust the nozzle on the water atomizer to spray a fine mist (test it out a few times, pointing somewhere other than your painting!). Then pull the trigger two or three times over the lake area (top).
This makes colour blending quick and easy (above). It also thins the paint, allowing you to see parts of the board in places.

▲ **4** Here you can see the subtle yet realistic colour mixes the artist used to suggest the dense clumps of reeds. Still working with the painting upside down, take up small, individual dollops of yellow ochre, white, burnt umber and ultramarine and apply them to the board. Allow them to blend as you work loosely and freely with the knife, creating smooth areas as well as ridges – these help to suggest individual stems and leaves.

Load the edge of the painting knife with a loose mix of yellow ochre, white and touches of burnt umber, and form the long stems. Allow the painting to dry thoroughly.

◀ **5** Notice how our artist has built up texture and tone by placing some angled slabs of colour next to others and some over each other. There are light areas over dark ones, and vice versa. A few diagonal stems complement and add interest to the composition, and they break the uniformity of the vertical stems, providing a sense of balance.

► **6** Mix yellow ochre and white, and paint the reedmace heads with your No.9 long flat brush. Firmly push the brush on to the board as you drag the paint down. This creates soft, feathery effects. Add burnt umber to your mix and use it to darken some of the heads.

Load the No.9 short flat with plenty of titanium white, and make a few dabs and brushstrokes on the palette to compress the brush bristles into a neat, compact head. Now paint the spikes on the male heads by carefully touching the brush to the board (inset). Re-form the brush shape after each mark.

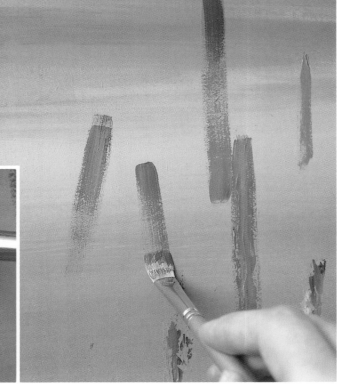

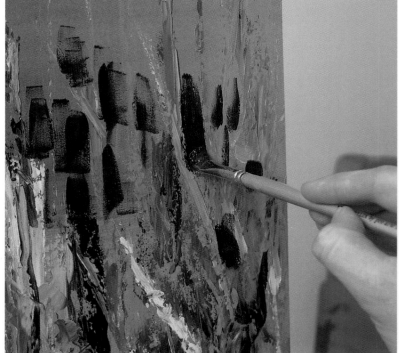

◄ **7** Using the No.9 short flat, paint the darkest foreground tones with mixes of burnt umber and ultramarine. Allow the brown to dominate the mix in some areas, and the ultramarine to dominate in others, to provide a sense of depth.

Paint quickly, with short, vertical strokes of colour, pushing the brush bristles hard against the board. As you move back into the reeds, drag a dryish brush over the ground to give a misty effect, creating a sense of perspective.

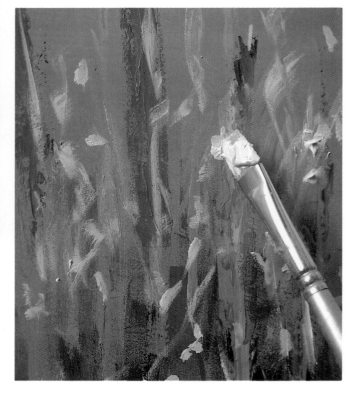

► **8** Now add pale impasto paint to the flowerheads. This will bring these areas forward. For the distant reedmace on the right, dab on small marks in a pale, thick mix of white and yellow ochre. Let yourself go – twist and flick the brush on the board to produce interesting textures.

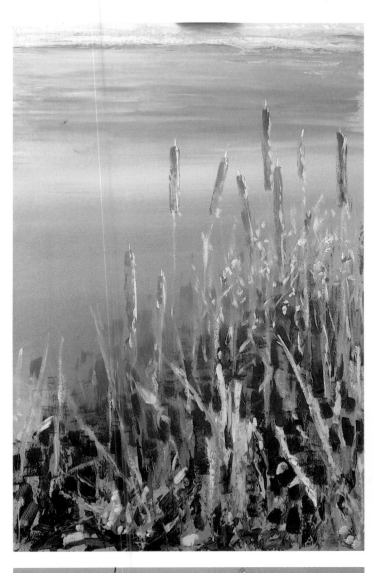

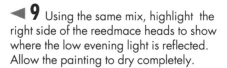**9** Using the same mix, highlight the right side of the reedmace heads to show where the low evening light is reflected. Allow the painting to dry completely.

▼ **10** Pour a few teaspoons of acrylic matt medium into a jar and mix it well with the same amount of water. On your palette, mix burnt sienna with this glazing medium in equal proportions, and then loosely glaze over the reedmace with the No.9 long flat. Scrub on the translucent colour with rough strokes in several different directions.

This glaze warms up the reedmace and creates the effect of rich evening light. The uneven application makes for different intensities of warmth, giving the impression of shimmering light.

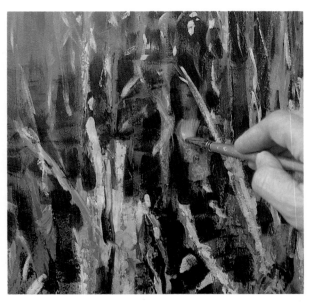

◀ **11** To build up the pale tones of the stems and to define their form further, add small strokes and dots of white (mixed with a little yellow ochre) with the No.6 round brush. Use the tip of the brush for fine detail and the whole brush for some bolder lines. Don't be afraid to apply the paint quite thickly in places.

▼ **12** With the same brush, apply burnt umber mixed with touches of ultramarine and yellow ochre to give dark shadows down the left side of the reedmace heads.

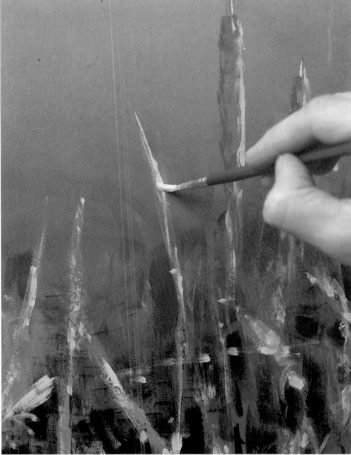

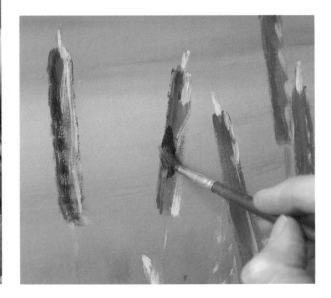

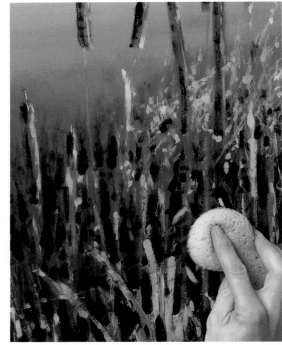

◀ **13** Our artist strengthened the distance between the reeds and the water by darkening the area where the two merge with a mix of ultramarine and burnt umber. Then, using grey-brown mixes of ultramarine, yellow ochre and titanium white, he added small dots of colour over the dark tone. Allow this to dry thoroughly.

With the same glazing mix you used in step 10, glaze the lower half of the painting. Use a large sponge to apply the colour fairly evenly to the reedmace and immediate vicinity of the lake. Leave the paint to dry.

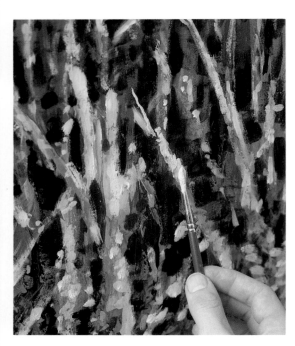

▲ **14** Re-establish the light tones over the glaze with the No.6 brush. Use dry mixes of white with a little yellow ochre added, applying the paint boldly and thickly in dots, dabs and some longer strokes.

◀ **15** Stand back from your painting to assess it. You may want to emphasize the dark tone between the reeds and the water with a wet mix of ultramarine, white and a touch of burnt umber, painting small dots of colour among the stems.

Because the glazes have the effect of warming and muting the colours, you may find you need to lighten the foreground further. Don't be nervous when applying the paint quite thickly in this area. Virtually pure white pigment with just a touch of yellow ochre achieves a dramatic effect.

Monochrome underpainting

A monochrome underpainting allows you to organize your picture from the word go, so you can respond freely to your subject when it comes to applying colour.

If you want to give your painting a really good start, especially if you're a beginner, then make a monochrome underpainting (known technically as *grisaille*). It's very similar to making tonal studies. You use one colour to organize the tones in your subject before you start to think about local colours. This avoids the confusion that can easily arise when you try to depict the colours and tones of an object in one go (an area in which many beginners fall down). Sorting out the underlying tonal structure of your subject early on – the positions of those vital lights and darks – can lead to a much more successful final result.

And once you've done the underpainting, you get a monochrome preview of your painting. This allows you the chance to look at how the composition works, and see if it's balanced correctly. At this stage you have the freedom to redraw until it's accurate. Later on, you obliterate the underpainting anyway. The monochrome underpainting means you can respond freely to what you see without worrying about the vital aspects you've already dealt with. For some artists, it's a good way of systematically organizing a painting from the start. Others would say it's saving the best until last!

▼ **The monochrome underpainting (left) looks very different from the finished picture (right). But if you squint at them you'll see the similarities – tonally they are almost identical. Once our artist had established the tones with Payne's gray, she was free to enjoy the rich application of colour.**

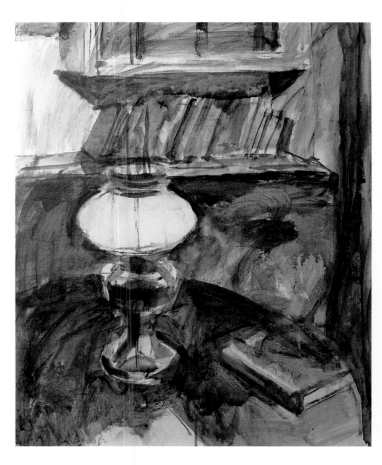

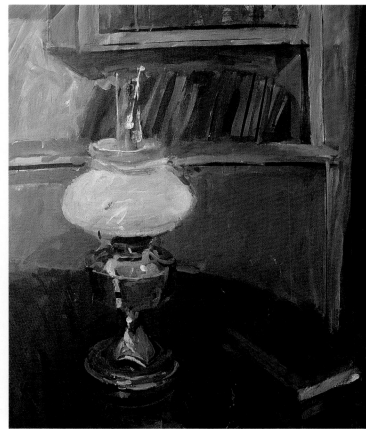

Keep responding

This demonstration shows how much a painting can change in appearance as it progresses. This isn't because the artist corrected mistakes, but because she responded directly to what she saw, making adjustments as she noticed new things.

When your painting begins to take shape, let it 'talk back to you' by taking ideas from the painting itself, as well as your subject. This enjoyable experience is often spoiled for the novice whose concern all along is how the final painting will look. Put aside preconceptions and simply look – you may surprise yourself with your finished work.

Establishing the structure in a monochrome underpainting gives you freedom for spontaneity with your brushwork, colours and ideas, and allows you to concentrate on adding that magical personal touch.

In the study

The set-up The focal point – the paraffin lamp – was the main light source in this still life. To suggest moving light, the artist worked in the classical system of 'lost and found edges'. Instead of making hard edges, you avoid working precisely around edges, letting them 'find themselves' as the painting develops.

▲ **1** Sketch the composition with your stick of charcoal. Make the proportions as accurate as you can, especially the ellipses of the lamp – they get deeper and more pronounced as they move farther down from the eye level. Draw a vertical line running down through the middle of the lamp to help you make it symmetrical. Indicate the cupboard and the books on the shelf in simple blocks.

▶ **2** Start by assessing all the tones. Hood your eyes and look for lights and darks. Put these in with your No.12 long flat brush, using dilute Payne's gray with more or less water for the various tones. Start with the table. Its dark surface is lighter where the lamp reflects on it, so leave this area blank.

◀ **3** Continue working in this way, depicting all the tones you see. Think about the shapes of the shadows too – they help to make the painting more interesting. The angular shadow under the cupboard contrasts well with the rounded lamp.

▼ **4** Compare one tone with another and build them up slowly and thoughtfully. For example, use the darkness of the table to show you how light the book should be.

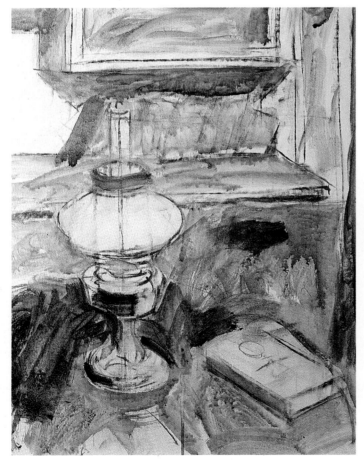

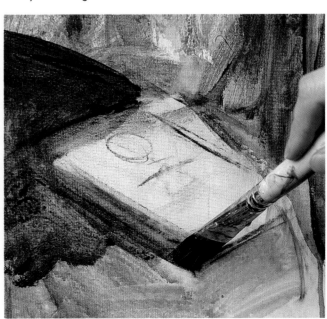

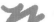

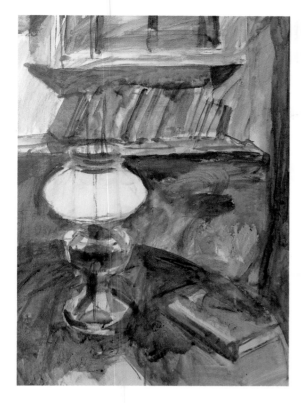

◄ **5** Keep building up the underpainting, assessing tones and deepening them where necessary. Continue until you're completely happy with your work. Allow the underpainting to dry.

▶ **6** Now begin to paint the local colours. Start with dilute washes that stain the support. You can slowly build up the painting on these.

 Apply dilute alizarin crimson to the background area around the lamp, using your No.6 round brush. Notice how, although the same wash is used above and below the bookshelf, it looks much darker below because of the tonal underpainting. Paint the edge of the cupboard door with a wash of burnt umber. Use very dilute phthalo green for the lampshade.

▼ **7** Using the same brush, paint the table top with burnt umber, enriching it with alizarin crimson. Use dilute cadmium yellow for the lamp stand. The underpainting turns this into quite a cool, greenish yellow which suggests the reflection of the light. Add the dark reflections of the table top to the lamp stand with the colour you just used on the table.

 Paint the book with dilute alizarin crimson, adding white and cadmium yellow for the highlight (see inset). For this, use your No.6 long flat.

▲ **8** Now start to use your paint thicker, diluting it with less water. Put in the background area around the lamp with a mixture of alizarin crimson, cadmium yellow and titanium white, using loose, general strokes. Add warmer reflections to the lamp stand with cadmium red and cadmium yellow.

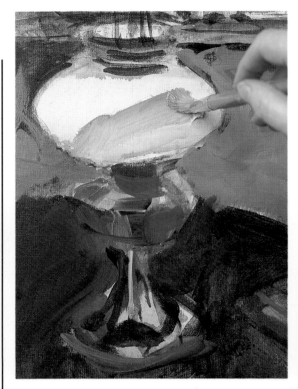

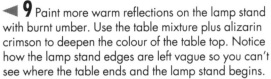

9 Paint more warm reflections on the lamp stand with burnt umber. Use the table mixture plus alizarin crimson to deepen the colour of the table top. Notice how the lamp stand edges are left vague so you can't see where the table ends and the lamp stand begins.

Mix phthalo green and white for the greenish tinge on the lampshade. Apply this loosely with your No.6 round brush, covering the outside edge.

Tip

Use your ruler
Hold a ruler firmly in your free hand and rest your brush against it, sliding it up

or down the edge to paint a straight line. This steadying guide is useful for those lines that need to be as straight as you can make them.

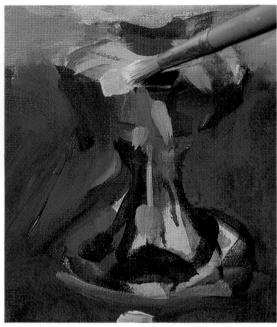

10 Use cadmium yellow for the bold areas of colour on the lamp stand. Put a dab of yellow on the table to suggest the lamp reflecting on the table top. Fill the blank area on the table – which you left for the lamp's reflection – with dilute cadmium yellow.

Add cerulean blue to the background mix for the area around the lamp, using smoother strokes for a more even coverage.

11 Using the same brush, paint the curtain on the right with permanent green. Our artist used her different mixes to put dabs of colour on the books and cupboard. All objects pick up colours from their surroundings, so train your eye to look for these. The left side of the cupboard takes direct light from the lampshade, so use the lampshade colour to paint it.

12 Using your finger, apply titanium white to the lampshade to tone down the green a little. Load the paint on thickly to make rich, fresh marks. Our artist also decided to tone down the yellow on the lamp stand with a little burnt umber.

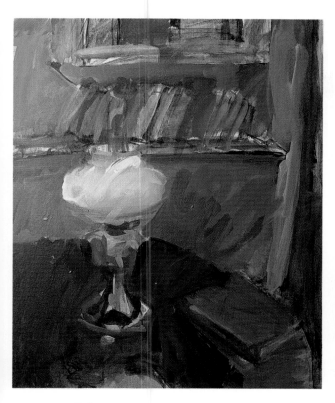

14 Mix phthalo green, white and a touch of cadmium yellow for a brisk attack with your No.12 flat brush to suggest the rounded shape of the lampshade. Again, don't worry about the edge – you'll deal with that later. Build up a little more detail on the lamp stand using a mix of cadmium yellow, burnt umber and alizarin crimson.

15 Study the lamp stand to pick out the subtleties of colour. The green reflections become bluish towards the base; the yellow gets very warm in the middle; the sides reflect the warm red table top. Add the yellow highlights with hard edges to echo the texture of the brass. Use the colours you've already put on the lamp stand, darkening them with burnt umber.

Create a variety of colours mixed from titanium white, alizarin crimson, cerulean blue, burnt umber, and Payne's gray to build up the books on the shelf.

13 Mix cerulean blue and titanium white, warmed with a little alizarin crimson. Scrub this on to the background area to the right of the lamp with your No.12 flat brush. This murky mix helps to lead the eye away from the brightness of the lamp, into the background. And by painting up to the edge of the lamp, you give its shape more definition. Apply brilliant strips of alizarin crimson and cadmium yellow to the books on the shelf.

The overall mood of the painting emerges now – warm and energetic, with a shimmering surface.

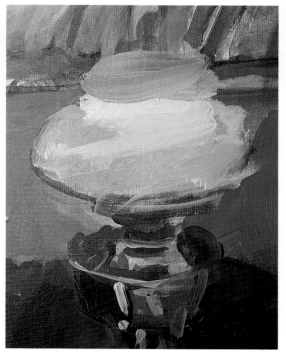

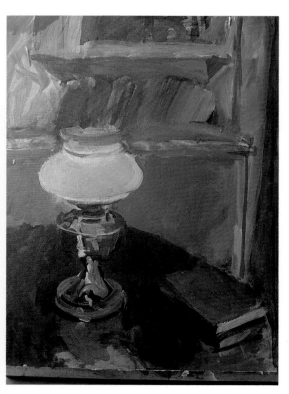

Tip

Thumbs up

Fingers and thumbs make excellent painting tools. The book and its reflection on the table (see step 16) are right next to each other, giving you the opportunity to use closely related colours. To make an impression of the two merged forms, blend their shapes with your thumb. It's the perfect shape for painting the rounded spine too.

16 Paint the book's reflection on the table using a mix of titanium white with alizarin crimson and Payne's gray. (See Tip above.)

Paint a crisp red line for the edge of the shelf – mix alizarin crimson with enough water to make it flow easily and use a ruler to keep your hand steady (See Tip on the opposite page.)

Bring on the lamp stand with the colours you've already used to add more details. Add lively brushwork to the table top using cerulean blue with a little phthalo green and white. Use cerulean blue along the bottom of the shelf, adding white for the energetic shadow to the left of the books.

Mix a pale yellow to give the lampshade an edge. Make sure you don't obliterate the greenish tint.

▶ **17** With your No.3 brush, give the books more definition by painting straight lines, using Payne's gray to suggest their edges. Rest your brush on a ruler to help you get the lines straight.

▼ **18** When the paint has dried, put in the glass chimney on the lamp. Use varying mixtures of titanium white, alizarin crimson, cerulean blue, burnt umber and Payne's gray to suggest the distorted shapes of the books seen through the glass.

Once this has dried, put a little titanium white on the edge of your ruler with a brush and press it on to the surface of your painting, making crisp lines that suggest the edge of the chimney and the highlight. Use more titanium white to tidy up the lampshade and give the top more shape and detail. Put a little dot of red from your palette on the lampshade to suggest a reflected highlight from the table.

▶ **19** The finished painting has a cosy warmth with a variety of rich pinks and reds. The feeling of moving, shimmering light is captured through all the sparkling reflections and fleeting dabs of colour. The many changes in the course of the painting, as the artist responded to the new things she saw, create a successful painting without ever altering the underlying tonal structure provided by the monochrome underpainting.

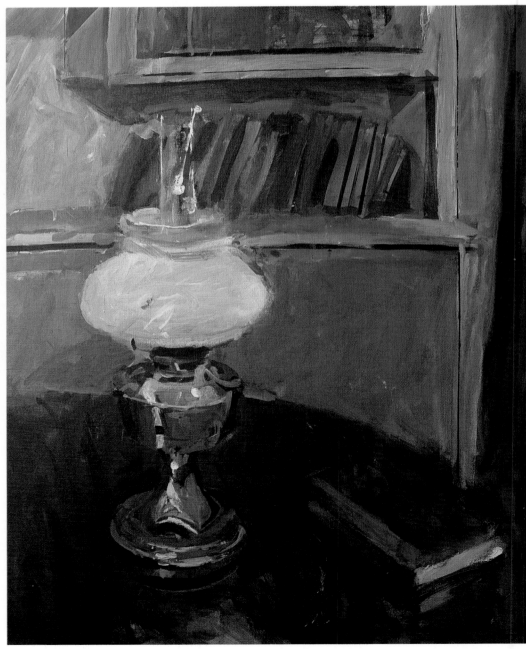

Glazing with acrylic

The technique of glazing helps you achieve a wide range of subtle – and beautiful – effects with acrylic paints.

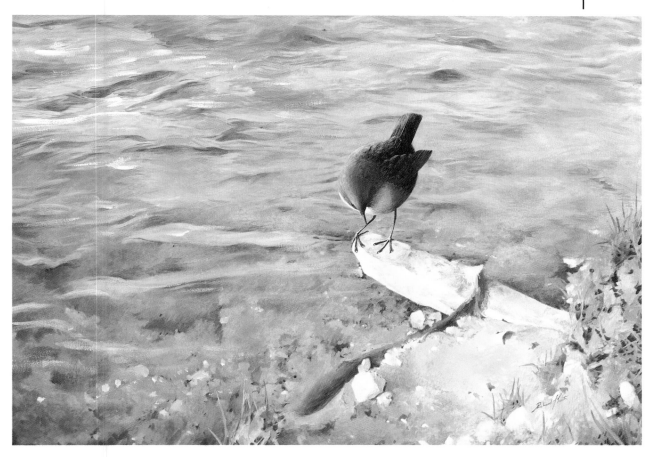

Glazing with oil paints to build up layers of colour – some opaque, some transparent – is a technique developed by the Old Masters. They produced paintings with a depth and subtlety impossible to achieve by any other means. And that is very much what you can do today when glazing with modern acrylic paint.

Acrylic is wonderful for glazing simply because it dries so quickly. You have all the advantages of the technique with only a fraction of the waiting time necessary with oil paints.

What is a glaze?

A glaze is a thin film of transparent colour laid over a dried underpainting. You can put a single glaze on top of a finished painting to give an overall unifying effect, or you can build up colour and tone with film after film of transparent paint, allowing each layer to dry thoroughly before applying the next.

Building up paint like this creates a final surface colour that is a complex combination of all the layers and gives your finished painting great depth and luminosity.

Using glazes

Glazing is suitable for almost any subject, but it is particularly good for portraits and figure painting. Here successive glazes help you to achieve delicate modulations of tone and colour that result in lively, fresh skin hues.

Shadows, too, are excellent subjects for glazing. Many people start by painting shadows as black or dark patches of colour, but if you look

▲ **Glazing is a marvellous technique for describing the translucency of water. You can use many thin glazes, one over another, to build up a feeling of depth and catch the reflection of light on the surface.**

The sequence of glazes perfectly captures the shifting, elusive qualities that make water such a challenge for artists.

'Dipper by the stream' by Richard Smith , acrylic on board, 17 x 27in

Trying out colours

Different colours act differently. Chromium oxide is opaque...

... while phthalo green is much more transparent.

Chromium oxide mixed with water is a little transparent.

Phthalo green mixed with water is highly transparent.

This is chromium oxide laid over cadmium yellow.

This is phthalo green laid over cadmium yellow.

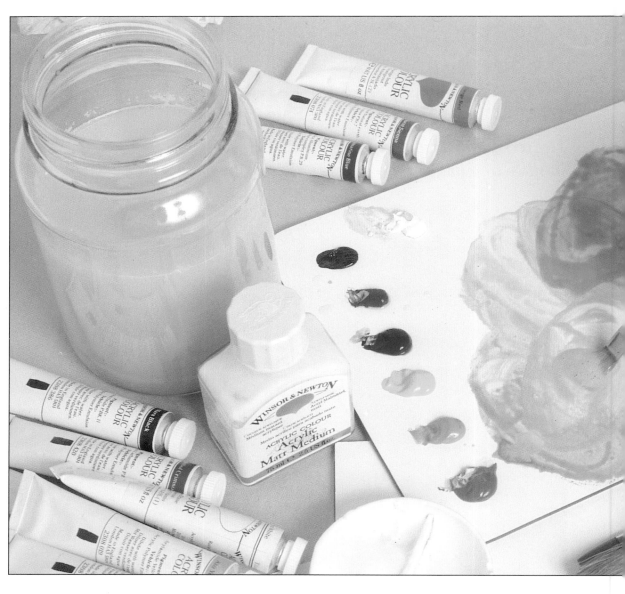

carefully you can see they have many colours – and great depth as well. If you block in opaque colour and then overlay it with several layers of glaze your shadow areas become much more realistic and interesting.

Of course, there are many other applications for glazes, especially if you want to create a certain mood or if your painting needs some help to 'hang' together.

For example, you may decide that the sky in a landscape is too cool, but adding another layer of paint would be too drastic. If you mix a glaze of ochre and apply it thinly over the area near the horizon you can give the sky a delicate blush of warmer colour.

Again, if you start by blocking in the main features of your painting as patches of colour and then work them up, the colours in the final image may not 'sit comfortably' with each other. Applying a glaze of a suitable tint over the whole painting helps pull the picture together so all the

different elements harmonize pleasantly.

Another use for glazing is to define space in a painting. If the background of a landscape is 'coming forward' too much, lay a pale blue or blue-grey glaze over it to unite all the background elements and 'knock' them back into the distance where they belong.

Glazing with acrylics

The simplest way to make an acrylic glaze is to thin the paint with water. Another way is to add some matt or gloss medium. These extend the paint and make it flow more easily, so it covers the surface but doesn't retain the mark of the brush.

A glaze made with water, or with a matt medium, dries to a matt finish. A glaze made with water can be used for washes that resemble watercolour, or for laying in an underpainting. A gloss medium creates a glaze which is more translucent than those made with water or matt medium, and it dries to an attractive sheen.

Working with glazes

▲ With acrylic glazes you usually work from light to dark for subtle colour effects and a sense of depth. Cadmium red over cadmium yellow makes a good orange.

▲ A pale glaze painted over a darker colour can modify it to some extent. Here a glaze of cadmium yellow over cadmium red gives a subtle orange tinge.

▲ You can also apply a glaze over a textured underpainting to bring out the irregularities of the surface and modify the colour as well.

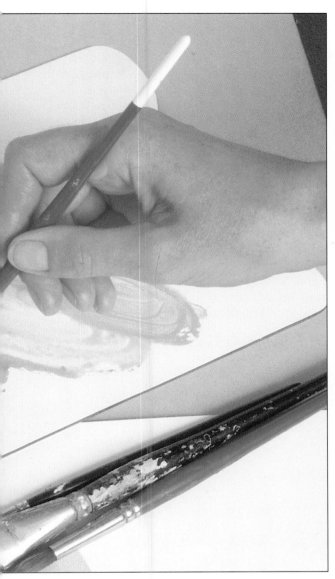

▲ Glazes need to be thin so the colour beneath shows through – you can use water for your initial glazes, then move on to a matt or gloss medium for the final layers.

Mixing and using different glazes require some practice. Only then can you see how all the various colours affect each other. You usually work from light to dark – laying glazes of transparent colour in increasingly darker tints over a dry underpainting of a paler colour. In this way you gradually build up tone and colour (much as you do in watercolour). It's a good idea to test your glaze mixtures on a sheet of paper – useful if you need to recreate mixtures later on.

But you can also use a pale glaze to modify a darker colour (although you can't obliterate underlying colour with transparent paint). For example, you could give an area of Payne's gray a bluer tinge with a glaze of cerulean blue, or warm it up a little with raw sienna.

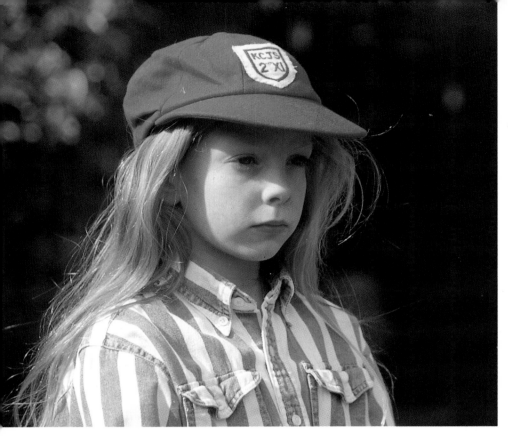

Alice in a red cap

Glazing is an excellent technique for portraits. Discreet layers of colour build up subtle gradations of flesh tones, the transparent glazes capturing the translucent quality of the skin.

Start with a clean, dry, dust-free support. At first you mix the glazes for the underpainting with water for thin, transparent layers of colour. Later on you switch to a glazing medium for glazes with more body. Don't use paint straight from the tube – always dilute it.

Remember you are building up transparent layers of paint which modify, but don't obliterate, the colours underneath. Use thin paint and allow each layer to dry before applying the next. Don't work on one area at a time. Build up the painting as a whole.

◀ **The set-up** A photo of the artist's daughter, Alice.

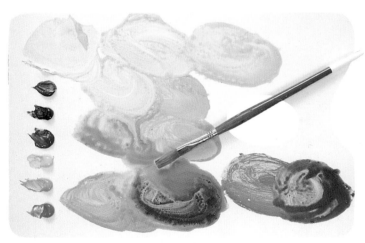

YOU WILL NEED

- ☐ Canvas board ready primed for acrylic
- ☐ Two flat synthetic fibre brushes – ⅜in, ¼in
- ☐ Matt glazing medium
- ☐ An HB graphite stick or pencil
- ☐ A plastic, porcelain or paper palette
- ☐ 10 colours: sap green, burnt umber, phthalo blue, naphthol crimson, azo yellow medium, yellow ochre, titanium white, ultramarine blue, cadmium red and Payne's gray

▲**1** For the first half of this painting, squeeze out six colours on to your palette – sap green, burnt umber, phthalo blue, azo yellow medium, yellow ochre and naphthol crimson.

▶**2** Sketch the outline and main details of the painting with the graphite stick or pencil. Include the facial features and stripes on the shirt. Then squint or screw up your eyes to look at the photograph: you want to reduce the tonal areas on the face and hair to about five or six. Lay in these main areas.

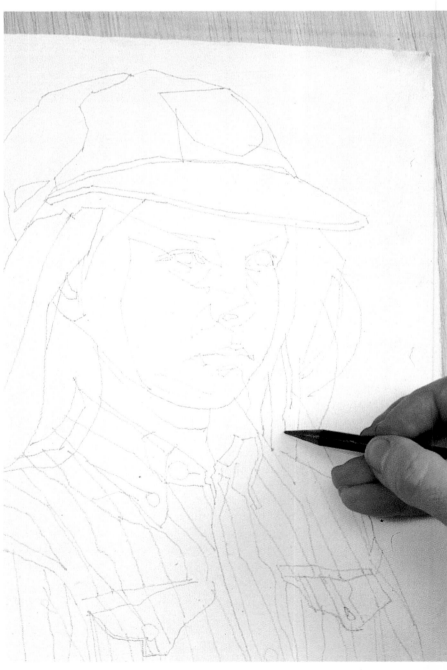

◀**3** Using water, mix sap green, burnt umber and a little phthalo blue and paint in the background with your ⅜in brush. Work freely, angling the brush in different directions to create texture.

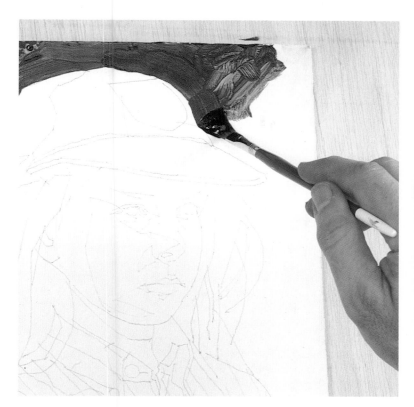

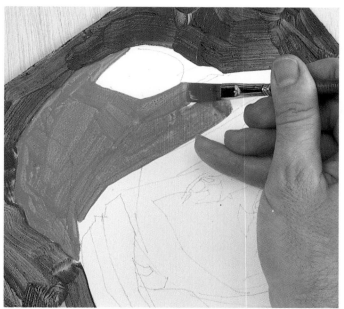

▲▲**4** With the same brush, fill in the cap with a mix of naphthol crimson and some azo yellow medium. Follow the direction of the curves on the cap (with your flat brush) to describe its volume and shape.

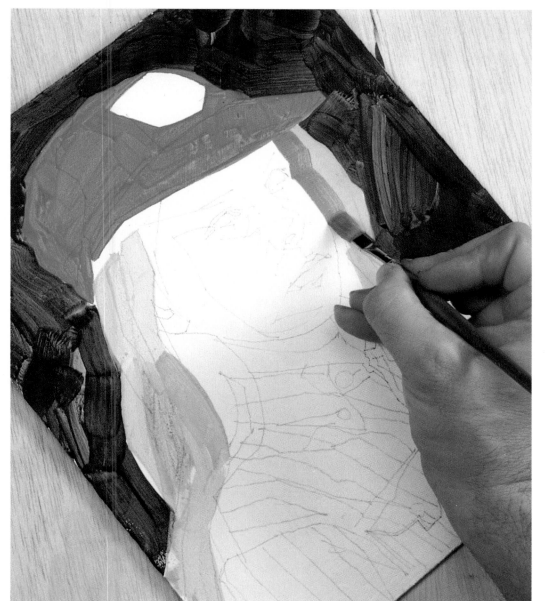

◀**5** For the hair, mix yellow ochre and titanium white warmed with a small amount of the cap colour. (Make a lot as you will use it in other glazes later.) Thin with water for the lighter strands. Add another layer for darker areas. Use broad strokes to convey volume and density, rather than simply blocking in flat strands of hair.

To create a darker tone, add a touch of phthalo blue and burnt umber to the hair mix and paint in the shadow along the right side of the face. Don't worry about the graphite or pencil lines showing through – they act as a useful guide and are covered over as you build up the painting.

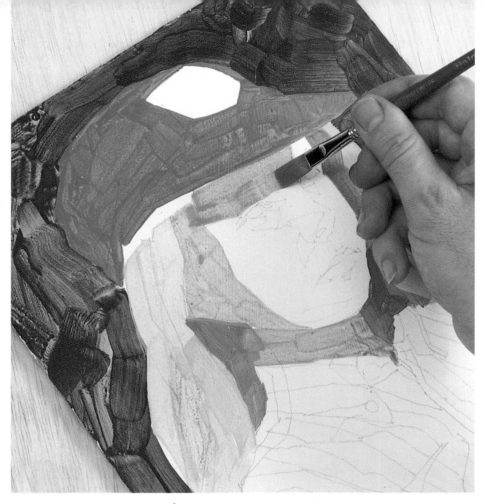

◀6 Still using the ⅜in brush, add naphthol crimson to the light hair colour for the shadow on the left side of the face. Dilute with extra water to make this mixture more translucent.

Add a little naphthol crimson and phthalo blue to this glaze to darken and warm it for the shadow on the forehead and rest of the face. The artist used plenty of red in the face mixtures because of the shadow cast on Alice's face by the red cap. Add a touch of phthalo blue for the dark shadow on the right side of the neck.

▼7 Now begin to modify the main shadow area across the face, working on the forehead, round the lip and on the chin, adding burnt umber and naphthol crimson to make the colours darker and richer. Use discreet layers of colour – overworking flesh tones makes them dull and muddy rather than translucent. Use your ¼in brush for these finer details.

Stand back, take a break and assess what you need to do next.

Tip

Caring for brushes
Brushes don't come cheap! So spend time taking care of them – rather than money replacing them. Keep your brushes in a jar of water while you are painting. Then, when you have finished painting, wash them in plenty of water before the paint on them dries. Acrylic paint is highly adhesive and almost impossible to clean off brushes once dry.

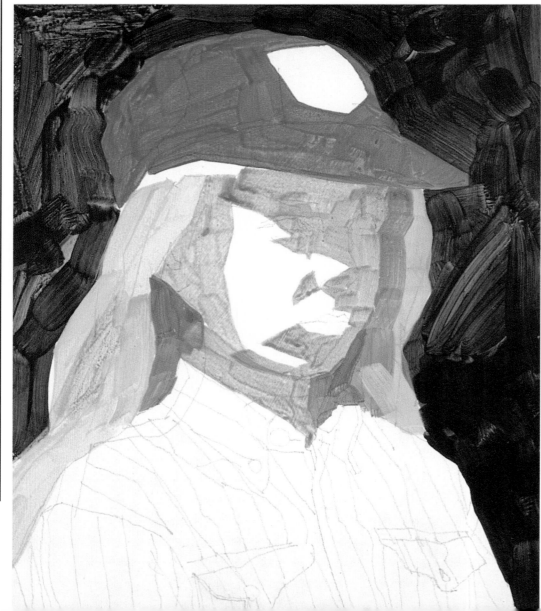

Finishing off the portrait of Alice

Our artist began his portrait of Alice with six colours – sap green, burnt umber, phthalo blue, azo yellow medium, yellow ochre and naphthol crimson – he added titanium white to the palette at a later stage. These colours were used for the red cap and the main tones on Alice's face and hair. The plan was to use 10 colours in all, building up the painting in thin glazes.

With the face and hair tones already established, our artist continued by squeezing out on to his palette the remaining three colours he was going to use – cadmium red, ultramarine blue and Payne's gray. These are for Alice's striped shirt and for adding deeper tones and stronger colours to cap, face and hair. At step 9 he also changed to matt medium to mix the paints – not water. The medium allows the paint to retain more body, while giving it the transparency essential for glazing.

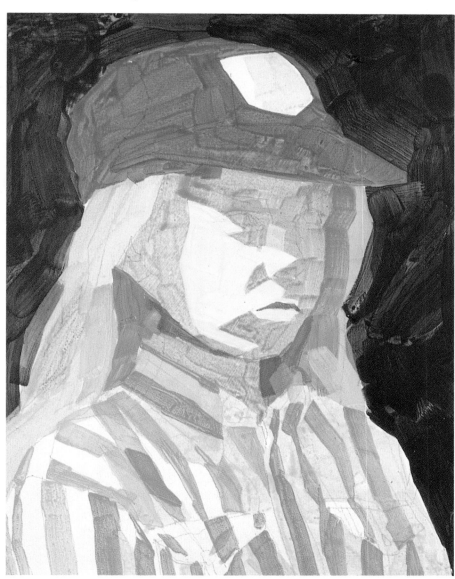

▶ **8** Using your ¼ in brush, lay in the pale areas of the face with titanium white warmed with tiny amounts of naphthol crimson and yellow ochre.

Use some of this glaze in a mixture of phthalo blue and titanium white for the blue stripes on the shirt. The flesh tone helps to 'knock back' the blue and white mixture which is otherwise too intense. Use the flat brush to lay in the stripes with crisp edges but don't make them too regular.

Add more titanium white and phthalo blue to this glaze for the lighter stripes on the shirt and the cap badge. Use the darker face mixture with a little naphthol crimson and burnt umber for the shadow under the cap. Paint the shadow under the jaw line using the darker face mix with a little phthalo blue.

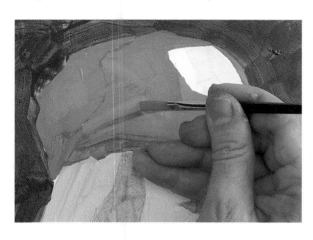

◀ **9** With the underpainting completed, start using matt medium to mix the glazes. Begin with the cap, using a little glazing medium with cadmium red and titanium white for the lighter areas.

▶ **10** Add a touch of this glaze to a mix of yellow ochre and titanium white and paint the darker strands of hair. Darken the same mix with some burnt umber and a little naphthol crimson if needed, and work it into the forehead and eye area for subtle tones.

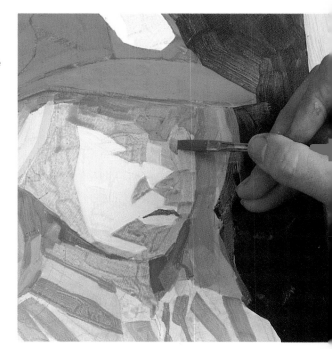

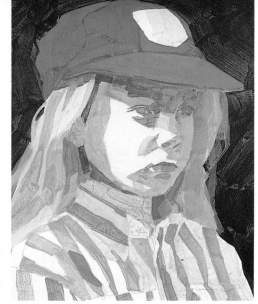

◀ 11 Use this glaze mixed with some sap green to warm up the background. This serves to pull the painting together as a whole. Move around the painting, modifying the colours from light to dark to give depth – you don't want flat layers of colour.

Using your ¼in brush, revise the colours on the face. Use a dark tone from your palette to strengthen the eyes, lids, pupils, eyebrows and nostrils, adding some burnt umber and naphthol crimson if needed. Put in a dark tone under the lower lip to indicate the light coming from above. For this, use a glaze of ultramarine blue, naphthol crimson (from the hat) and a small amount of yellow ochre (from the hair).

◀ 12 Outline the face with a mix of ultramarine blue and burnt umber blended with some of the darker brown face mixtures. Continue putting in the facial details. Use a mix of burnt umber with some sap green for the eye area and the parting between the lips. Keep altering and modifying until you get the exact effect you want. Leave any areas you are satisfied with.

Develop light and dark tones in the hair by modifying the original hair mixture. Mix titanium white and yellow ochre for the light tones, and some burnt umber with phthalo blue for the dark tones. Do the same for the light areas on the face, refining the tones on the cheek, nose and chin.

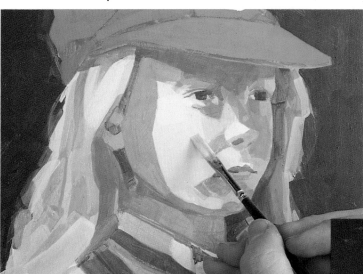

▶ 13 Lighten the face mixture with yellow ochre and titanium white for the left cheek (See TIP). Add the highlights on the lighter areas of the face – the tip of the nose, top lip and cheek – with an opaque layer of white. Put in a few warm shadows on the right side of the face with some titanium white and naphthol crimson added to the face mixture.

Tip

Flesh tones

For variations of flesh tone, mix one colour which you can lighten or darken. The basic flesh tone in step 13 is lightened with yellow ochre and darkened with burnt umber or some phthalo blue and naphthol crimson.

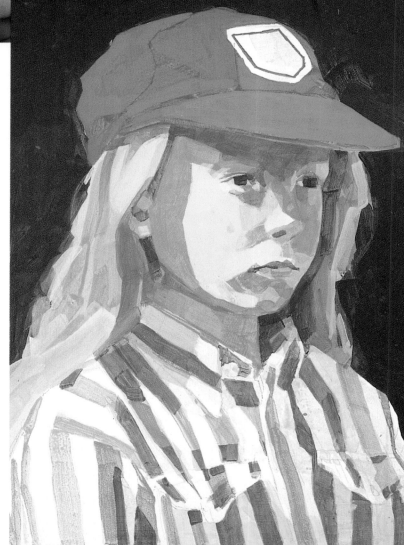

14 Mix a titanium white glaze for the lighter areas on the shirt and the cap badge. Use a glaze of sap green, phthalo blue and burnt umber for the background around the edges of the hair, putting it over the lighter colour on the hair to make the edges look strandy. For the darker stripes on the shirt, mix Payne's gray, a little ultramarine blue and titanium white to lighten it.

15 Finally, modify the skin tones around the mouth and nose with a mix of naphthol crimson, azo yellow medium, yellow ochre and a little titanium white. Use the red glaze (from the cap) to put in the outline on the badge.

Spattering and sponging

Spattering and sponging can be used to create purely abstract patterns – but they come into their own when you want to capture the energy and excitement of fast-moving water.

Fast-moving and churning water are both notoriously difficult subjects. As soon as you begin to 'labour' the paint, the impression of fluidity is lost. To do them justice, try dispensing with traditional brushwork, using instead the techniques of spattering and sponging.

Spattering is both more fun and messier than sponging. For a picture of any size, it involves flicking paint from your brush on to your support from a distance of just over an arm's length. This produces a remarkable illusion of running water. The secret is to achieve a series of roughly parallel lines of spattered paint, not a completely random collection of marks. You need a consistent arm action – don't bring your body into the motion.

However controlled your action, though, you can guarantee that not all the paint will end up on your support. If you don't have a studio, the place to do this type of painting is in a garage, workshop or an undecorated room.

The sponging technique is used for trapped and churning water and requires a more delicate touch. You apply the paint with a damp sponge using a gentle press-and-lift motion to simulate steaming foam.

Unless you want your painting to become an abstract work, it's best to include a detailed focal point. Our artist added a leaping salmon, which adds greatly to the drama of the picture. You may choose plant life, rock details or human figures.

▼ **Sponging is the perfect technique for suggesting foaming water. The detailed rendition of the grey wagtail offsets the blurred impression of the water and provides an important focal point to the picture.**
'Grey Wagtail, White Water', acrylic on hardboard, 12 x 14in

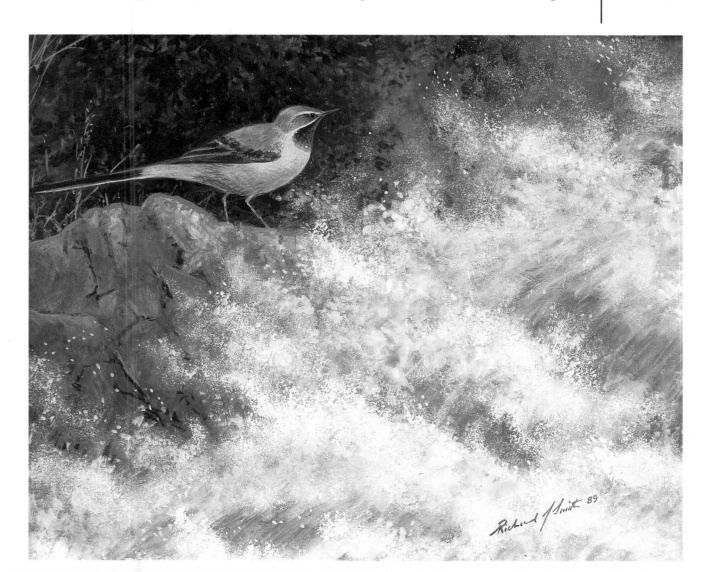

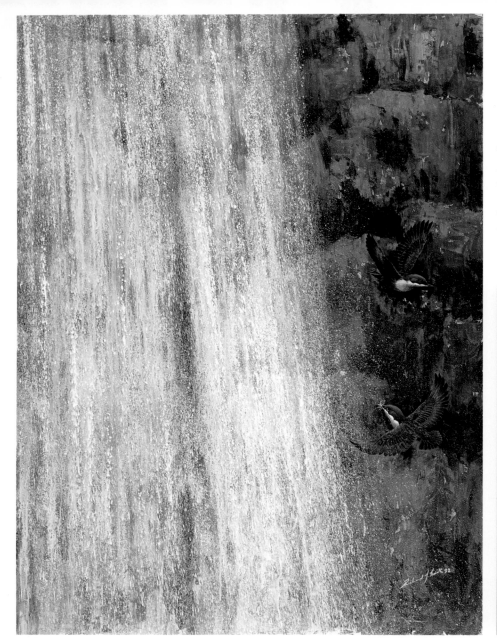

Leaping salmon

The set-up The beauty of painting running water by spattering and sponging is that you are aiming for an overall impression – you don't need a specific reference. For the salmon, use a photo, try to get hold of a wildlife video or study a few in a fishmonger's shop. Our artist is a keen angler and naturalist and has observed – and painted – fish for many years.

▲ **The violent, rushing descent of water is captured here by a vigorous spattering technique. As a final step to add to the excitement, the artist added the spray that appears in front of the rocks. He did this by judicious spattering with very dilute white paint.**
'Dippers' by Richard J Smith, acrylic on MDF board, 48 x 36in

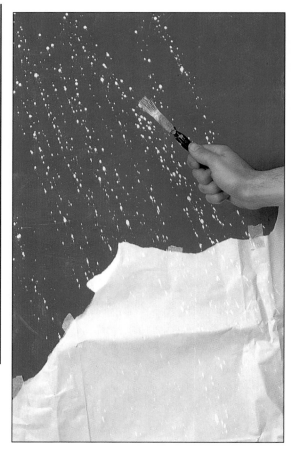

▲**1** Prime the entire sheet of hardboard with a thin coat of household matt emulsion (flat latex) paint in a darkish shade of blue. Now mask off the lower half of the support – this part will show the foaming water and the fish jumping. To do this, tear up a large sheet of scrap paper or newspaper to form a steep, dynamic angle, and tape it firmly to the hardboard.

◄**2** Mix some white paint to a medium consistency for spattering: if it's too thin it will fly everywhere, if it's too thick it will leave the brush in large, unsightly blobs. Now the fun begins – dab some of the paint on to the ½in decorators' brush. Standing just over an arm's length away from the easel, raise your arm above your head and bring it down sharply to spatter a line of paint on to the board diagonally from top left to bottom right. Repeat this action several times across the whole of the exposed board.

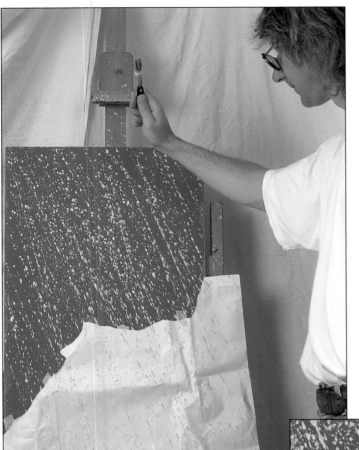

◀ 3 Add a touch of cadmium red to the white to create a pale pink and continue spattering. Bear in mind that you are painting the fall of water, not just making random marks. To control the spattering, use only your arm – not your whole body.

▼ 4 Continue mixing the colours slightly. Use the following colours, each mixed with a large amount of white: cadmium orange, cadmium yellow light, brilliant yellow green and phthalo green.

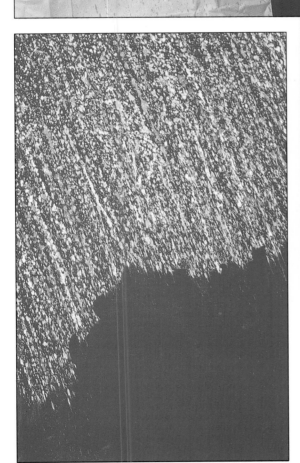

◀ 5 Next spatter with cobalt blue and white. Then add a little cadmium red to this mix to create a grey-purple and spatter once again. Don't completely hide the blue undertone as you work – this should show through to represent the dark shadows of rock beneath the waterfall. Once most of the area is spattered, remove the paper mask.

YOU WILL NEED

- A 32 x 18in sheet of hardboard
- Dark blue matt emulsion (flat latex) paint
- Paper and old sheets for protection and to mask the painting
- A palette; an easel
- Masking tape
- Two jars of water
- Three brushes: Nos.6 and 8 round synthetic fibre and a ½in flat decorators' brush
- A natural sponge
- A soft pencil
- Acrylic matt medium
- Seven acrylic colours: titanium white, cadmium yellow light, cadmium orange, cadmium red, cobalt blue, brilliant yellow green, phthalo green

Tip

Cover up
Before spattering, put newspaper down to protect the

floor and hang up old sheets to cover the walls. Also, make sure you wear old clothes. To protect his shoes, our artist has found that it pays to wrap his feet in old plastic bags!

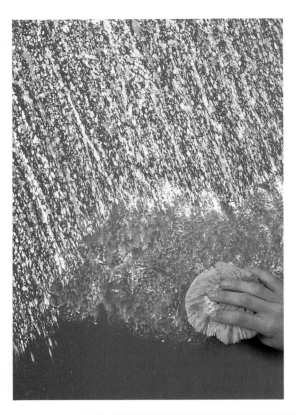

6 Now start work on the foaming water at the bottom of the waterfall. Mix titanium white with water and a little matt medium to a fairly thin consistency. Wet a natural sponge with clean water and then wring it out so it's just damp. Pick up a small amount of paint on the sponge and dab it on to the board with a gentle press-and-lift motion. Cover the whole of the bottom area with a cloudy pattern of semi-transparent colour.

7 Add some cadmium red with the sponge, spacing the colour fairly widely. Then put on a few dabs of cadmium orange. Go over the whole area with more of the white mixture, to soften the effect.

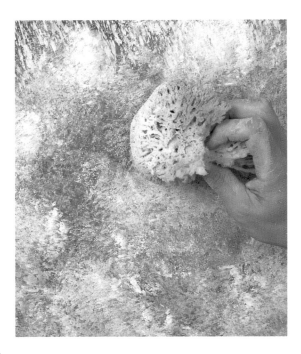

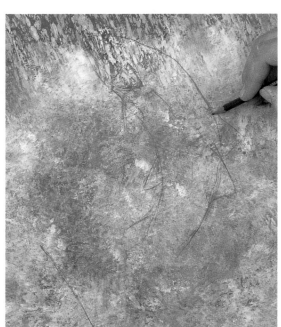

8 Vary the tones by adding a denser application of white in some areas, particularly along the upper edge to give form to the churning water.

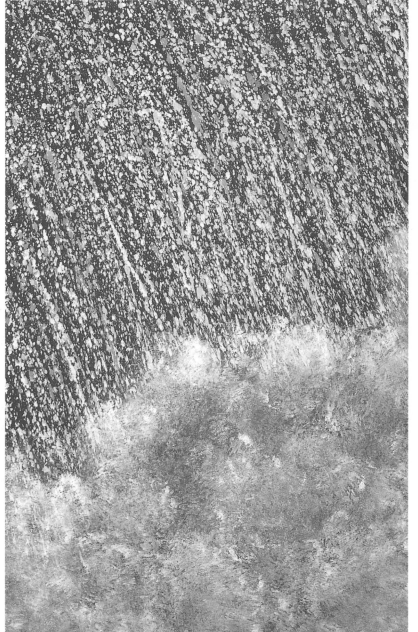

9 Returning to the spattered area, mix a little 'palette mud' – that is, the colours left over on your palette, combined with water and acrylic matt medium. Brush this on with the No.8 round in long strokes – at the same angle as your spattered marks – to suggest the shadows in the water.

While this glaze is drying, draw the outline of the leaping fish in soft pencil.

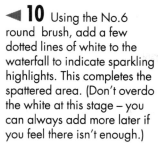

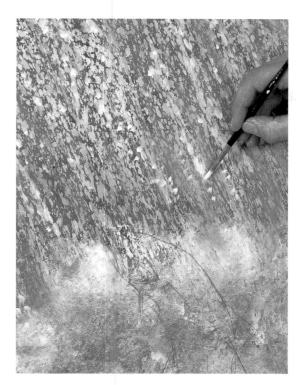

◄ **10** Using the No.6 round brush, add a few dotted lines of white to the waterfall to indicate sparkling highlights. This completes the spattered area. (Don't overdo the white at this stage – you can always add more later if you feel there isn't enough.)

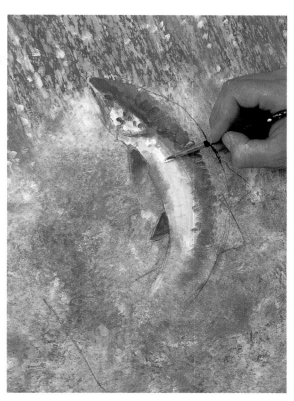

► **11** Now begin painting the fish. The sponged pattern applied earlier provides an ideal middle-toned base from which to work up to the lights and down to the darks. With the No.6 brush, paint the dark pattern on the fish's body with a mixture of cadmium orange and cobalt blue. Apply pure white for the silver belly.

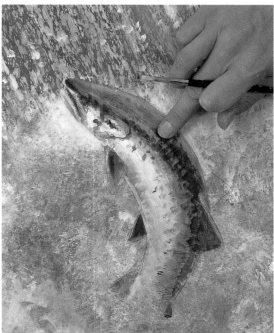

▲ **12** Use more orange and less blue to make a browner grey mix for the fish's back. Apply very thin glazes of cadmium red and phthalo green to suggest the subtle 'rainbow' sheen of the skin. Then add highlights with white and a touch of grey. Use your fingers and the brush to blend the colours and tones softly, indicating the rounded form of the fish.

► **13** Paint the fish's tail using the cadmium orange and cobalt blue mix. Keep the details soft and not too clearly defined to indicate the movement of the fish and the turbulence of the water. This avoids a static, pasted-on effect.

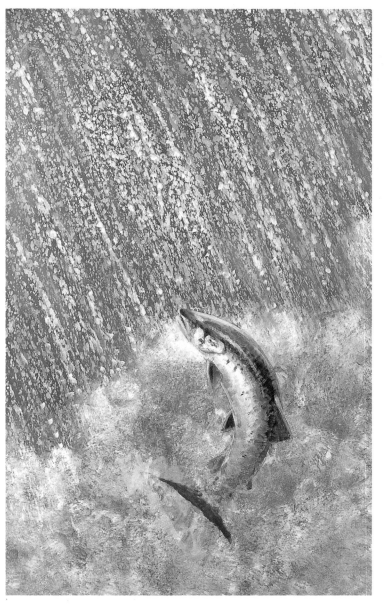

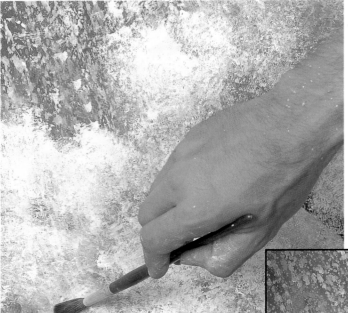

◄14 Strengthen the impression of churning water by adding more highlights and shadows. For the highlights, sponge on a little more white paint. When this is dry, indicate shadows with a thin glaze of 'palette mud', mixed with matt medium and water. To do this, use loose, cross-hatched strokes with the No.8 brush, keeping the colour subtle.

Tip

White water

Although rushing water appears white at first glance, it does in fact contain all the colours of the rainbow. This is because the water droplets refract and reflect the sun's rays. Therefore, by introducing tiny amounts of a wide variety of colours, you'll create a much more realistic impression of 'white' water than with white alone.

►15 Our artist finished by sponging over the lower half of the salmon with a little very dilute white paint to create a blurred sense of motion. Now the salmon really seems to be leaping out of the churning water.

The final picture successfully captures the vitality of the waterfall. Although the painting appears quite complex, it takes a surprisingly short time to complete.

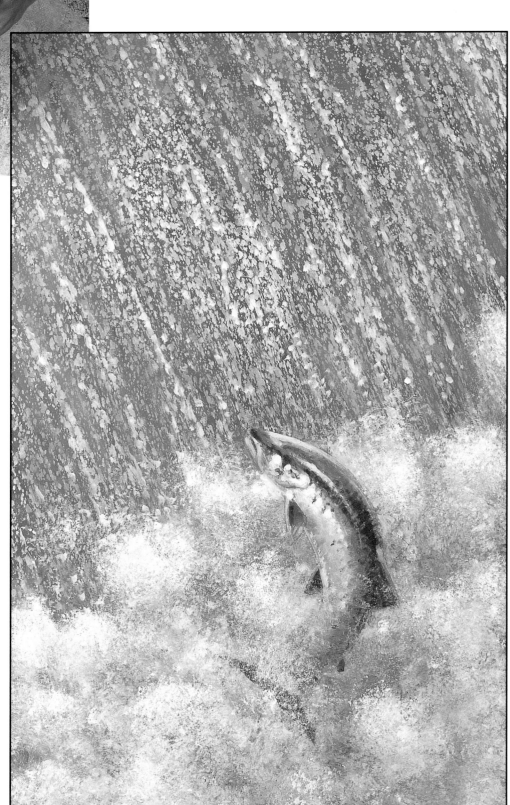

Knife-painting in acrylic

Painting with a knife allows you to work fast, directly and boldly to create vibrant, thickly textured pictures. Since acrylic dries so quickly, you can usually complete a knife-painting in one sitting.

Palette and painting knives are excellent with both acrylic and oil paints. High-quality knives have wooden handles and thin flexible steel blades, but you can buy perfectly adequate, inexpensive plastic ones. **Palette knives** usually have flat blades and handles, making them ideal for mixing paint, cleaning the palette and scraping paint from the board or canvas – but not for painting. **Painting knives** have cranked handles which keep your hand away from the painting surface, allowing you to manoeuvre them easily.

You don't need many painting knives to begin – two or three in addition to a palette knife are enough. The shapes and sizes depend on your painting style and the scale at which you work. Obviously, if you want to work on a large support, use a large knife, and vice versa.

Why paint with a knife?

Knife-painting allows you to paint quickly and directly and is primarily for impasto work – that is, thickly applied paint which retains the brush or knife mark.

You can use impasto descriptively to capture the ruggedness of bare rock or the spikiness of grass, for example. In the best knife-paintings slashes and dabs of colour give the surface an expressive quality and an excitement which you cannot create in any other way. Besides adding texture with painting knives, you can also scrape off the paint to leave a stained area, or use them to draw linear detail in the wet paint (this technique is known as sgraffito).

Knife-painting is also ideal for working *alla prima* – when you paint fast and directly, completing the picture in one sitting with a single layer of opaque paint. Alternatively, you can keep adding successive layers of paint slowly and deliberately until you're satisfied with the textures and colours.

Using painting knives

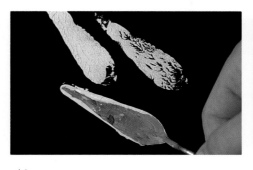

▲ Try using the actual shape of the painting knife in your work. Load the blade of the knife with paint, and press it on the board several times.

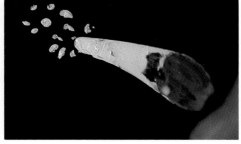

▲ You can stipple with a knife as you would with a brush. Use the very tip of the knife to add small, thick blobs of colour.

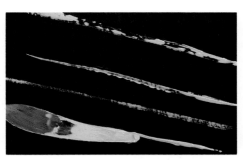

▲ Create long linear marks with the side of a knife. Pear-shaped knives have long edges and are better for making lines than trowel-shaped ones.

▲ Press the whole of the blade against the support, and then drag it over the board to cover a large area quickly.

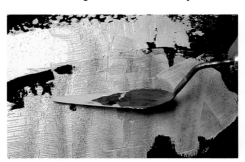

▲ Use the edge of the knife to scrape off large sections of paint, leaving behind a thin, semi-transparent layer.

▲ Lay a band of colour. Then scratch into the wet paint with the tip. This is called sgraffito and is yet another way to add texture to your work.

Using mediums

You can only use a knife with paint that has a thickish consistency (this is known as 'body'). Some acrylic paints are better for impasto techniques than others – you should enquire about the consistency of individual brands at your local art shop.

Adding appropriate impasto-improving mediums such as acrylic gels or texture pastes gives the paint further body and creates more texture in a painting.

There's a wide range of painting knife shapes to choose from. Large trowel-shaped knives are handy for applying generous dollops of paint and laying large areas of colour. Smaller knives, especially those with pointed tips, are essential for small-scale work and adding details. Every manufacturer produces a slightly different range, so shop around until you find a selection that suits you.

YOU WILL NEED

- [] 20 x 30in sheet of hardboard primed with black emulsion (latex) paint
- [] Two painting knives – a 70mm (3in) long pear-shape and a 45mm (2in) long trowel- shape
- [] Palette knife
- [] One jar of water
- [] White Conté crayon
- [] Disposable palette
- [] Eight acrylic colours – cadmium red, yellow ochre, cerulean blue, naphthol crimson, azo yellow medium, ultramarine, titanium white, burnt umber

An exotic macaw

▶ **The set-up** Colourful birds make wonderful subjects to paint with knives. You can refer to this photo for inspiration, or find one that suits you from a wildlife book. (Our macaw came from a zoo.)

Prepare the hardboard by priming it with two coats of thinly applied black emulsion paint. Leave to dry.

▼ **1** Sketch the outline of the bird with a white Conté crayon, putting in the shape of the head, wing and tail feathers. (The artist thought the stand looked too artificial, so he removed it in his painting.)

Next, squeeze out some naphthol crimson and cadmium red on the palette and, using the tip of the 70mm (3in) painting knife, lift up a dab of each. Apply the paint to the board to create the upper part of the bird's head – again using the tip of the knife and twisting to make a series of short stabbing marks on the board. Though some mixing occurs on the board, the individual colours still show through. Notice the rich undulations of crimson.

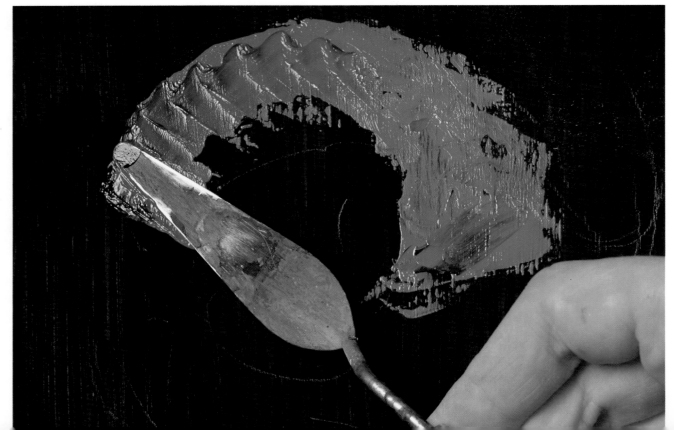

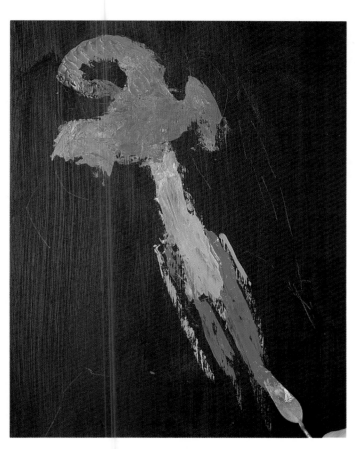

◀ **2** With the tip of the knife apply more cadmium red and crimson to paint the back and shoulders of the bird, allowing the black of the board to show through in places. Mix ultramarine and burnt umber to make a black for the lower head area.

Mix cerulean blue with a little white and yellow ochre, and paint the main back area. Create the long tail feathers with a mix of naphthol crimson and a touch of yellow ochre and cerulean blue. Make long, sweeping knife marks, adding more blue towards the tip of the tail.

▶ **3** Use a mixture of ultramarine and burnt umber (which makes a rich black) to tidy up and redefine the edges of the tail feathers.

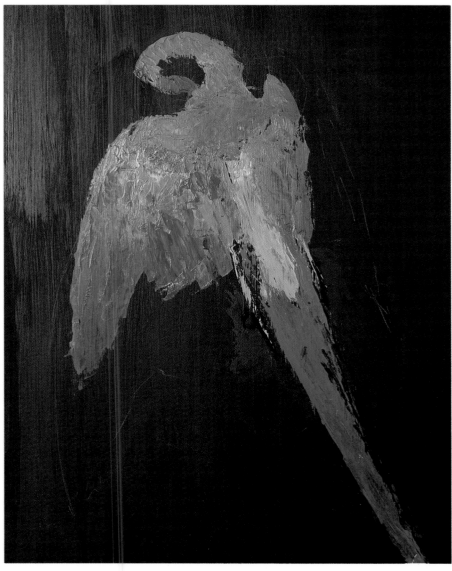

▲ **4** Mix cerulean blue and azo yellow medium with a palette knife (but not too thoroughly) for the green back – apply the paint with the tip of the large knife, making short angular jabs.

To cover the large area of the wing (and also the back) as quickly as possible, the artist applied the paint straight from the tube to the board.

He used a little azo yellow medium, cadmium red, ultramarine and a generous amount of cerulean blue.

◀ **5** The overall colour of the wing at this point is a combination of cerulean blue and ultramarine, but there are hints of yellow, red and black (the primed board) showing through.

The artist modified the green in the left wing with areas of azo yellow medium. Then he went over parts of the back and top of wings with a mix of cerulean blue and ultramarine.

▲ **6** Using the small knife, paint the beak of the macaw with a mixture of yellow ochre and titanium white. For detailed work such as this, flex or bend the knife so that you use only the tip of the blade.

▲ **7** Add more white to the mixture you used for the beak, and paint in the face of the macaw. Touch in the dark lower part of the face with a mixture of ultramarine and burnt umber.

Then mix a little naphthol crimson and cadmium red, and with the edge of the knife, apply it in three short lines to the face. Then lightly drag the upper part of the knife across the right-hand edge of the face to add reddish tints.

At this point the artist felt that the head was too big, so he used his black mix to re-shape it and reduce its size.

◀ **8** For the iris of the eye (the coloured part) use a mixture of white and azo yellow medium, but notice that the paint isn't thoroughly mixed. The pupil is black. To help make the eye stand out, apply a white highlight above it, using the tip of the knife to create a broad stroke.

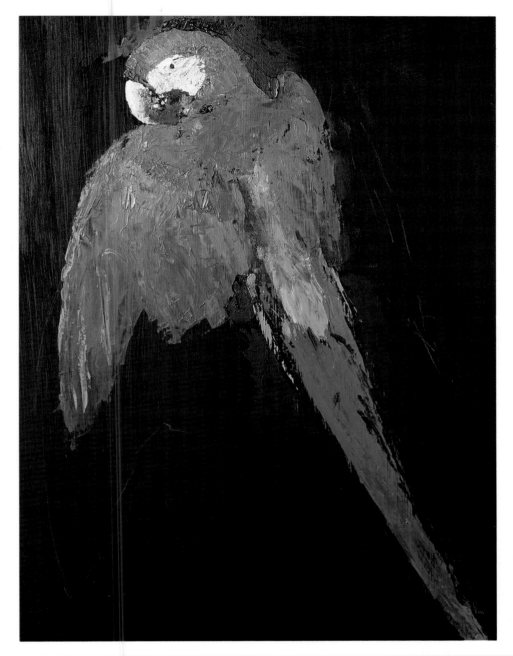

Tip

Combating rust

If you keep your knives in water for too long (or if they're exposed to moisture), they will rust. But you can remove any rust by rubbing fine sandpaper on the blades.

◀ **9** Highlight the outer edge of the beak with a thin white line to give it a round, three-dimensional look, again using the tip of the knife.

Now that the basic shapes and colours are mapped in, look for details to add.

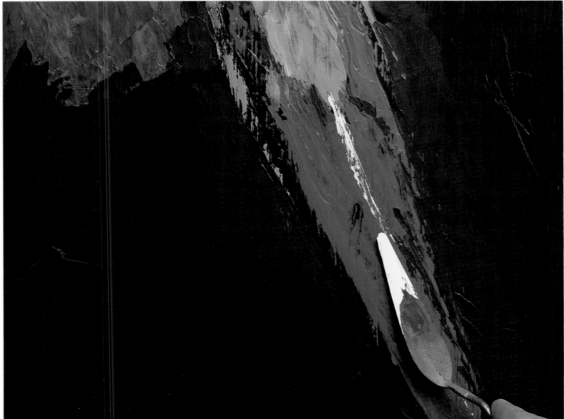

◀ **10** For the white line on the tail feathers, make a long, sustained sweep with the edge of the large knife.

► **11** The artist felt that the wing was too big and too bright. Using the large knife, he re-shaped it and darkened it in places with the black mix.

Then he added cerulean blue straight from the tube to suggest rows of individual feathers.

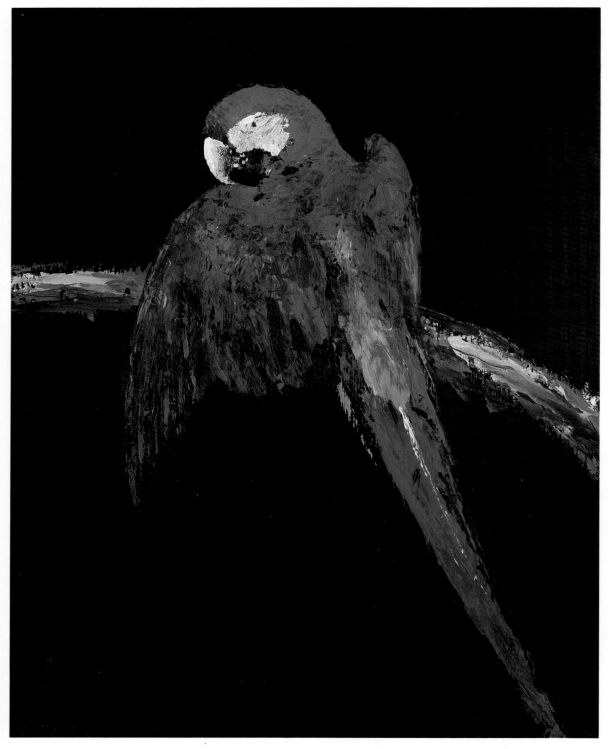

◄ **12** Put one dab each of yellow ochre, titanium white and burnt umber on the flat portion of the large knife. Then sweep it evenly over the board to form the branch that the macaw is sitting on. Use the tip of the small knife to scratch into the wet paint to add more detail and texture.

The finished knife-painting is full of energy with its many bright, exciting colours and angular knife marks.

Using liquid acrylics

Liquid acrylics are the most fluid form of acrylic paint. They handle much like inks, so you can use line and wash to capture the character of your subject with these deep, vibrant colours.

One manufacturer of liquid acrylics markets them as acrylic 'inks', hinting at their affinity with coloured inks. Both are similar to use, but liquid acrylics are coloured with pigments, while inks are dye-based, so the strong acrylic colours don't fade as much as inks (see Acrylic, Equipment 5).

You mix liquid acrylics with water to make washes, adding more paint for stronger colours, or extra water for delicate washes. Used on wet paper, you can create some beautiful flared effects very like wet-in-wet watercolour. Dry paint becomes waterfast, so you can overlap washes without the colours merging. Undiluted, some are opaque, allowing you to work light over dark.

Pen and brush work combine wonderfully. In this demonstration, our artist used bamboo pens with washes for a charming, illustrative effect. Bamboo pens are cheap to buy and lovely to use. Buy several sizes – fine, medium and thick – to allow for a range of marks, from thin, delicate flowing lines to thick, dark strokes. You can't avoid spills and blobs with these pens, but don't worry – these only add interest and spontaneity.

Liquid acrylics do justice to the colourful shop fronts in this Mayfair street scene, while the bamboo pens enabled the artist to pick out the architectural details.

▶**1** Draw the scene with your 2B pencil. Dilute yellow ochre with water and use this to outline the buildings and windows at the far end of the street with the fine bamboo pen. Mix a grey with sepia and cyan blue and begin to outline the buildings on both sides of the street. Draw through some of the yellow outlines with this colour.

Warm up this wash with a little sepia, then draw it in next to the existing grey lines to reinforce them. For the left foreground, switch to the medium bamboo pen.

▶**2** Now complete the process on the right side, using both warm and cool greys. Outline the chairs and tables on the pavement, and the figures too. Use the warm grey for the closest figure (to bring it forward) and the cool grey for the figures in the distance (to make them recede).

▶**3** Drop a little cyan blue on to the nib of the thinner pen (see Tip on page 91) and draw in the lamp post and sign to its left. Put in the paving stones with the cool grey. Blot off excess paint with blotting paper or tissue to stop the lines becoming too dark.

Using the No.10 brush, wet the sky with clean water. Load the brush with dilute cyan blue and wash it into the wet area so the paint spreads. Add more cyan blue to vary the wash in places.

Paint the distant buildings with the No.7 brush. Use yellow ochre for the light tones; mix in a touch of grey for the mid tones; add sepia to yellow ochre for the darkest tones. Allow the tones to blend together.

YOU WILL NEED

- ☐ A 12 x 17in sheet of 140lb Waterford HOT pressed paper, stretched on to a drawing board
- ☐ 2B pencil, palette
- ☐ Two bamboo pens: small and medium
- ☐ Jars of water
- ☐ Blotting paper, scrap paper and tissues
- ☐ Two soft round brushes: Nos.7 and 10
- ☐ An old toothbrush
- ☐ Eight Daler-Rowney FW Acrylic Artists' Inks: burnt umber, yellow ochre, raw sienna, sepia, process cyan, olive green, process magenta and black

Tip

Blotting for texture
Keep a box of tissues close by when you work with liquid

acrylics. They come in very handy for blotting off excess paint. They can also be useful for introducing a bit of texture. Here, our artist blots the paint on the window pane with a piece of crumpled tissue to suggest its reflective surface.

▶ **4** Mix a fresh grey with sepia and cyan blue. Use this for the dark buildings on the left side of the street. Add more cyan to vary the colour. Paint the brick wall at the corner of the street with sepia, adding some of your greys to vary the tone.

Now touch in a few details. Apply burnt umber and yellow ochre to the sign beneath the brick wall; put in the shop signs and awnings towards the end of the street with varying mixes of burnt umber and magenta. Add a few dabs of this mix here and there to brighten up the area.

◀ **5** Make a series of very dilute washes for the paving stones – a grey with sepia and cyan blue, then yellow ochre, burnt umber and magenta. Wet the entire paved area and apply these washes to separate paving stones to give the impression of different coloured slabs. Leave some of the paving stones unpainted. These pale washes add subtle interest to the area. Use your sepia/cyan mix to wash over the rooftops, blotting them with tissue to soften the effect.

▶ **6** Increase the amount of sepia in your sepia/cyan mix for the buildings on the right side of the street, adding olive green as you work closer to the foreground for the lower areas on the shop fronts. Use sepia to depict the glass of the shop window (see Tip, left).

When this dries, wash very pale cyan over the whole block of buildings on the right. Then bleed in some yellow ochre to vary the colours of the shop fronts slightly.

Go back to the No.10 brush to paint the step and corner stone of the doorway in greenish-grey. Add burnt umber and a touch of magenta to make the rich colour of the door. Then put in the panel edging with yellow ochre to give the door a subtle, aged look.

Creating texture in acrylics

There's a whole armoury of techniques for creating interesting textures with acrylics. Spattering, tonking and rolling paint are just a few of the most important ones.

Creating texture in your paintings may appear difficult, but all you need is a few basic techniques to help you produce a variety of textures which you can tailor to your subject matter.

Spattering This is a technique for applying paint in a field of erratic dots and blobs. Some of the most common objects you can spatter with are a comb, bristle brush, toothbrush and a decorators' brush.

Experiment with various brushes and some fairly watery paint mixes (on a separate sheet of paper, not your support) to see what effects you can produce. Spattering with a toothbrush, for example, can capture the fine texture, energy and feel of frothy waves at sea.

Tonking – named after the watercolourist Henry Tonks (1862-1937) – also allows you to create lively textures. You simply apply a wash, lay a sheet of paper over it, press the paper down with your hands then peel it off, leaving a highly textured surface. (You can tonk with acrylics, oils and even watercolours.)

Rolling You can apply paint with a small wallpaper roller, as our artist did in this demonstration. He rolled paint on to create irregular patches of broken colour which suited the markings of his moonlit cow.

Linear effects Use a phone card or an old credit card to make straight or curved lines, such as grass in our artist's demonstration.

▼ **This happily grazing cow, spattered with greens, browns and white, blends peacefully into the background – at one with nature. See how many other textural effects you can see in this painting.**
'Cow' by Peter Folkes, acrylic on paper, 15 x 22in

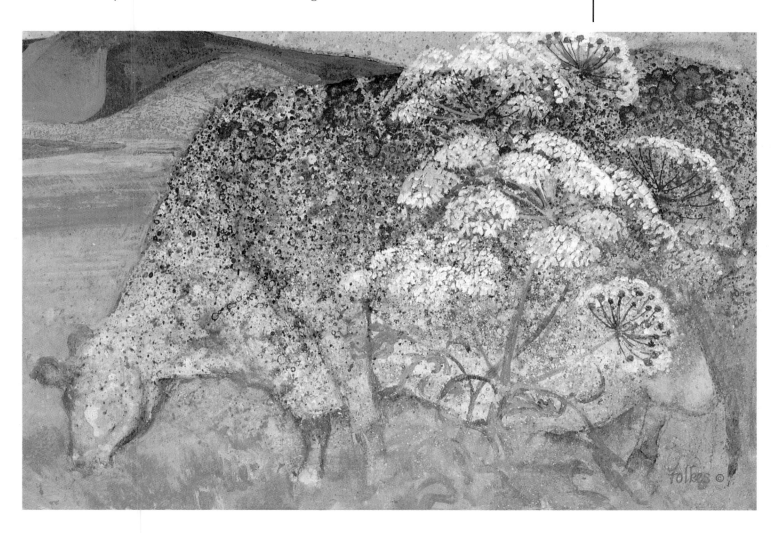

Trying out a variety of texture effects

Spattering Create fine dots of paint by loading a toothbrush with thinned paint then stroking the fibres with a palette knife. For larger spots of colour, load your bristle brush with thinned paint, then lightly tap the brush over the support.

Tonking (a) First apply a loose wash. While it's still wet, lay a sheet of newspaper over it, pressing down firmly. Then remove the paper – and see what you are left with. Blotting like this with newspaper lifts the colour and creates interesting textures.

Tonking (b) Try tonking with other materials such as cartridge/drawing paper or kitchen towel to produce different textures. You may even want to scrunch up the paper slightly and experiment to discover what suits your subject best.

Blotting and drying Spatter watery paint in two areas of the support with a soft brush. Blot one area immediately with newspaper (right), leaving irregular blobs.

Dry the other area with a hair dryer. Then wipe over the blobs with a damp cloth, removing the surplus paint and leaving white in the centre (left).

Rolling with acrylic paints A small wallpaper roller – or roller for lino printing – covered randomly with paint, creates interesting trails of broken colour. It's very important to vary the amount and thickness of the paint for maximum textural differences. For even more exciting effects, add texture paste.

Lines and curves You can add long straight or curved lines with the edge of a piece of cardboard, a phone card or an old credit card. Use these various linear marks to add interest and even texture to your paintings. Sometimes a piece of card will describe reeds or grasses more accurately than a brush.

Moonlight by the pool

▶ **The set-up** Cows – especially the mottled, brindled type – are one of our artist's favourite subjects. He has made numerous charcoal and pencil studies of them. Use these sketches as a reference, or better still, try your hand at sketching a few yourself.

Our artist worked first on the background then sketched in the cow. He continued with a variety of textures on the cow itself and then modified and developed the sky and field.

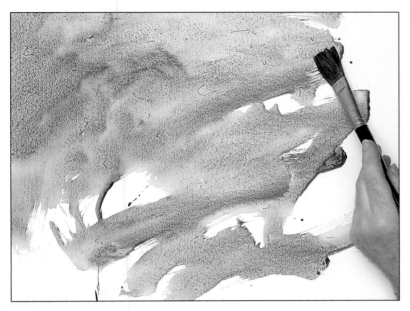

◀ **1** First stretch your watercolour paper and, when it's dry, prime it with a thin coating of acrylic gesso. Then mix a fairly loose wash of burnt umber and ultramarine and apply it at random with your 1in wash brush.

(Keep the painting flat until you're ready to start drawing the cow – it's easier to tonk and to control the spattering.)

▲ **2** Carefully lay a sheet of newspaper over the wet wash, and press your hand on it. Then peel it off. Repeat if you want a paler effect.

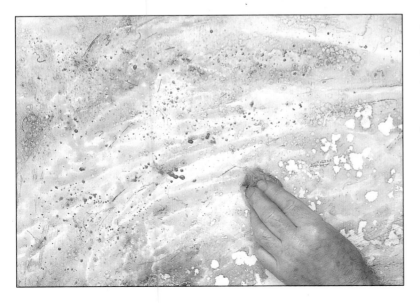

◀ **3** Make a watery mix of yellow ochre, and spatter large blobs on to the textured ground with the 1in flat wash brush. Using a hair dryer, quickly dry the drops – but not thoroughly.

For this texture technique to work – both spattering and tonking – it's essential to gauge when the outer edges of the drops are dry while the centres are still wet. Wipe over the spatters with damp kitchen towel, removing the wet centres to create ragged, crater-like marks. Wipe again to get a cleaner look, if desired. Repeat with a little ultramarine and burnt umber.

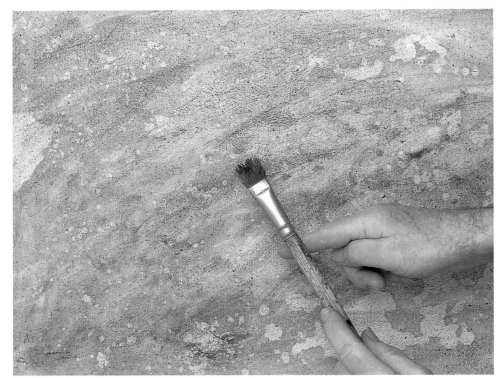

► **4** Apply a dark wash of burnt umber and yellow ochre with the 1in flat brush. Then add a little more burnt umber to the mix and quickly spatter it on with your No.10 flat brush, tapping the handle of the brush against your fingers to flick the paint irregularly on to the painting.

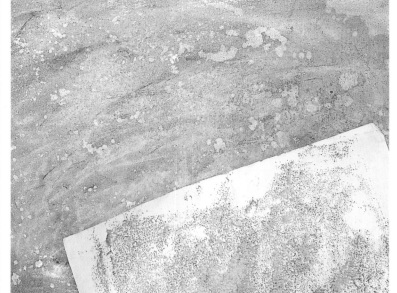

◄ **5** Blot over this with a sheet of cartridge/drawing paper to provide a slightly darker, smoother texture. Blot several times to lighten the tone. Notice how different layers of texture and tone build up on top of each other.

Have fun experimenting with tonking and spattering until you build up confidence and develop the textures and effects you want for your composition.

► **6** Repeat the wash and spatter techniques with yellow ochre, white and phthalo green until you're satisfied with the depth of tone and texture.

You cannot really plan this type of background – it develops as you go along. Once you're satisfied, though, leave the painting to dry thoroughly.

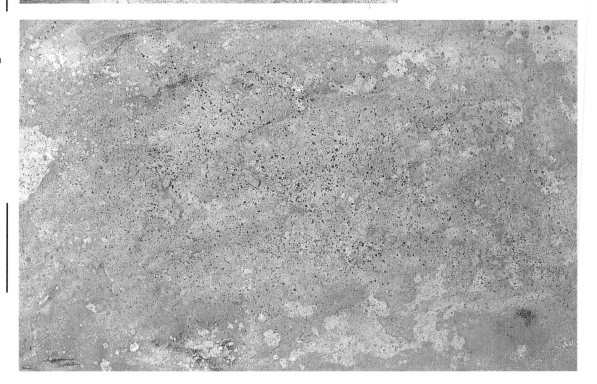

► **7** (At this point our artist put the painting on an easel to provide plenty of freedom for drawing.)

Lightly sketch in the outline of the cow with a soft charcoal stick. Make light strokes because heavy applications muddy further colours.

▼ **8** Mix up raw sienna, rose and a little matt medium to make a rich reddish brown. Use a crumpled piece of kitchen towel to dab on some large spots, following the backbone of the cow. Spatter on some finer spots with a slightly thinner wash, using the No.10 flat. This additional spattering helps to hold together the larger splodges.

Wipe away any stray spots outside of the outline of the cow with your cloth. Use the hair dryer to dry the spots – but not completely – along the backbone. As before, wipe them off with a damp cloth, leaving doughnut-like rings of paint.

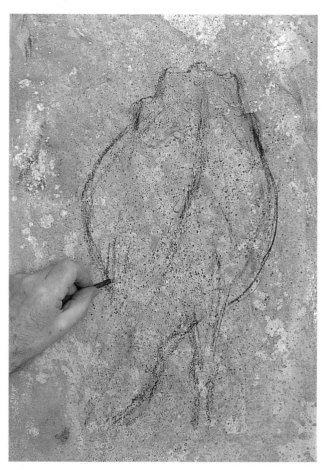

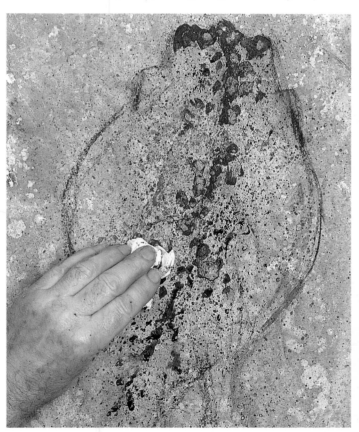

► **9** Mix phthalo turquoise, permanent green light and raw sienna on the palette, and drybrush in the reeds using the No.6 flat brush. Begin to fill in the cow's head, belly and rump a bit more with a wash of burnt umber and ultramarine, using your No.14 round brush.

Dab metallic gold spots down the cow's back, then spatter over these with finer spots. Leave to dry completely.

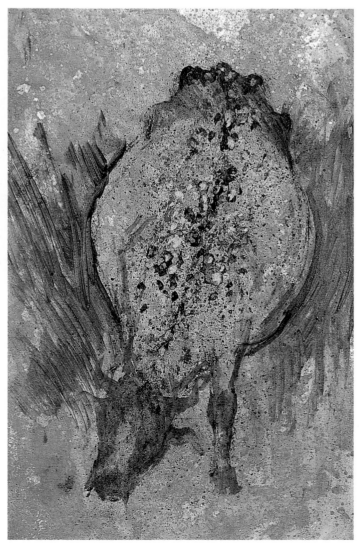

▶ 10 Now concentrate on the sky. Mix up a wash of copper, adding plenty of water and retarder gel to keep the paint wet and workable for a while. Apply the mix evenly, using the 1in flat wash brush, smoothly filling in the whole sky area. Blot immediately with a sheet of newspaper to remove the residual wetness yet leave a finely textured surface.

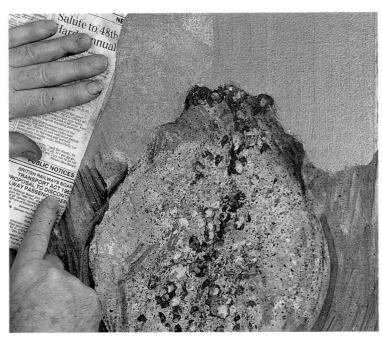

▼ 11 Lay another sheet of newspaper over the sky, applying firm pressure with your hands. Peel back the edge. Try to remove enough of the copper wash to allow the textures and colours of your first brush wash to show through slightly.

▼ 12 Balancing the colours and textures of your subject with the foreground and background is important in any painting. Because the sky is rather bold, the cow – the focal point – needs a coarser texture to make it stand out.

Mix white and matt medium with water on your palette. Apply it loosely to the cow with your small roller – but don't overload it because you want a trail of broken texture. (Before the paint dries, wipe off any white outside the outline of the cow.)

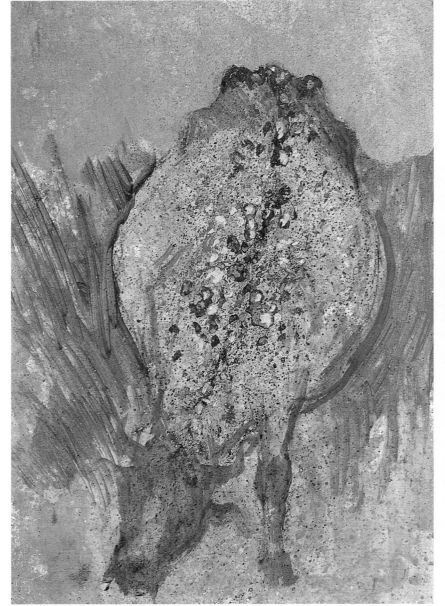

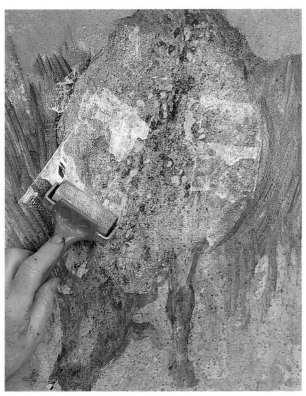

Finishing the moonlit cow

The texture of a painting is an important, and often overlooked, part of the composition, conveying the subject's energy or setting the mood. This painting demonstrates a wide variety of textures which you can try.

There are only a few basic texture techniques, but you can enlarge your repertoire by varying the materials you use. For example, you can spatter with a lacquer brush to produce large blobs of colour, or use a toothbrush to create a field of tiny dots. And tonking with a crumpled piece of newspaper creates a rougher looking texture than an uncrumpled one.

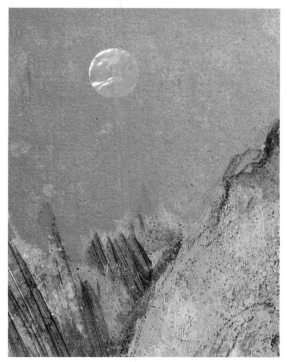

◄ **13** To create a distinctive-looking moon, use a circular piece of mirror foil, sanded slightly to dull the shine. Stick it on, painting around the outside with matt medium to hold it firmly. Then use your No.6 bristle brush to stipple a very thin white halo over and around the moon.

► **14** Mix a smooth wash with Prussian blue, white, a small touch of turquoise and retarder gel. Paint smoothly over the sky, including the moon, with the No.10 filbert.

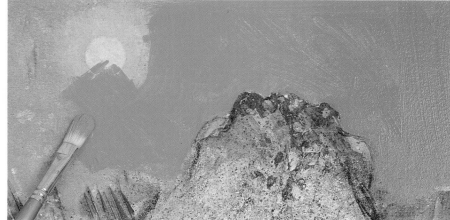

◄ **15** Tonk the area immediately with newspaper. The coppery red sky area should glow through the blue wash – even the moon halo should show.

Tip

Foil paper
Foil paper/mirror foil is available in specialist art shops, but for small pieces (such as used here), just check your larder! It's used a lot for fresh packaging. Tea bags and peanuts are quite often packed in this way. The foil is printed on the outside but the inside is generally mirror silver.

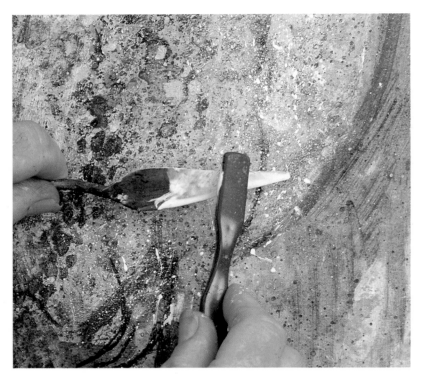

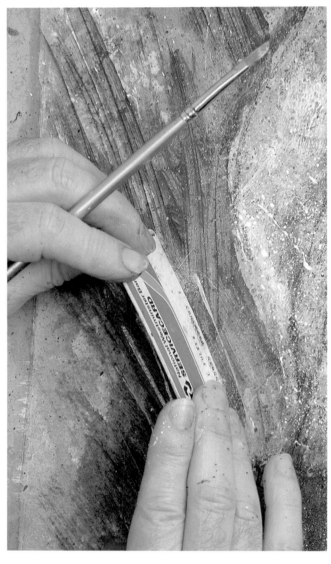

▲ 16 Sharpen the cow's outline, the feet and the head with a mix of burnt umber and ultramarine. Make a very fine spatter over the cow's back and sides with a wash of white and matt medium, using your toothbrush. (This acts as a highlight on the front of the cow.)

► 17 Mix a little yellow ochre with white and use the edge of a phone card or an old credit card to 'print' on straight and curved reeds.

► 18 Make up a mix of phthalo turquoise, Prussian blue and white for the aqua blue pool. Loosely paint in the water with your No.6 brush. Lighten the mix with white and add the rings as well as their highlights in pure white.

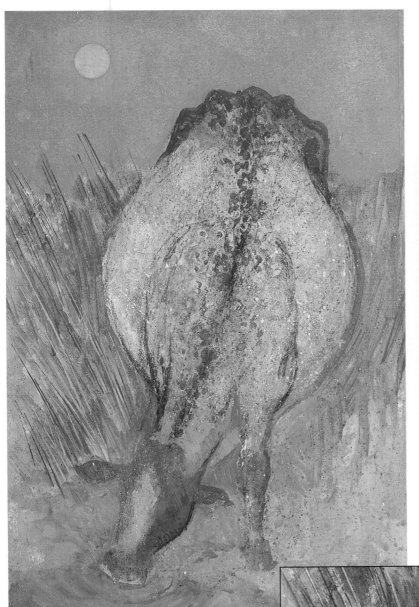

◄ **19** Sharpen up the cow's ears and face with a mix of ultramarine and burnt umber. Stand back from the work to assess any other fine points you may wish to add.

▲ **20** Our artist felt the sky would look better if it were darker. (This sort of decision is always on the cards – don't be afraid to alter things at once if you aren't happy.) He covered the area with a mix of Prussian blue, ultramarine, violet, white and retarder then blotted it with a piece of newspaper. This meant he had to paint the halo around the moon again, this time using turquoise and white.

▶ **21** The next stage was to put in some fine details. For this our artist mixed various shades of pale green with different amounts of yellow ochre, phthalo turquoise and white. He applied this paint thinly to the nib of a ruling pen, then used it to add more details to the reeds. He also drew some very fine lines around the neck and head of the cow.

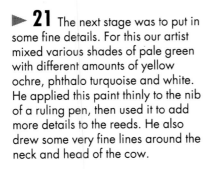

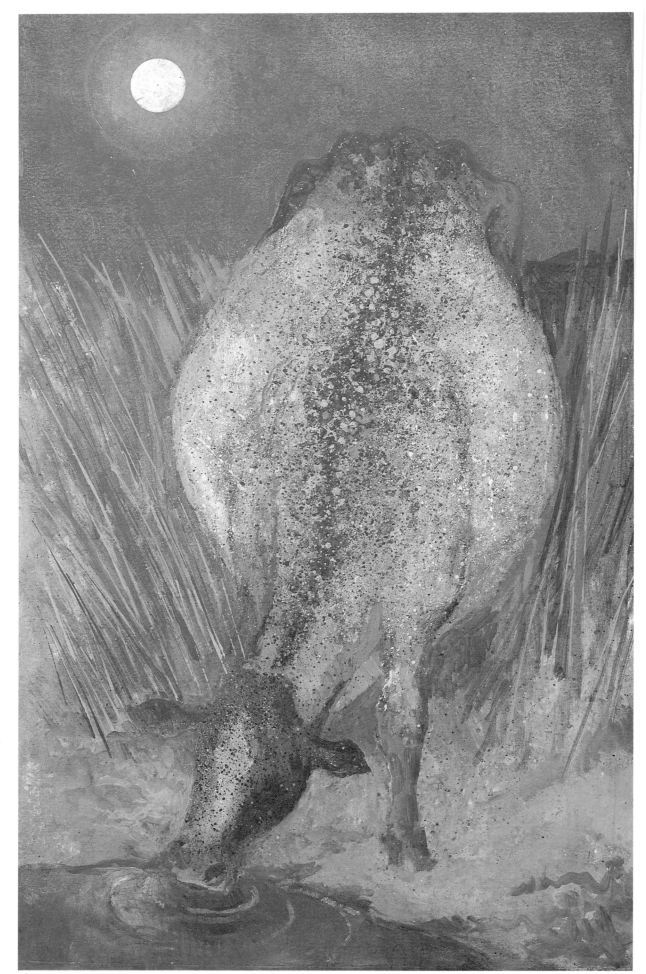

▶ **22** Make any final adjustments to the painting. Add a hint of pearlescent paint to highlight the water and give it more of a moonlit quality.

Our artist has used many different texture techniques for his moonlit scene in order to demonstrate what can be done. Usually it's best to use only one or two textures in your painting, otherwise the effect can be rather fussy. Nevertheless, it's fun to try them all out, as here, and you'll learn some useful tricks for your future paintings.

Creating a high finish

Given the versatility of acrylics and their quick drying time, you can achieve very delicate textures and a high degree of finish in your paintings.

The beauty of acrylic paints is that they dry quickly, allowing you to take a finely detailed painting to completion in a few sittings. You can apply acrylics with a very fine brush, or in loose washes; you can use them thinly or thickly; and you can chop and change technique at will. With acrylics you are not constrained by the stricter working practices of, say, fat over lean with oil.

Their immense flexibility allows you to achieve a high degree of finish in your painting, but you

also need to be absolutely meticulous in your brushwork – and be possessed of abundant patience. You constantly hone down from a broad base, searching out the finer details that ultimately make the picture succeed or fail.

In the demonstration overleaf of a plate of ripe strawberries sitting on a delicately embroidered white cotton cloth, our artist's attention to the tiniest seed and to the smallest patch of reflected light brings the strawberries to life.

▼ **A meticulous eye for detail brings each item in this picture to life, yet the picture still retains an appealing painterly quality.** *'Pomegranate and Rosehips' by Susan Pontefract, acrylic on paper, 7 x 8in*

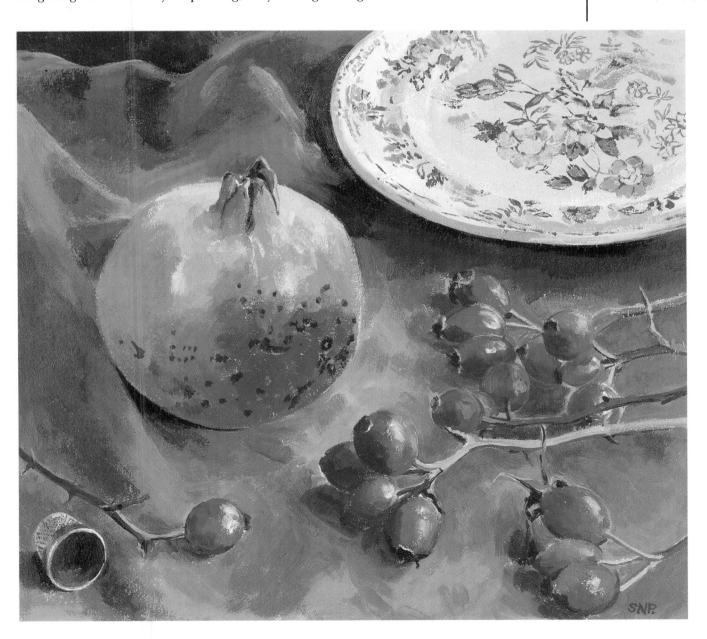

Tantalizing strawberries

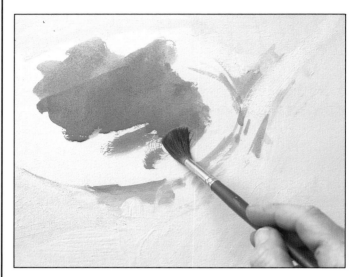

◄**1** Use a dilute mix of white tinged with cobalt blue and olive brown to position the plate and the folds in the cloth with your Cryla C10 brush. Warm the mix with a little yellow ochre and work across the cloth, putting in more folds.

Block in the mass of strawberries with a thin mix of cadmium red, permanent rose and a little cadmium yellow light, using your No.10 brush. Continue with the same brush, putting in the shadow beneath the plate with a mix of yellow ochre, olive brown, plenty of white and a touch of ultramarine. Use the folds and shadows in the cloth as a compositional aid.

►**2** Before positioning any fruit, dab in the plate pattern with cobalt blue and white, using your No.4 brush. Vary the colours, adding a little permanent magenta, then chrome oxide green.

With a more intense mix of cadmium red and permanent rose, outline a few strawberries, using your No.2 brush. Fill in the fruits and their stalks and sepals as you go, following the instructions in the box below. Use cadmium red and a little olive brown for their darker sides.

Fine detail – placing the seeds

▲ Fill in the painted outline of a strawberry with a thin mix of cadmium red, permanent rose and a little cadmium yellow light, using your No.2 brush. Indicate the stalk and sepals with chrome oxide green and cadmium yellow light mixed with a touch of ultramarine.

▲ Switch to your No.1 brush and paint highlights around the seed positions, using white mixed with a little cadmium yellow light. Then begin to place some of the paler seeds with a mix of cadmium yellow light and a tiny touch of permanent magenta and chrome oxide green.

▲ Now repaint between and around the seeds with the red and pink. For the darker seeds, add some olive brown to the seed mix and edge some seeds with this to bed them down firmly, as shown. This attention to detail brings a high degree of realism to the picture.

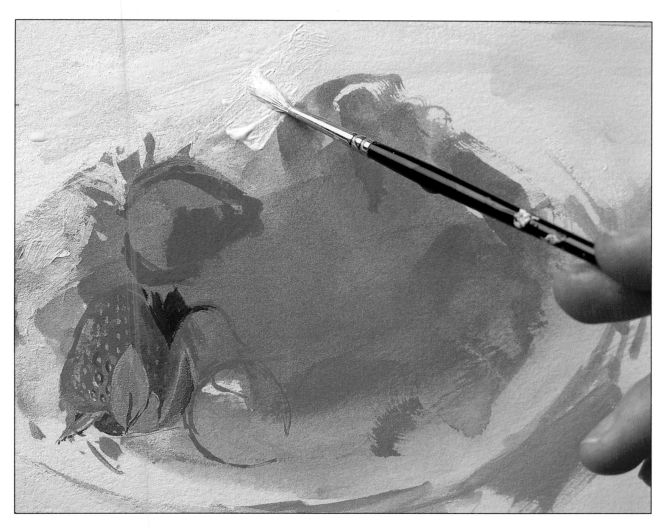

▲**3** With your No.4 brush, dab some pure white into the cloth above the strawberries. Work on more of the pattern on the left side of the plate with dabs of cobalt blue and yellow ochre mixed.

Placing the seeds calls for some delicate brushwork, so make sure your No.1 brush is clean and the hairs come to a fine point. Paint the seeds in the strawberries (see the box, opposite page below left). Add some ultramarine and olive brown to the red mix and paint the dark areas between the strawberries to give depth to the composition.

▶**4** Switch to the No.4 brush and paint the lighter sepals in loose, fluid strokes with a mix of chrome oxide green and cadmium yellow medium. Use a darker green, with more chrome oxide and less cadmium yellow for the darker sepals on the top strawberry, adding a little olive brown for the shadows. Paint the darker seeds on this strawberry, with the seed mix and a little olive brown added. Put touches of white between and around the seeds.

Now go back to the first strawberry and dab tiny touches of white around the seeds on the left, using the No.1 brush. Work around the small strawberry in the front with your dark mix from step 3.

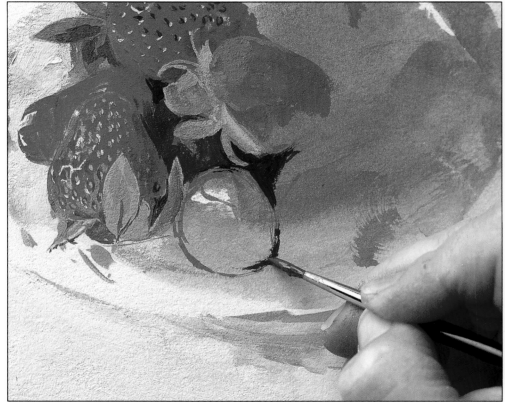

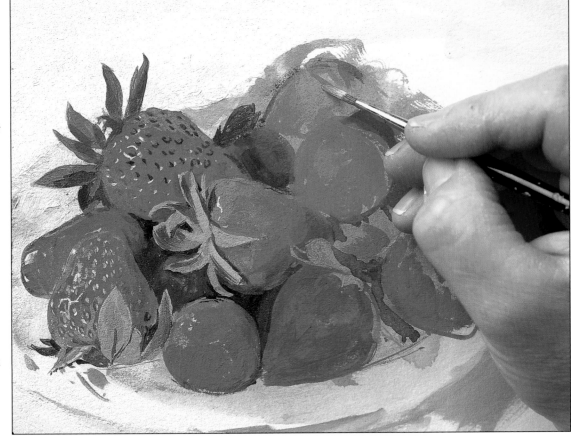

▶5 Block in the remaining fruit with the original red mix. Flesh out the unripe centre strawberry near its stalk with cadmium yellow light, cadmium red and permanent magenta, darkening it with more red and permanent rose towards the tip. Paint the very ripe front strawberry with cadmium red and permanent rose.

Make a more intense mix of cadmium yellow medium, cadmium red and olive brown for the dark strawberry at the back, and use the same mix between the strawberries. Work on the back edges of the plate with cobalt blue, yellow ochre and white.

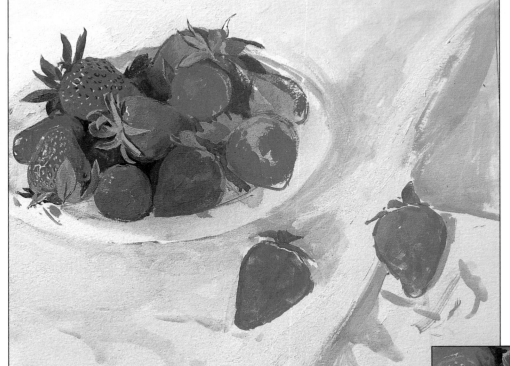

◀6 Position the two stray strawberries on the cloth with the cadmium red and permanent rose mix, using your No.2 brush. Then paint their stalks and sepals with the green and yellow mix used in step 4.

Change to your Cryla C10 brush. Now mix up a dilute grey wash with white, cobalt blue, yellow ochre and olive brown and work on the cloth, tidying up the shapes of the strawberries on the plate and cloth as you do so. Add a little olive brown and more blue to develop the folds and shadowy areas and to paint the shaded area of cloth to the right of the plate.

▶7 Put in the seeds on the front round strawberry, adding olive brown to the mix for the darker, lower seeds. Edge some of the lighter seeds with this same mix. Pick out tiny highlights with white and a little cadmium yellow light. Now paint the remaining sepals, looking carefully for the lighter and darker shades.

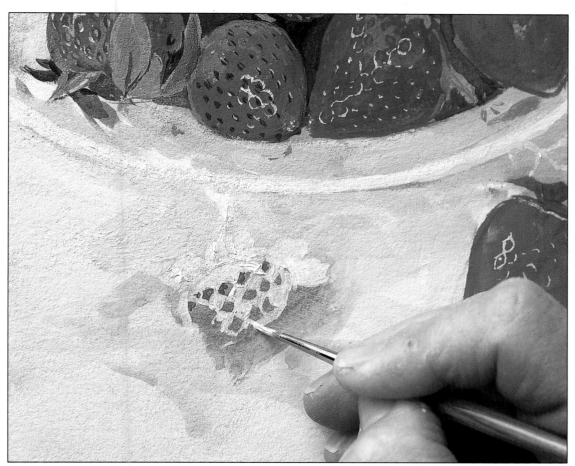

◀8 Delicate work is needed for the lace on the cloth. Paint the dark tone of the table beneath the cloth with a mix of yellow ochre, olive brown and white, using the No.4 brush.

When this is completely dry, paint the lace on top. Using white, cadmium yellow light and a little olive brown, lay the paint on quite thickly to suggest the raised stitching of the lace.

Work over the dried dark area with white and yellow ochre to warm it up. With some cobalt blue and olive brown added to the previous mix, put in the shadows appearing within the holes – see how the details of the intricate lace pattern emerge.

▶9 Now is a good time to assess the picture as a whole. Continue working on the lace area of the cloth with your No1 brush, using white, cobalt blue and a touch of olive brown for the shaded area. Continue to work on the shadows of the cloth with various mixes of white, yellow ochre, cobalt blue and olive brown.

Roughly block in more of the pattern on the rim of the plate with cobalt blue and white. Add cobalt blue to the shadow inside the plate as it dips away from the lip at the front.

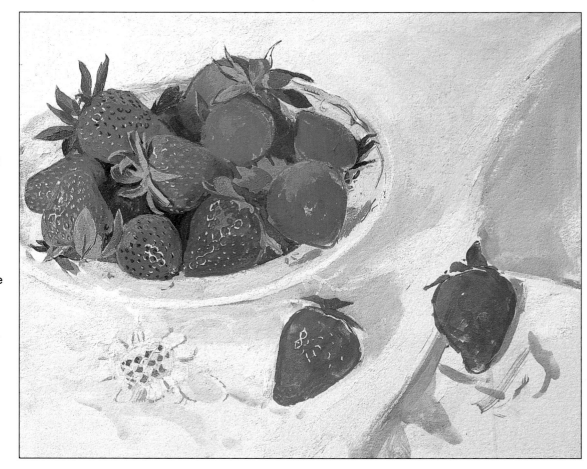

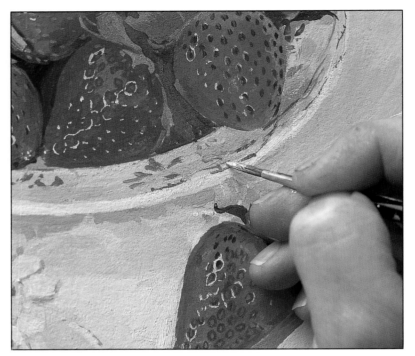

► **10** Carefully position the seeds on the strawberries on the right, using the previous colour mixes, then put in the highlights. Freshen up the colours on the plate with a bright blue mixed from cobalt blue, a little permanent rose and white, and refine the details of the pattern with your No.2 brush, freshly cleaned. Use white to brighten the rim of the plate.

With the same colour mixes used in step 9 for the folds in the cloth, work around the loose strawberries, laying the paint on fairly thickly. Add a little more olive brown and cobalt blue to the mix and paint the shadows under the two strawberries and the plate rim.

▼ **11** For the finishing touches to the cloth, sweep through the shaded area to the right with the No.4 brush and a mix of white and cadmium yellow light, creating a raised fold. Work around the fruit on the cloth, smoothing lines of paint across the fabric. Use white to add a little more detail to the embroidery and the shadows within it. Darken between the strawberries for added depth.

As you can see in the finished picture, our artist has described the strawberries beautifully, building on loose washes with exquisite, fine detail.

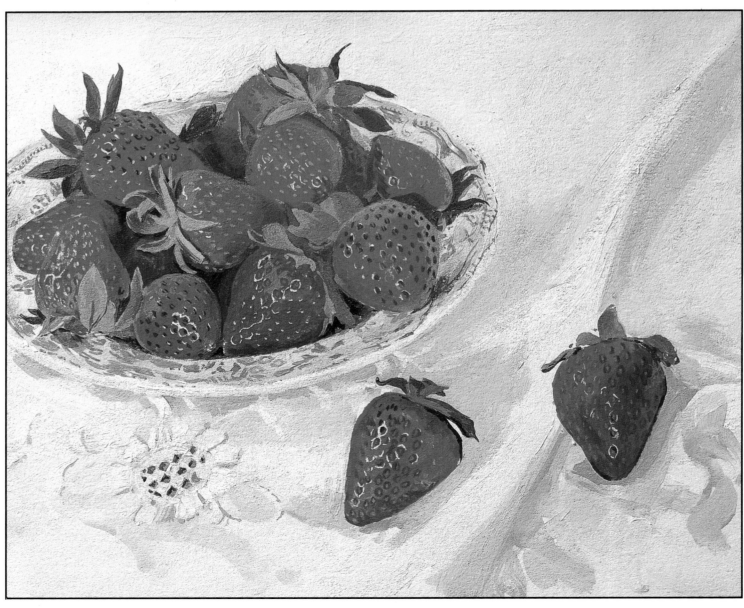

A splash of masking fluid

The vivid colours of liquid acrylics can be combined with a bold use of masking fluid to create some lively images.

Masking fluid is usually associated with watercolour, but it's also compatible with liquid acrylics. Just as in watercolour, you can use it to protect the fine details of your painting while you apply the main washes. However, because liquid acrylics produce such vivid results, our artist decided to make use of the masking fluid in a more flamboyant fashion.

Firstly he applied it to the areas he wished to keep white – the turbulent water around his diver. Then he used it again, once the initial washes of colour had dried, to protect them from later washes.

When using masking fluid, you must think in terms of the negative – what you leave behind is just as important as the positive marks you make. If you want to leave areas white, you should mask them out at the start. This means you must think ahead.

With liquid acrylics don't use the colours too strong – that way you can keep your options open. Aim for a thin, watery mix – you can always strengthen the colour by washing over it again once the first wash has dried. Wash your hands thoroughly before you start – any fingermarks will show up under the thin washes.

Our artist chose a range of liquid acrylics – Golden Fluid Acrylics – with a consistency similar to Indian ink. They are intense colours made with lightfast pigments with good durability, flexibility and adhesion. But if you already have some liquid acrylics from another range, use them instead.

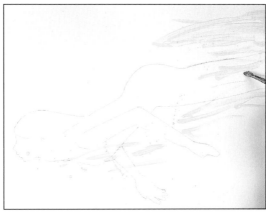

The set-up Our artist based this painting on one he'd done earlier. You can use his finished painting as a guide, or work from a sketch.

◀**1** Loosely sketch the diver on the paper. Using the masking fluid and your old brush, mask out the water turbulence around the diver with vigorous strokes. Dab a few bubbles around the figure for a lively touch. Apply a thin line of masking fluid to define the back of the diver's head and her left arm. Leave this to dry.

◀**2** Mix diarylide yellow with quinacridone red and add pyrrole red and water for a deep flesh colour. Try it on spare paper, then paint the face and chest with the No.4 round.

Mix pyrrole red and yellow to make orange and apply it to the thigh. Now use dilute quinacridone red to paint cheek, arms and body; overlay the chest and body with pyrrole red to indicate form – if you darken the areas of the body farthest away from you, the form becomes more three-dimensional.

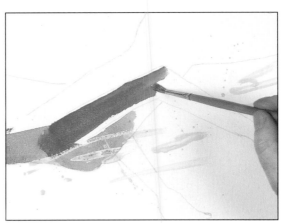

▶**3** Paint the girl's hair with an almost black mix made from blue, diarylide yellow and quinacridone red. Don't paint the long streak of hair nearest the face – leaving it blank gives the diver more movement.

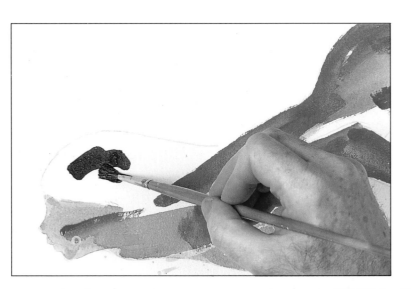

YOU WILL NEED

- [] A 66 x 48cm sheet of 140lb NOT/cold pressed watercolour paper and a scrap of the same paper
- [] Masking fluid and an old No.4 or No.5 round hog brush
- [] Two brushes: a large wash and a No.4 round hog
- [] Palettes or two plastic egg boxes
- [] Large drawing board and gummed tape
- [] Water dropper
- [] Several jars of water
- [] Soft eraser
- [] Hair dryer
- [] Five Golden Fluid Acrylic colours (or equivalents): quinacridone red (crimson), pyrrole red (scarlet), phthalo green (emerald), phthalo blue, diarylide yellow (spectrum yellow)

▶ **4** Now that the darkest colour is in, stand back and check the balance of tones in the painting. Assess which areas you wish to tone down when you add the turquoise wash in the next step.

Notice how the bold, vigorous brushstrokes indicate the speed of the diver. (It's also more fun to paint in this way, with lots of energy and enthusiasm.)

◀ **5** The next stage is to wash over the whole picture with turquoise for the sea. Protect any areas you don't wish to be tinted by the wash with more masking fluid. As before, apply it vigorously with your old brush. Don't cover the whole figure though – the areas of the diver farthest away from you would naturally be coloured by the depth of water, so leave these unprotected.

Leave the masking fluid to dry thoroughly – if it's not dry, the next wash will move it and drag it over the painting.

▶ **6** Mix phthalo blue and phthalo green with plenty of water. Test the mix on the spare paper – you want a rich turquoise. Use the dropper to adjust the water in the mix until you are happy with it. Now sweep the colour across the painting with your wash brush, starting just off the paper so the colour is smooth and even. Don't try to avoid the figure – just go straight over it.

If you get a build-up of paint on one edge, turn the paper upside down and repeat the strokes across the other way. Keep the paper fairly flat to prevent runs.

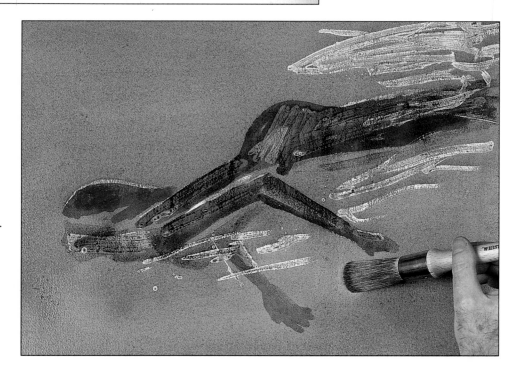

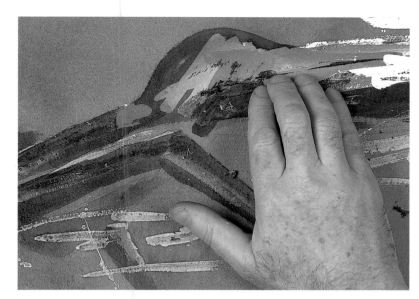

◀**7** Leave the wash to dry. If it hasn't dried evenly or it isn't deep enough, reapply it, then leave it to dry again. When it is completely dry, rub off the masking fluid with your fingers or a soft eraser. Then feel over the page with your palms to pick up any bits you've missed.

Tip

Testing ground
Rather than experimenting on your painting, follow the advice of our artist and try out

each colour on scrap paper. You can even test successive layers of colour in this way, avoiding any unnecessary mistakes on your painting.

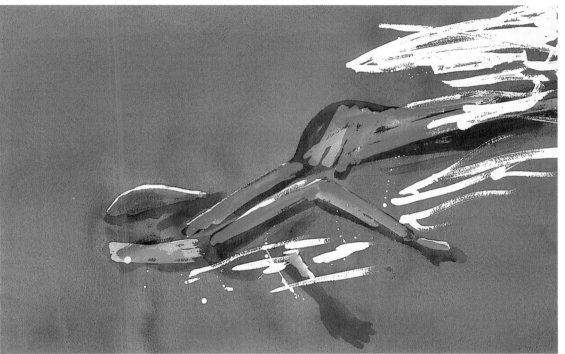

▲**8** Now that the masking fluid has been removed, you can see exactly where our artist used it in step 5, before adding the turquoise wash. By masking only the areas of the diver nearest to him and the highlight on the far arm, he has given the figure plenty of form. Notice also how the sweep of masking fluid laid over the face has added to the sense of movement.

▶**9** Our artist felt the face had lost definition, so he overlaid it with another flesh-coloured wash. He kept the effect lively by applying the paint unevenly, leaving some of the paler shade to shape the face.

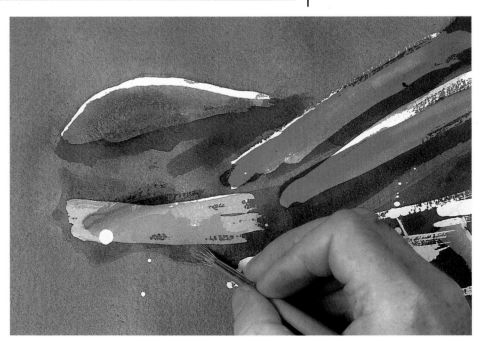

▶ **10** The white lines defining the arm and shoulder looked a little harsh, so our artist washed over them with a wonderful splash of yellow. Since this is the complementary colour of the violet shades created by washing turquoise over the body, it makes the painting sing.

▼ **11** In the finished painting you can see how the vigorous brushstrokes and washes of colour combine to give the figure its sense of movement and form. It's like a freeze-frame shot of a diver, suspended in the moment of diving. Her position over to one side adds to the sense of movement, with the water in front alive with anticipation.

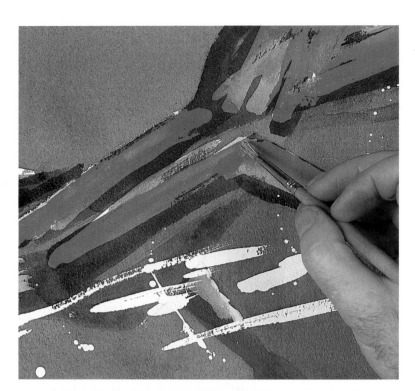

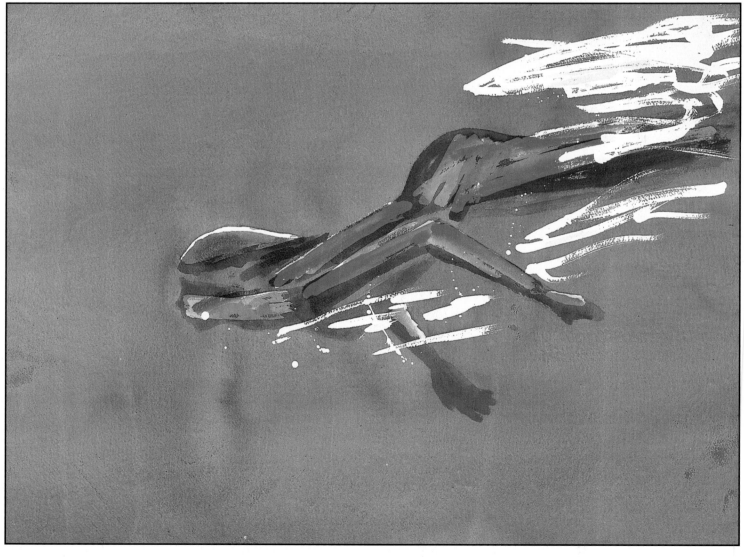

Optical mixing

The pointillist technique of optical mixing, originally done in oils, is perfect for fast-drying acrylics which almost eliminate the tedious time spent waiting for the little dots of pure colour to dry.

Pointillism is the technique of placing small, regular dots of pure, unmixed colour side by side on the canvas so that, when viewed from a distance, they react together optically, producing more vibrant colour effects than if the same colours were actually mixed together.

Georges Seurat (1859-1891) developed this technique towards the end of the nineteenth century. Using oil paints and working with pure colours – straight from the tube – he produced pictures which were composed entirely of dots of colour.

A drawback in this type of painting is the length of time oil paint takes to dry – the build-up is slow because you usually work wet over dry to retain the purity of the colours, so you have to work in stages, over a number of days. With quick-drying acrylic paints, of course, this problem simply disappears.

With this technique you can avoid the confusion of colour mixing, often a problem for the amateur painter, because you use paint straight from the tube. Although time-consuming, the pointillist technique is well worth the effort. The result is a shimmering picture exploding with fresh colours.

▼ **The shimmering quality of evening light captured here shows an attractive form of optical mixing in acrylics.**

Over a ground toned in raw umber (applied in vertical, striated, graded tones), the artist has applied dabs and dashes of colour so the ground shows between and, in places, gleams through the patches of colour. The complex broken paint surface gives the painting a wonderful luminosity.
'Winter Sunshine' by Michael B. Edwards, acrylic on board, 16 x 20in

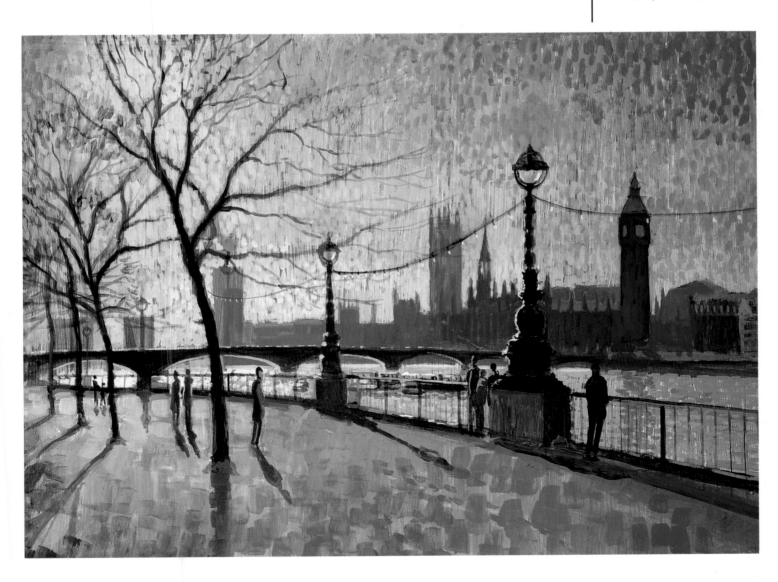

Two old gardeners — and their dogs

◀ **The set-up** By taking many photographs for reference, artists can capture natural, unforced positions and movements for use later in their paintings. This artist takes many photos of people, and finds them extremely useful.

You need only one brush – a No.2 flat – for the entire painting, and you use colours straight from the tube, unless you are lightening them with titanium white. To create the dark colours, simply load a lot of one colour on top of another – the colours mix optically on the canvas.

◀**1** Before beginning to paint, spend some time making a good drawing from which to work. This gives you a chance to make adjustments and refinements – our artist changed the level of the feet for his painting.

Draw the figures on to the canvas board with the 2B pencil, using your reference drawing, and check that all proportions are correct. (Note the positions of the two little dogs – these change later on; there's no reason why you shouldn't alter and adapt as you see fit; the photo is only a starting point, not something to be copied slavishly.)

YOU WILL NEED

- ☐ A 10 x 14in primed canvas board
- ☐ One No.2 flat synthetic brush
- ☐ 2B pencil and an eraser
- ☐ Disposable palette
- ☐ Cotton rags
- ☐ Three jars of water
- ☐ Water atomizer (to keep paint moist on the palette)
- ☐ Nine Rembrandt acrylics: titanium white, lemon yellow, cadmium red, carmine, sap green, ultramarine, Rembrandt blue, raw sienna, burnt sienna

▶**2** Start with the figure on the left. For his cap, make some initial dots in ultramarine, followed by similar marks in burnt sienna and raw sienna. Don't drag the brush in a conventional stroke – dab the brush on to the canvas and then remove it. Paint the hair using the same two colours and white.

Now apply colour for the face – first cadmium red, followed by lemon yellow, and finally burnt sienna mixed with titanium white.

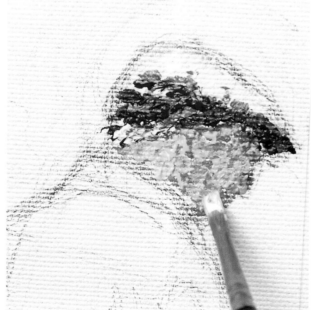

◀**3** Paint over the pencil outlines (both figures and dogs) with little dashes of ultramarine so you don't lose track. Then apply dabs of burnt sienna to the first man's jacket. All the colours show through when finished, and they mix in your eye to produce the right tones for fabrics, skin and so on.

► **4** Build up consecutive layers of ultramarine and burnt sienna to develop the volume of the jacket (add more dabs for the darker areas). Use raw sienna for the lighter tones and raw sienna with titanium white added for the highlights, such as on the shoulders and arm.

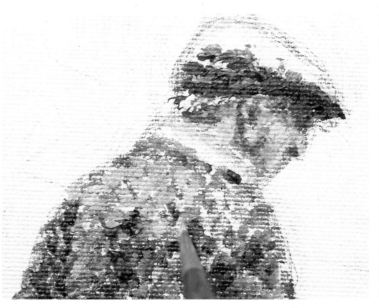

▼ **5** Still on the same figure, paint the shoes with the same two colours as the jacket, again making burnt sienna the predominant colour. Add white areas last for the highlight on the side of the shoe.

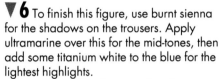

Tip

Take a break
Don't forget to distance yourself from your painting at regular intervals to check that the optical mixing works. And don't neglect the opportunity to take a break so that when you come back to your painting you can look at it afresh.

▼ **6** To finish this figure, use burnt sienna for the shadows on the trousers. Apply ultramarine over this for the mid-tones, then add some titanium white to the blue for the lightest highlights.

Use mixes of cadmium red and titanium white followed by yellow to dot in part of the background. Because of the speed at which acrylic dries, you can paint whole areas in one go – first the brick wall in the background, for instance, then the plants and bushes almost immediately afterwards.

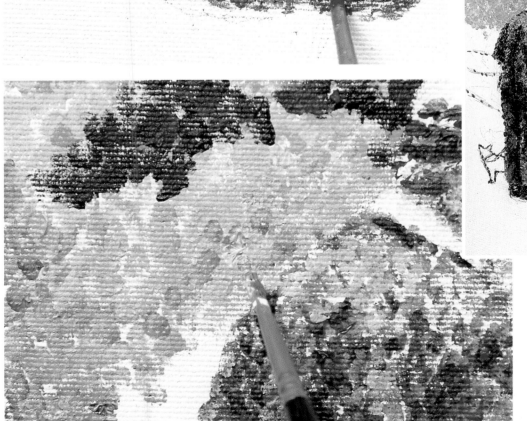

◄ **7** Continue on the background with sap green – sometimes straight from the tube, sometimes mixed with white for a range of tones. Lay carmine over burnt sienna for the copper beech tree.

▶**8** Apply dabs of cadmium red to the head of the man on the right. To develop the volume of his head, use sap green for the shadows and lemon yellow for the light tones, followed by burnt sienna mixed with titanium white. (Note the enhanced colour effect gained by using red, and its complementary, green, side by side.)

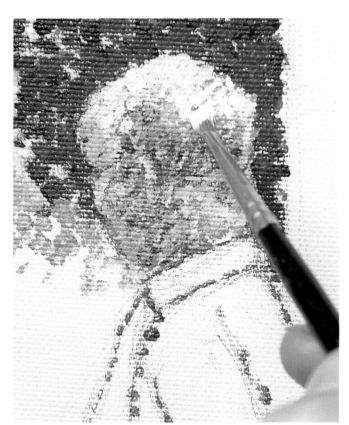

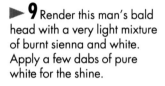

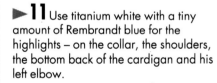

▶**9** Render this man's bald head with a very light mixture of burnt sienna and white. Apply a few dabs of pure white for the shine.

◀**10** Paint this man's shirt, using Rembrandt blue and titanium white. Apply burnt sienna to the darkest parts of his cardigan, then paint Rembrandt blue over the burnt sienna to form the folds and darks.

▶**11** Use titanium white with a tiny amount of Rembrandt blue for the highlights – on the collar, the shoulders, the bottom back of the cardigan and his left elbow.

◀**12** Establish the darkest folds in the trousers with burnt sienna. Over this apply pure raw sienna for the mid tones. To finish the trousers, mix raw sienna with titanium white for the highlights. (Note that the positions of the dogs are different – the artist has moved them so that they look into the picture, not out of it.)

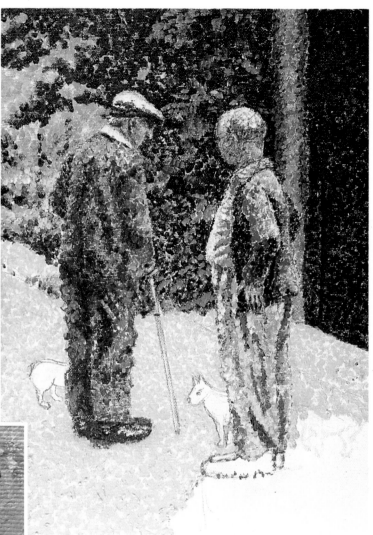

▲ **13** To strengthen the edge of the figure on the right, use a mixture of sap green and titanium white to push the background farther back. Make sure that all edges butt up to each other.

▲ **14** Paint in the old garage doors on the right in ultramarine and sap green. Paint the post in raw sienna and burnt sienna with touches of red and blue for the darkest tones.

◀ **15** Next paint in the little dogs. Use ultramarine, followed by raw sienna and burnt sienna for the dark areas. The tail of the dog on the right is mostly white.

▶ **16** Paint the road with successive layers of ultramarine, raw sienna, carmine (mixed with white) and titanium white. The walking cane has two sides – a dark one (ultramarine and burnt sienna) and a light one (raw sienna with white). Now paint the grass in the foreground using sap green, blue lightened with white and lemon yellow in sequence.

▲**17** Step back to examine the finished painting. The artist felt that she had painted the bald head too large, so she just extended the background colours to reshape the crown.

▶**18** After all that dabbing, the artist has created a vibrant painting, full of life. The colours shimmer and blend together in the eye. The only mixing of paint has been done with white. This was, in fact, crucial in the work of Georges Seurat, who felt that white increased the reflective powers of the other colours and evoked a feeling of natural light.

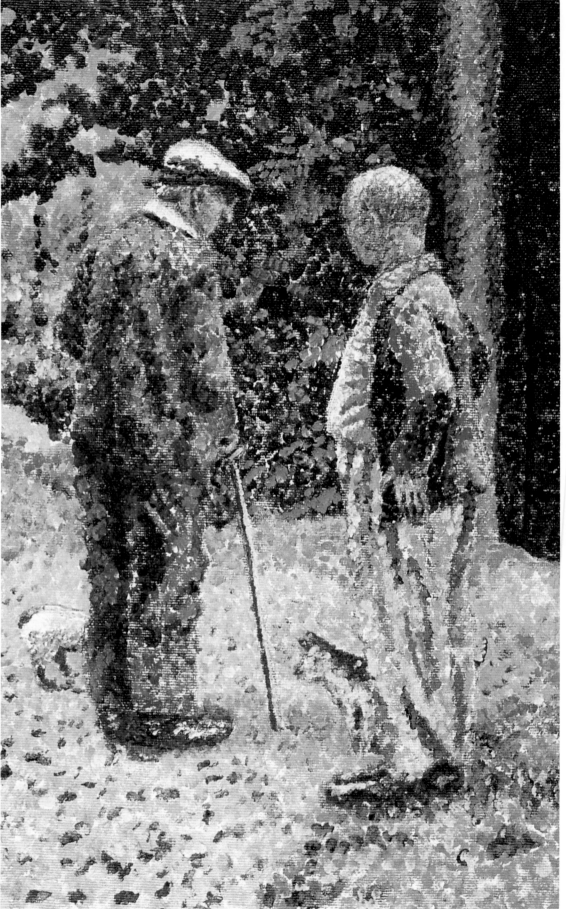

Interpreting what you see

Your subject may be as magnificent as the Taj Mahal, but it's how you interpret it that makes a good painting. Take liberties with reality to explore the potential of your subject and your imagination.

Edgar Degas (1834-1917) once said 'a painting needs as much fraudulence, trickery and deception as the perpetration of a crime'. Perhaps his criminal imagery was a little strong, but it does emphasize the idea that you can exaggerate and invent to make a good painting. Even from the most mundane of subjects, if you use your imagination and work with what's in front of you, you can create a fascinating picture.

This demonstration painting shows a view of London's Blackfriar's Bridge leading to some sky scrapers and St. Paul's Cathedral – a view that many artists have probably considered as a subject.

Our artist's painting, however, is unique. Instead of recording the scene exactly, he invents colours and textures to give it a magical and rather abstract quality. For example, he saw no reflections in the muddy water when he sketched and photographed the scene, yet in the painting they make up a large and interesting part of the composition.

The colours in the painting are most striking. Their bright, lively quality belongs very much with modern paints like acrylics. And they allowed our artist to create a personal, imaginative interpretation of his subject.

▼ Our artist took reference photographs of his scene on two different occasions. In between, the bridge had been painted, and construction work with cranes had finished in one area and begun in another. He picked out only the elements he liked most.

Don't copy photographs. See them as a springboard, not a finishing point.

▼ You can see from these thumbnail sketches that already our artist brings in some imaginary reflections and plays around with their shapes and tonal values. He also uses these quick sketches to decide how high the waterline should go and where to crop the scene.

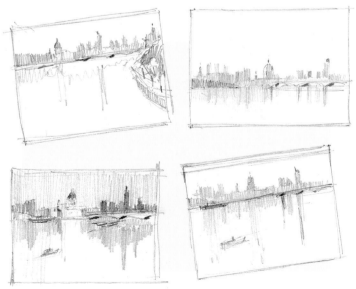

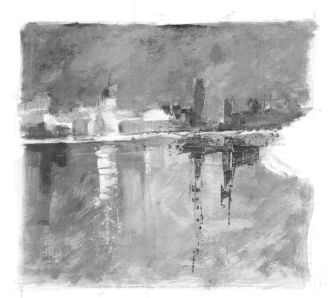

◄ Having decided on a composition, our artist made a small colour study to crystallize his ideas. He establishes his colour theme, the quality of light, the painting's atmosphere – and explores various textural possibilities.

YOU WILL NEED

- ☐ *A 39 x 52cm sheet of white mount/mat board*
- ☐ *An HB pencil*
- ☐ *Our artist used a variety of brushes for this painting – you'll need at least four: a large mop, a medium mop, a 1in flat wash and a small round*
- ☐ *Trowel-shaped painting knife*
- ☐ *Jars of water and shallow tray for storing the brushes*
- ☐ *Palette*
- ☐ *Seven acrylic colours: French ultramarine, cadmium red, magenta, burnt umber, yellow ochre, phthalo green and titanium white*

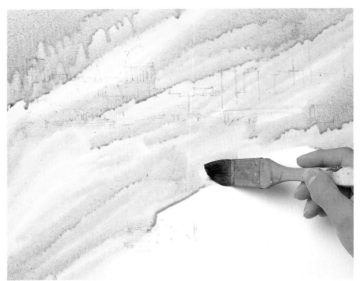

◀ **1** With many of the decisions regarding composition already made, start by sketching the outlines of the main features with the HB pencil, paying special attention to the position of the horizon line. Our artist placed it high, on a third division, in fact, to give maximum emphasis to the enormous expanse of water.

Tilt the board at a slight angle and apply a loose wash of dilute French ultramarine all over the board with the 1in flat wash brush. Make the covering deliberately uneven to enliven the successive layers.

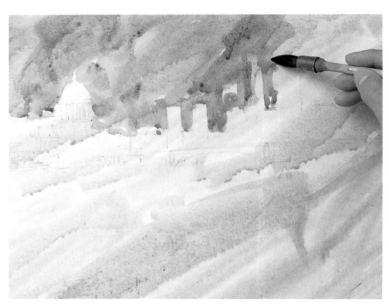

▶ **2** Mix a wash of ultramarine warmed with a little cadmium red and, using the medium mop brush, fill in the sky, carefully cutting out the shapes of the buildings as you go.

Wait until this has dried thoroughly before continuing.

▶ **3** Now apply a dilute wash of phthalo green over the water with the large mop brush, leaving the space for the foreground boat blank. Again, do this loosely, allowing the underlying blue to show through in places. This gives a sense of depth and translucency to the water.

These underwashes help to set the colour key of the painting and also establish a harmony which binds the painting together.

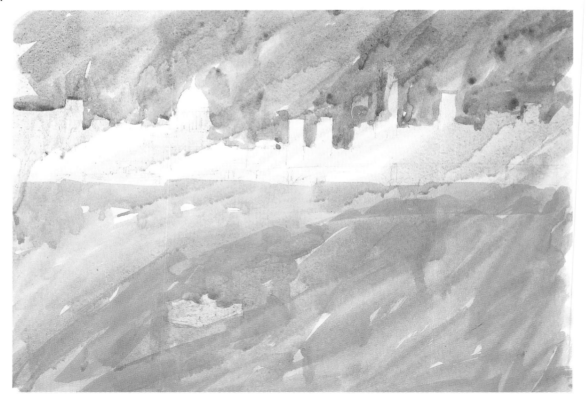

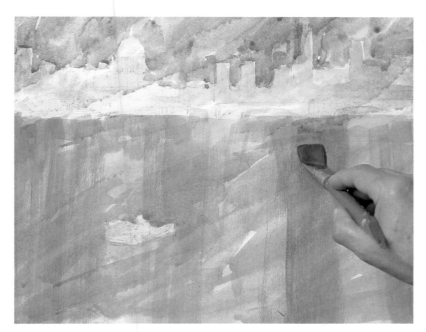

◀ **4** Paint some shadows on the buildings with your small round brush and a thin mauve mixed from cadmium red, ultramarine, magenta and plenty of water. Then start to indicate the reflections in the water with a mix of phthalo green, ultramarine and a tiny touch of cadmium red. Use your flat brush to make long, vertical strokes.

Tip

Brush care
If you don't wash your brushes immediately after use, leave them in water to prevent the

paint from drying on them and rendering them useless. If you leave them standing in a jar, the bristles resting at the bottom may bend and distort. Instead, lay them in a shallow tray of water, handles propped against the edge and bristles resting in the water.

▶ **5** Start to use thicker paint to build up the picture. Mix French ultramarine, cadmium red and titanium white and, keeping the paint quite dry, scumble loosely over areas of the sky with the small round brush. Let the underpainting show through in places to give the sky an airy quality.

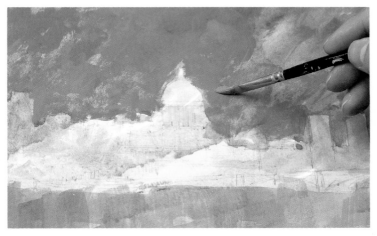

◀ **6** Pick out the buildings to the right of St. Paul's with the painting knife. (The knife doesn't allow you to put in too much detail, so these buildings are kept firmly in the background. What you can achieve with the knife is sharp outlines that retain a fresh, spontaneous feel.)

Use the sky mix from step 5, darkened with burnt umber. Start at the outer edges of the buildings and slide the knife inwards, making block-like shapes. The paint doesn't settle in some areas – leave these gaps to stand as highlights.

▶ **7** Add the buildings to the left of St. Paul's with a blue-grey mix, still using the knife. Then paint the cathedral itself with mauve-greys and a range of earthy yellows mixed from varying proportions of yellow ochre, white and cadmium red. Print the pillars beneath the dome – apply paint to the edge of your knife and press it down on the surface to make vertical lines.

Our artist wanted to reinvent the area around the cathedral by adding some foliage. Use phthalo green, with touches of yellow ochre and burnt umber for variation.

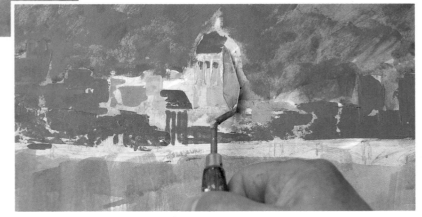

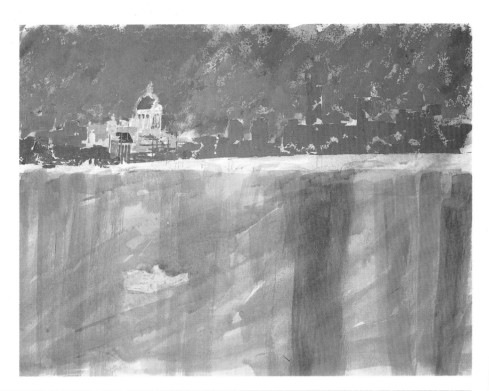

▶ **8** Mix a range of brooding greens for the clouds with varying amounts of phthalo green, ultramarine, yellow ochre, burnt umber, cadmium red and white. Obviously, clouds aren't normally green – this is an excellent example of colour used as an emotional element to express mood and convey a particular atmosphere.

Mix the paint thicker and drier now, and slide it lightly over the sky with the edge of the knife. This gives areas of broken colour through which you can see the underlying layers of paint.

Add some cranes in front of St. Paul's with a neutral blue-grey, printing them with the edge of the knife blade.

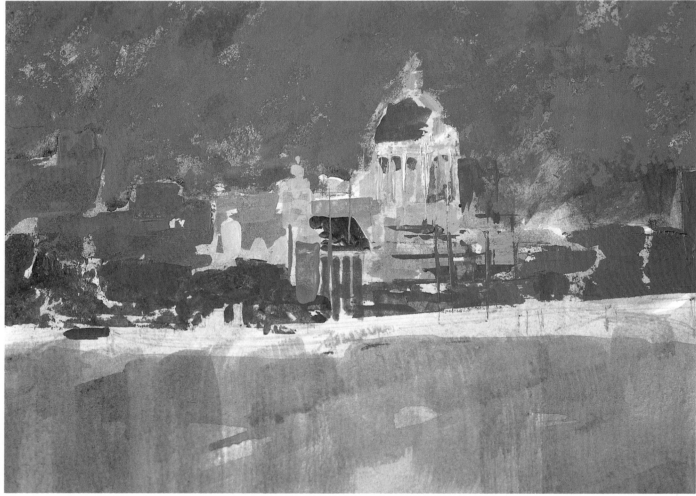

▲ **9** Knife painting encourages a broader handling of the paint so you don't become too involved in detail and labour the painting. Here, you can see the variety of lively and expressive marks our artist made with his painting knife.

Finishing the River Thames view

Our artist began this painting of St. Paul's Cathedral and Blackfriar's Bridge viewed from London's South Bank by covering the board with loose, dilute washes, then worked over these using thicker paint and blocking in the buildings with a painting knife.

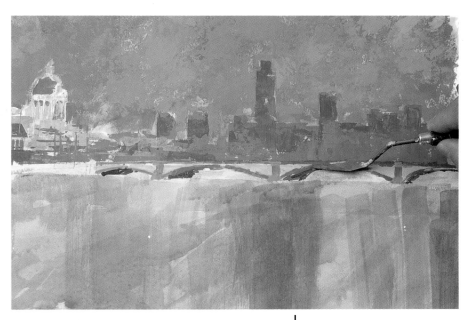

▶ **10** Pick out the shape of the bridge with a pale green mixed from yellow ochre, white and a touch of ultramarine. Wait for this to dry, then paint the decorative red 'trimmings' with dilute cadmium red and the edge of the knife. Make your paint mixes thicker and brighter as you move towards the foreground to help the area advance.

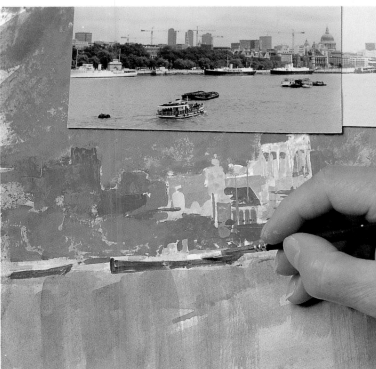

◀ **11** Now paint the moored boats. Our artist used his photographs to help with details of shapes and colours, but avoided the temptation to put in too much detail. Observe the shapes carefully but paint them with brief lines and strokes, using neutral colours to keep them in their place in the background.

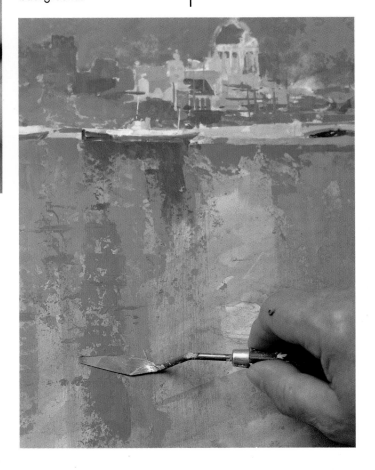

▶ **12** Start putting in the reflections in the water. Mix some stunning turquoises with phthalo green, and ultramarine, both mixed with varying amounts of white. Use stronger blue-green mixes for the darker reflections beneath the bridge and boats.

Apply the paint with sweeping downward strokes of the flat of the blade, using light pressure so the marks break up to suggest movement on the water's surface. (Don't overdo the reflections, or the water will look more like a patterned carpet!)

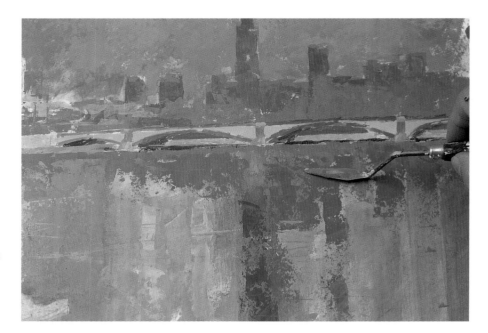

13 Continue painting reflections. Don't forget to relate them in shape and colour to the objects they reflect. St. Paul's, for instance, casts yellowish reflections – paint these with mixtures of yellow ochre and white, varied with either ultramarine or cadmium red. Paint the reflections of the skyscrapers with various mixtures of phthalo green and ultramarine. Use the edge of the knife blade to tick in a few red reflections beneath the bridge.

Tip

Knife edge
Painting with a knife produces some quite different results from painting with a brush. So if you want to add variety to your paintings, you can't beat a little knifework. Practice using the base, side and tip of the knife, and try out knives in different shapes – you can buy pear-shaped ones, long, straight ones or trowel-like ones.

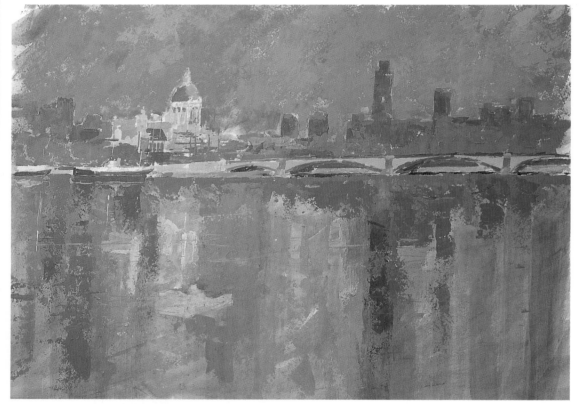

14 Take a break – stand back and have a look at your painting from a distance. The reflections have been painted loosely with plenty of broken colour, giving them a wonderful, shimmering quality.

15 You may find it easier to evaluate your painting if you use a mount to 'frame' it. This cuts off the ragged edges and encloses it in a border so you can assess the balance of tones and colours within the image, and make any necessary adjustments.

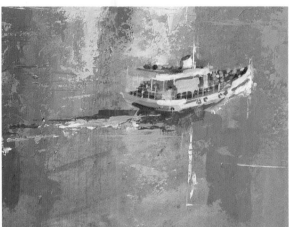

◄**16a** Paint the pleasure boat in the foreground using the small round brush. Begin with an underwash of pale blue, then pick out the shadows and highlights in various colours. Suggest figures on deck with tiny dots of paint, taking care not to make them look mechanical.

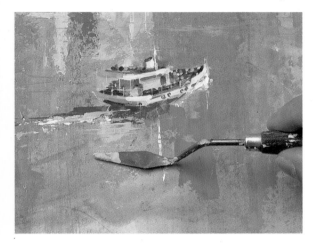

▲**16b** Continue adding detail to the boat, then put in a dark blue-green shadow beneath it, trailing behind into the boat's wake. Paint the vertical white radio transmitter with the side of the knife. Make its reflection less fine and regular than the transmitter itself. Stay with the knife to add the boat's frothy wake – ladle the paint on thickly and let it peter out away from the boat. For this, add plenty of white to the blue-green shadow colour.

▲**16c** This boat is one of the few areas of tight detail in the picture. Its foreground position attracts your attention and leads the eye into the picture. Notice how well the reflections work – the greeny-yellow one (towards bottom left beneath the boat) looks as though it's part of the reflection of St. Paul's which has been disturbed by the boat in its path.

Add white, horizontal lines for highlights with the side of the knife in areas of the water. Make the marks broken and textured to give the water a glassy appearance.

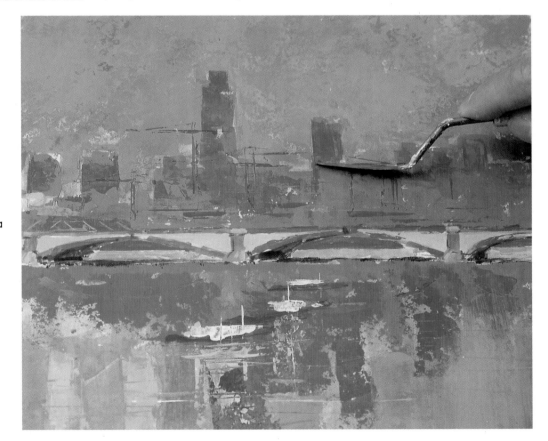

▶**17** Loosely put in the barges by the bridge with the tip of the small round brush. Then indicate the cranes and gantries behind the bridge using cadmium red applied with the edge of the knife blade. Make any final adjustments you think necessary to the tones and colours.

▶18 Notice how our artist has built up the area around St. Paul's. The building itself is a focal point. Although there are trees, buildings and cranes around it, they are put in very loosely, blocked in broadly with the knife, so the main emphasis remains with St. Paul's.

However, this is put in loosely too – notice the pillars and windows beneath the dome. This keeps it in the background and gives its pale, dramatic silhouette great emphasis.

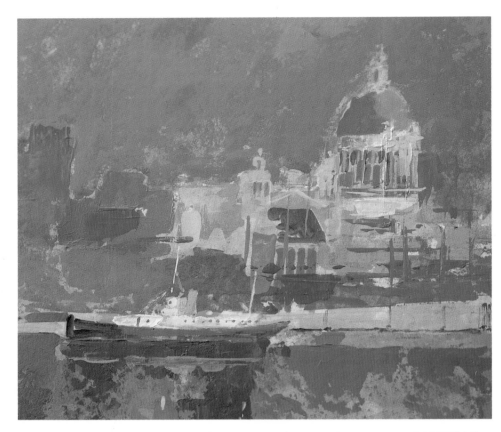

▼19 Successive layers of transparent and opaque colour build up a lively, textured surface which plays a large part in the impact of the finished painting. The broken colour, which reveals small areas of underlying hues, sets up subtle and complex harmonies between the rather abstract shapes and colours – not only of the reflections, but in the skyline behind.

Because acrylic paint dries quickly, it is possible to develop successive layers of colour in rapid succession, without any fear of picking up and muddying the layers beneath.

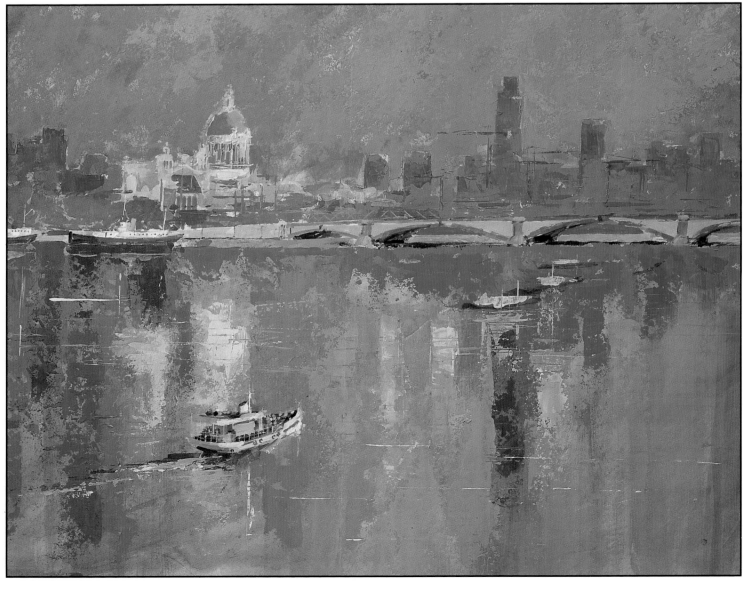

Index

Acknowledgements

Artists

Alastair Adams 27(b); Paul Apps 45-50;
Adrian Bartlett 109-112; Gordana Bjelic-
Rados 9; Brenda Brin Booker 27(t); Rob
Boudreau/Tony Stone Images 51(r);
Terry Burke 10-11; Gillian Burrows 89-92;
Anne-Marie Butlin 26(b); Sarah Cawkwell
10; Michael B Edwards 113; Peter Folkes
93-102; Kate Gwyn 34(b), 35-38; Marianne
Hellwig John 28; Terry McKivragan 13, 29,
119-126; Hamlyn-John Melville 114-118;
Susan Pontefract/Duncan Campbell Fine
Art 103; Susan Pontefract 104-108; Ian
Sidaway 40(b), 41-42, 51(l), 52-56, 70-76;
Richard J Smith 12(b), 69, 77-88; Richard
Smith 57-62; Stan Smith 63-68; Bill Taylor
12(t); Jenny Tuffs 17(t); Peter Unsworth
17(b), 26(t).

Photographers

Our thanks to the following
photographers: Mike Busselle, Geoff
Dann, Jeremy Hopley, Ian Howe, Patrick
Llewelyn-Davies, Robert Pederson,
Graham Rae, Nigel Robertson, Steve
Tanner and Mark Wood.